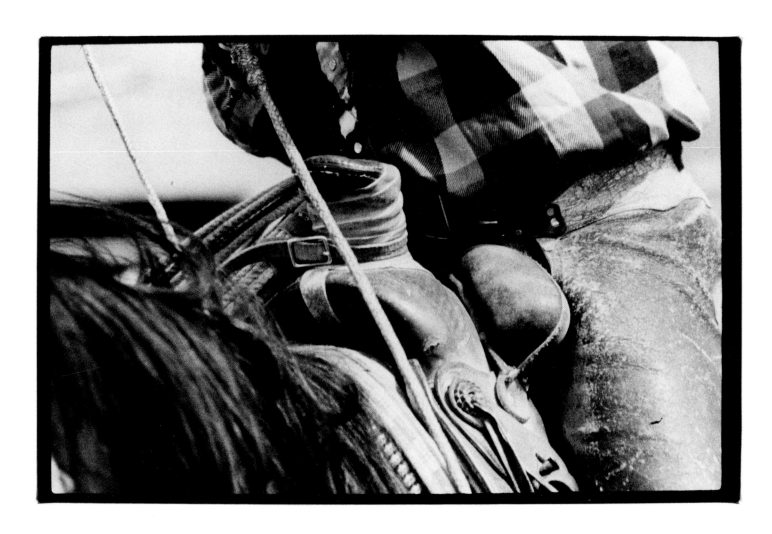

♦ FIRE & RAIN ♦

A PORTRAIT OF THE CONTEMPORARY WEST

IMAGES FROM THE GREAT SNAKE RIVER COUNTRY OF IDAHO AND OREGON

Photography, Text, and Design by Ed Guthero

CCI Books
A Division of Coffey Communications, Inc.
WALLA WALLA, WASHINGTON

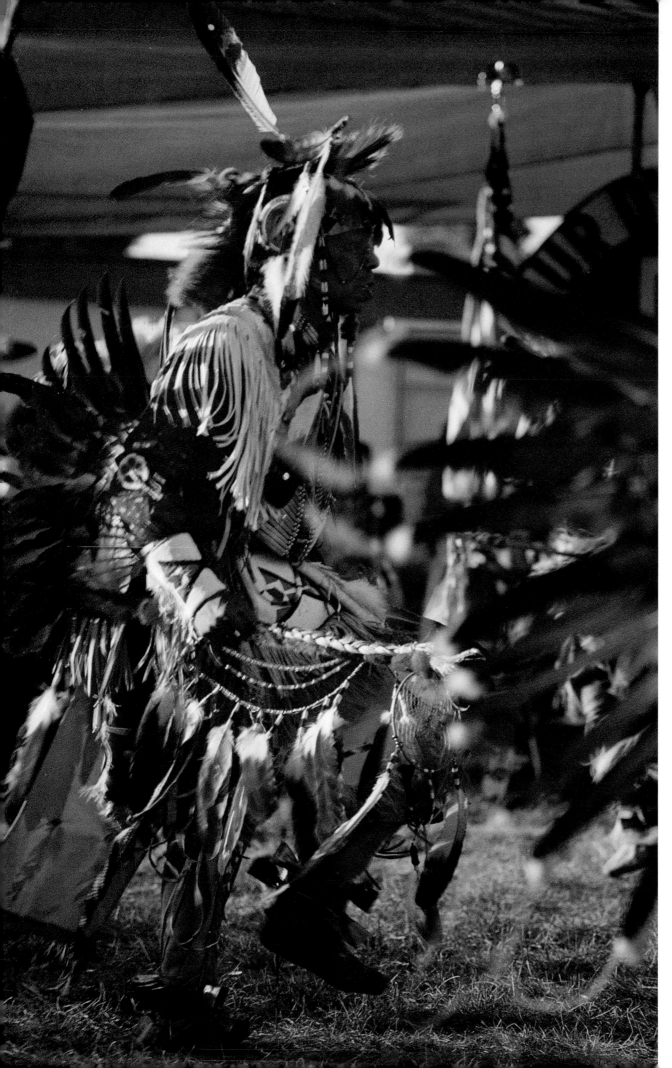

T he first time I saw the American
Indian Village at Oregon's Pendleton
Round-Up, I was astounded.
Mounted, feathered horsemen in complete
regalia were gathering among the rows of
tepees. Intricate beadwork, white fringed
buckskin, breastplates, and headdresses were
everywhere. I quickly fired off roll after
roll of film, lost in the visual splendor of
the moment.

Similar experiences occurred at rodeos
throughout Idaho and Oregon. The lure
of the West is enduring—the timeless
orchestration of horse and rider, Stetson
hats, chaps, faded denim, and silver buckles
are consistent reminders of its power.

One of the things that impressed me was
how these events seemed to transcend time.
The past and the present appeared to merge.
For a brief period, I seemed to be at another
place in time.

Later, when researching historical
background for this book, I would come
across old photos from the late 1800s.
The images of American Indians especially
intrigued me. Their world was under siege,
rapid change whirled all around them,
yet their dignity overwhelms the picture
frame—men and women frozen in time,
their individualities intact.

An in-depth look into the history of
the American West reveals a time of great
turbulence, injustice, and struggle. It can be
a disturbing revelation. I wondered how to
relate this to my project—it seemed the
West was far more complicated than I
originally perceived.

Today, the West still wrestles with its past,
as well as a host of new problems. Modern
technology and the demand of civilization
clutch at the land; still it emanates grandeur.
The sage-covered high desert of Idaho,
contrasted by rolling mountain ranges
against the purple sky, appears to go on
forever. Will it always be so? In this age of
computer chips and fax machines, perhaps
the West is under siege again.

The images in this book focus on people
of the Contemporary West. People who wear
tradition with pride and a unique flair. It is
best to let the images speak for themselves.
I hope you enjoy viewing these photos as
much as I did taking them.

ED GUTHERO
BOISE, IDAHO

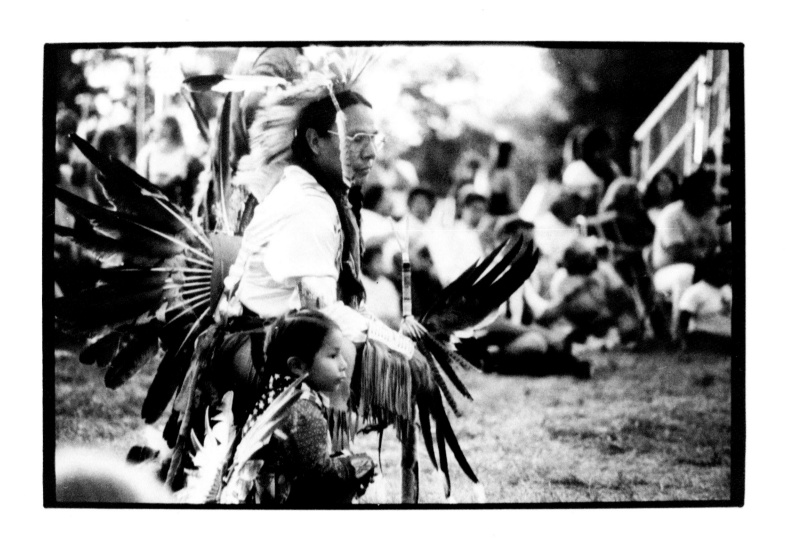

◆ C O N T E N T S ◆

FIRE & RAIN
A Portrait of the Contemporary West

Copyright ©1993 by Ed Guthero
All rights reserved
Printed in the United States of America
Library of Congress Catalog Card No. 93-071353

ISBN 1-881802-00-0

CCI Books, a division of Coffey Communications, Inc.
1505 Business One Circle, Walla Walla, Washington 99362

♦ I N A P P R E C I A T I O N ♦

Many people influenced and encouraged the development of FIRE & RAIN. It is impossible to list them all, but special thanks to Alan, Jane, and Barbra Coffey, Paul Ricchiuti, Dick Springs, Melda Roberts, the Caldwell Night Rodeo, the Pendleton Round-Up, the Snake River Stampede, Andrea Schlapia, the American Indian tribes of the Snake River Country, One-Hour Photo (Boise), Timeless Photo (Boise), the many fascinating people of the Contemporary West whose images appear in these pages, Joe and Ethel Guthero, Hugh O'Brian and Johnny Cash.

Special thanks to editors Ken McFarland and Russell Holt for their assistance.
Color separations by Hi-Tech Color, Boise, Idaho.

To the memory of Cecil Coffey, journalist and publisher.
A man of vision, who proved that good business, kindness, and creativity are all compatible.
Thanks.

Photo (right):
Idaho cowgirl Debbie Hall, rodeo
warm-up, Homedale, Idaho.

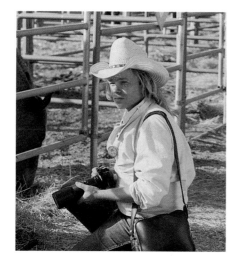

ABOUT THE PHOTOGRAPHER/AUTHOR
Ed Guthero

Ed Guthero is a national award-winning art director and graphic designer. Publications on which he has been art director have won nearly 60 national publishing awards in recent years, including recognition from *Communication Arts* magazine, *Graphis, PRINT* magazine, the New York-based *Society of Illustrators Annuals, Religion in Media,* and *The Associated Church Press.*

In FIRE & RAIN, Ed presents a unique vision of the Contemporary West, recalling the past with images of the present.

The Canadian-born artist's background includes experience in advertising, illustration, copywriting, photography, and editorial design. His design studio is located in Boise, Idaho.

"FIRE & RAIN has been an enjoyable project," Ed says. "It gave me the opportunity to combine photography, design, and writing to communicate a personal statement."

It is said that Crazy Horse, the heralded Oglala Sioux chief of the late 1800s, wouldn't allow anyone to photograph him. "My friend, why should you wish to shorten my life by taking from me my shadow?" he once asked.

"It seems a shame that no confirmed image of such a major figure in Western history exists," Guthero says. "I'd like to think his legacy and that of other legends of the American West are reflected in the contemporary images of this book."

Caught between myth and reality, the Contemporary West reflects the tensions of its past. Amid the dust and smoke, the past and present appear to blur. You can sense the pounding of hooves…the steady rhythm of the dance-arbor drum…the blaze of swirling feathers…the slapping of leather…the flash of silver and rhinestones…the jingle of a bridle…the pageantry and power.

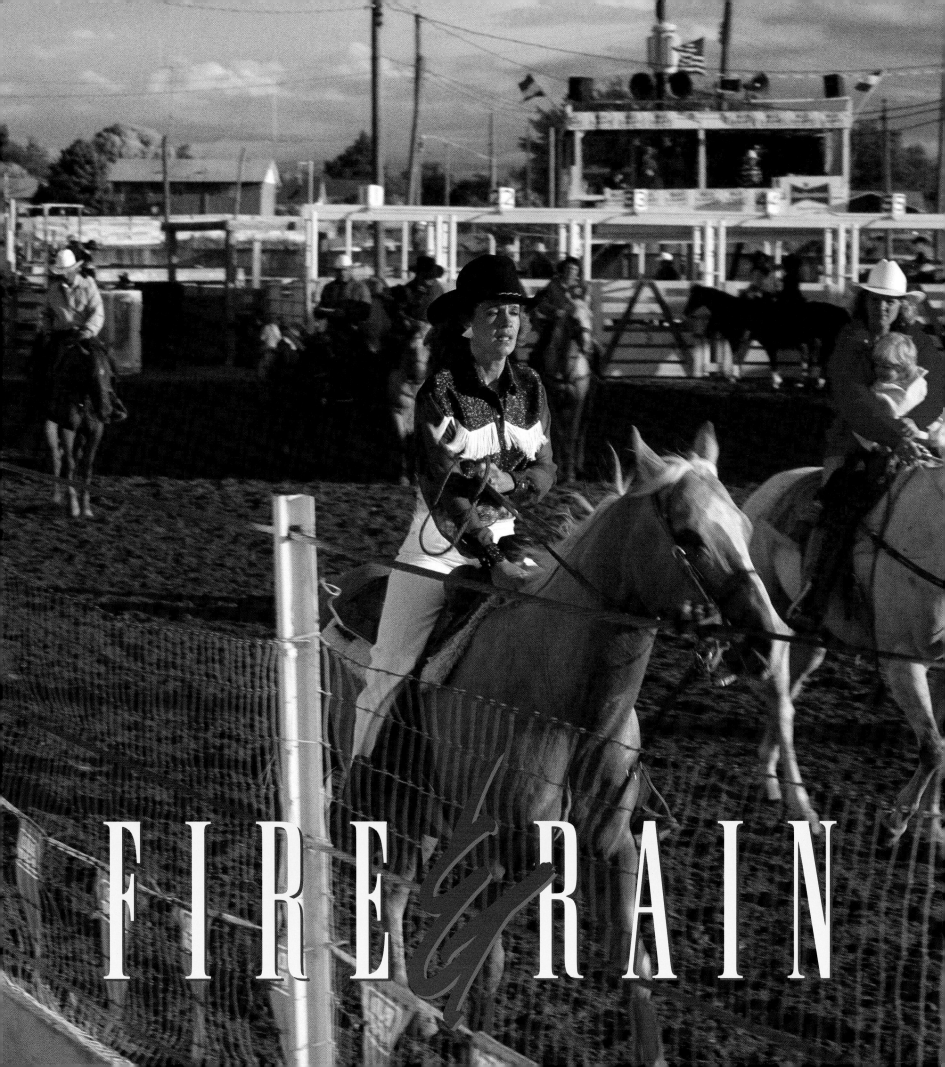

FIRE & RAIN

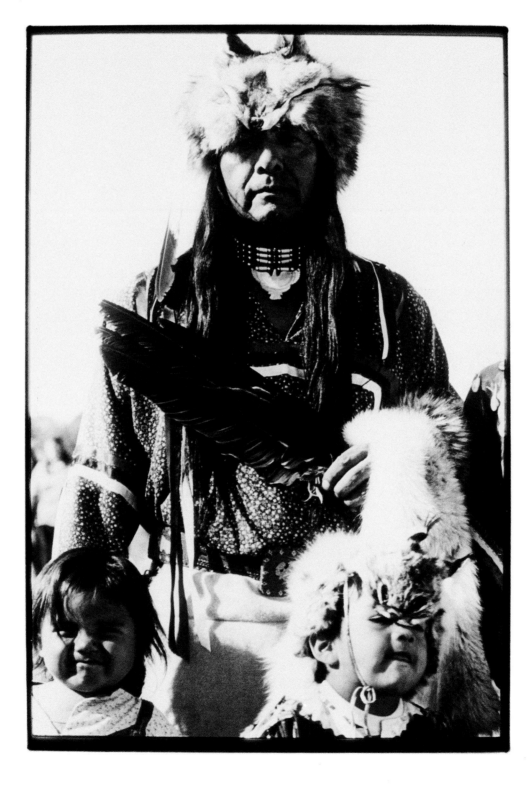

A PROUD HERITAGE
Marvin Martinez stands beside his children at Oregon's Pendleton Round-Up.

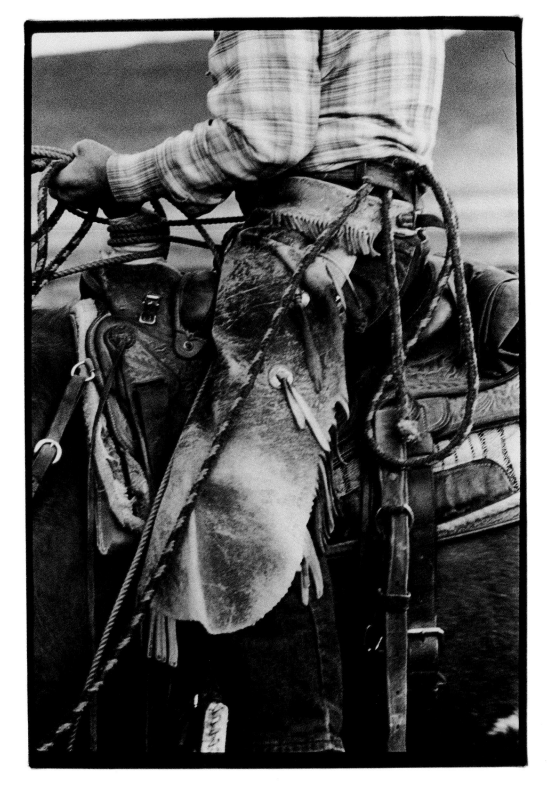

YEARS OF EXPERIENCE
Bob Davis, a veteran Oregon rancher, and the traditional tools of the trade.

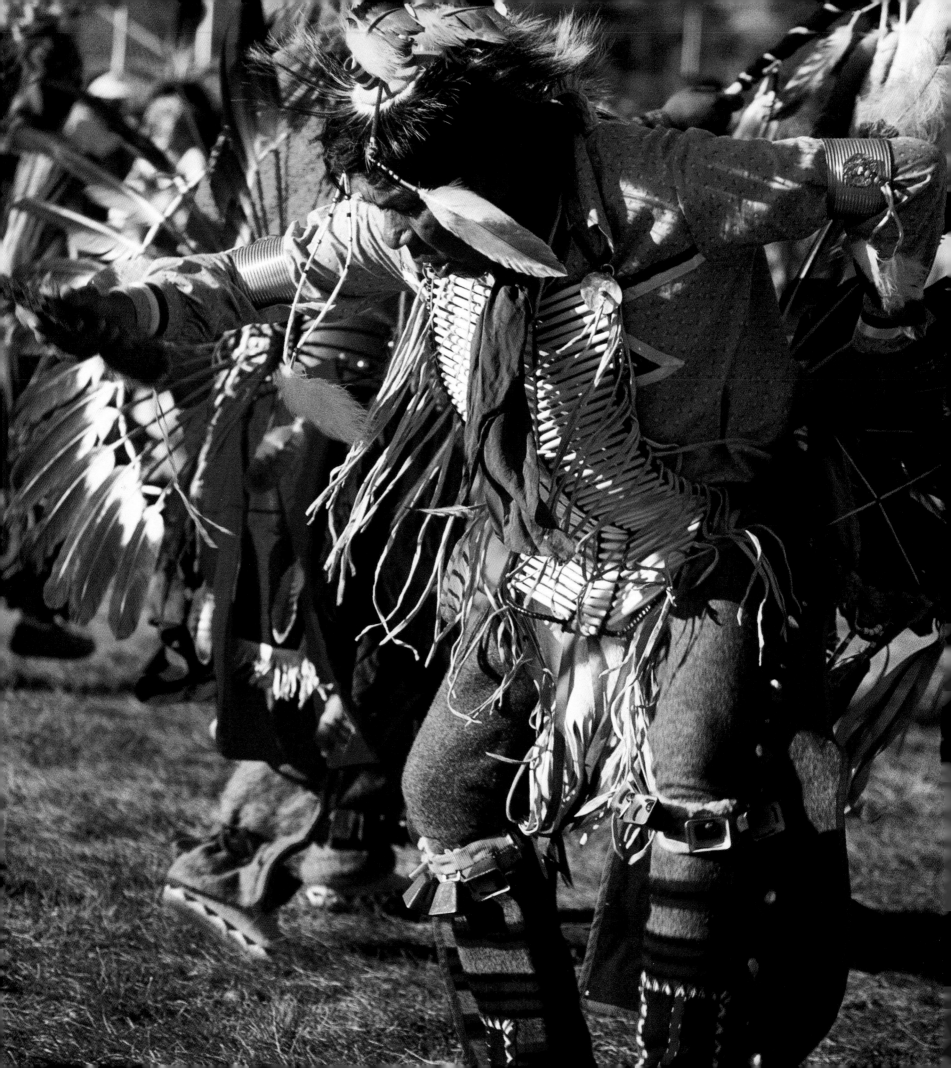

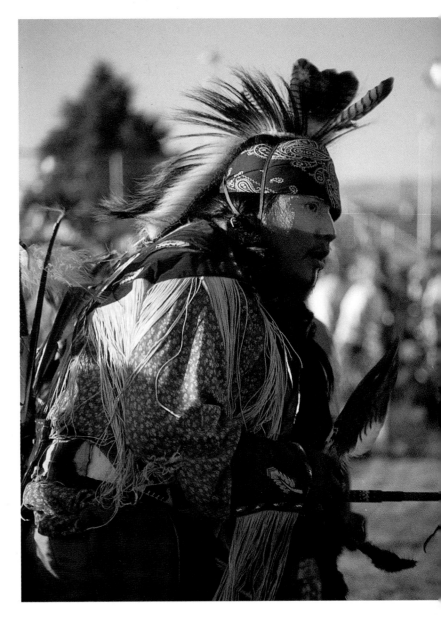

SOUNDS OF THUNDER

Traditional dancers circle the grounds to the pounding of the dance-arbor drum during a centennial gathering of Idaho tribes (Nez Perce, Shoshone-Bannock, Kutenai, Coeur d'Alene, Northern Paiute, and Kalispel).

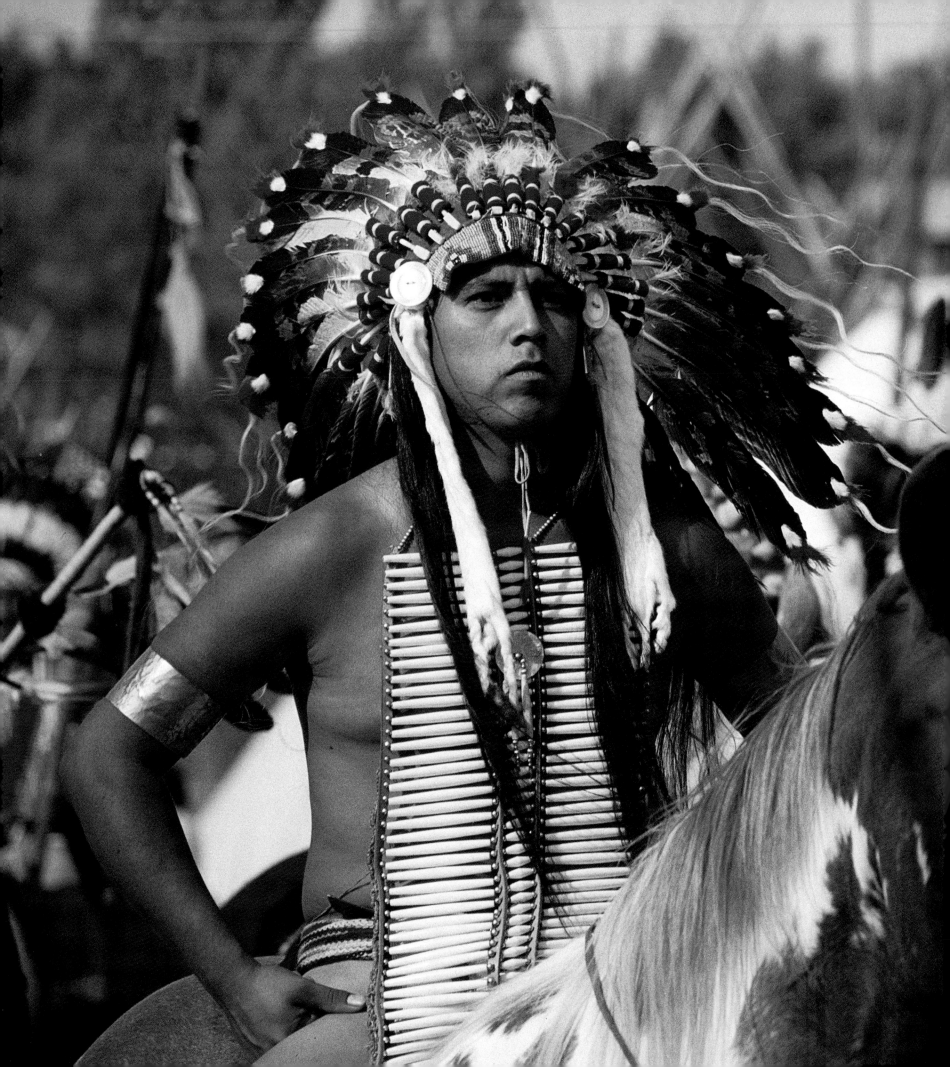

REFLECTING THE PAST

Mounted horsemen gather at Oregon's Pendleton Round-Up. Lance Dick cuts a dramatic figure (foreground). Pendleton lies near the Umatilla reservation, and tribes including the Yakima, Cayuse, Nez Perce, Umatilla, and Walla Walla put on a spectacular annual display of American Indian pride in conjunction with the Round-Up.

13

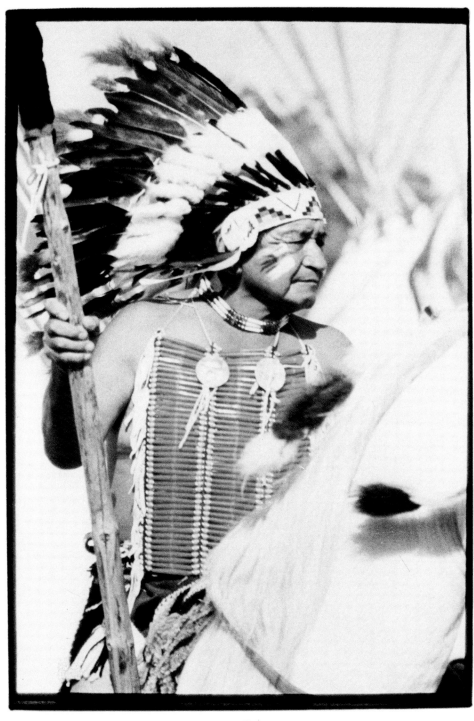

Massive herds of buffalo once thundered across the North American plains… To the Indians the buffalo was more than an animal, it was the staff of life.[1]

*T*he tribes utilized virtually the entire animal for food, clothing, and shelter.

There were still an estimated fifty million buffalo roaming the great plains by the mid-nineteenth century.[2]

An army officer of the era, who spoke of being engulfed by a migrating herd, was forced to climb a large rock formation to escape the hordes.

He observed the prairie covered with buffalo for ten miles in every direction. Another man told of traveling through an almost continuous herd for a length of two hundred miles.[3]

The onslaught of professional

white hunters, catering to the lucrative Eastern demand for robes and tongues, wreaked havoc on the great herds. Their long-range rifles felled the massive animals with numbing efficiency.

Roughly eight million buffalo were shot for their hides during a three-year period, as the stench of rotting

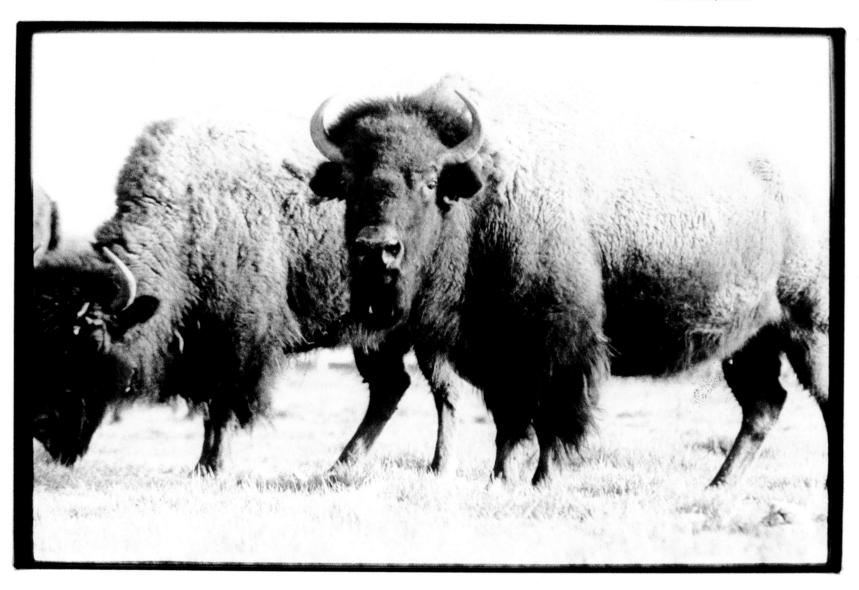

meat violated the plains. [4]

By the turn of the century, the legendary animals were near extinction.

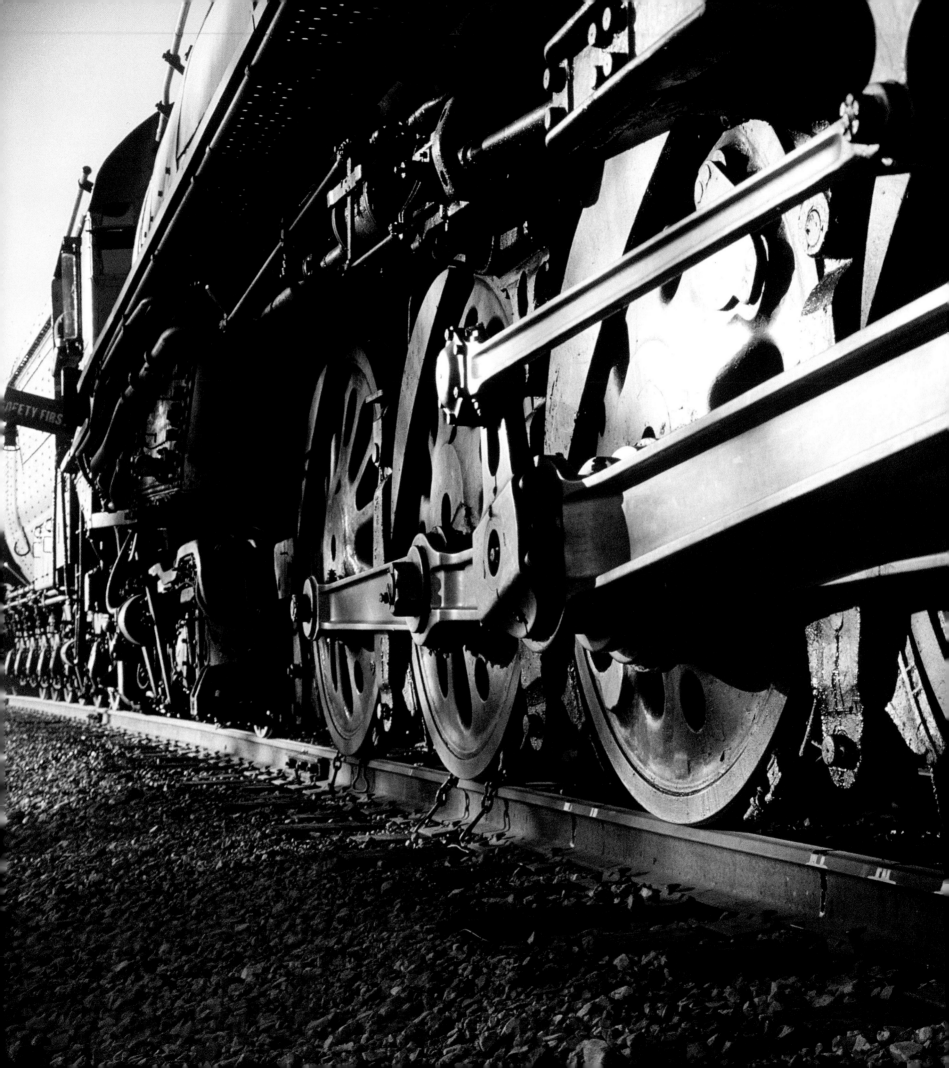

THE IRON HORSE

Hissing steam and smoke, the iron horse, laden with settlers and supplies, rumbled over the Great Plains. By 1869, East and West rail lines met at Promontory Summit, Utah. The West would never be the same.

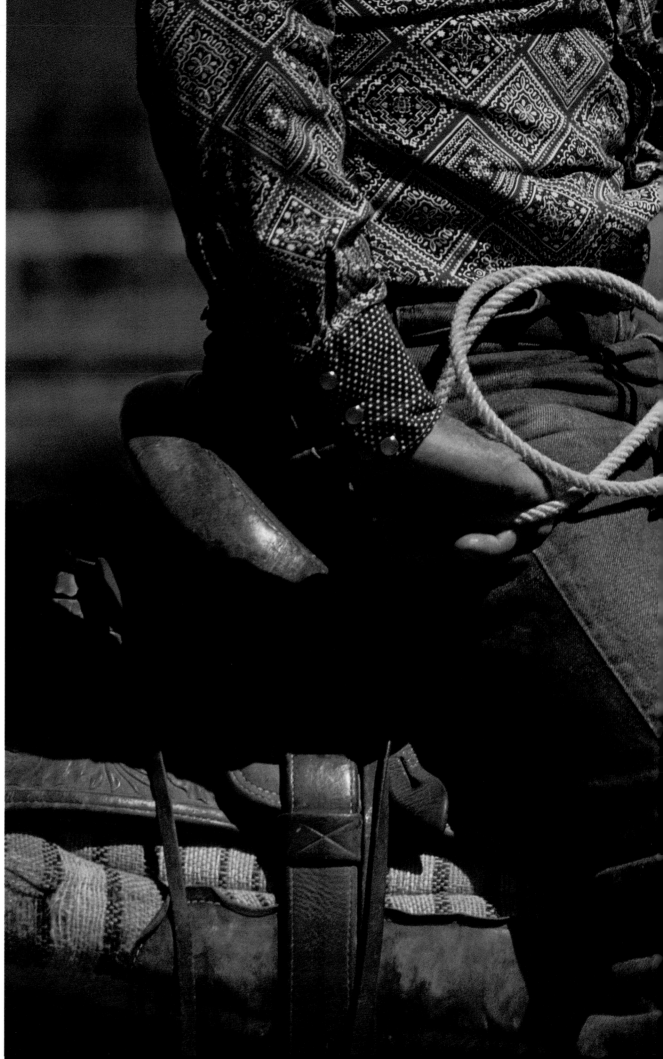

*T*he cattle industry originated in New Spain and spread throughout California, Texas, and northward to the great Western states. Long cattle drives became firmly entrenched in Western lore.

TOOLS OF THE TRADE

Bob Davis, a contemporary rancher, using the traditional gear of a working cowboy, readies himself between ropings at an Oregon roundup.

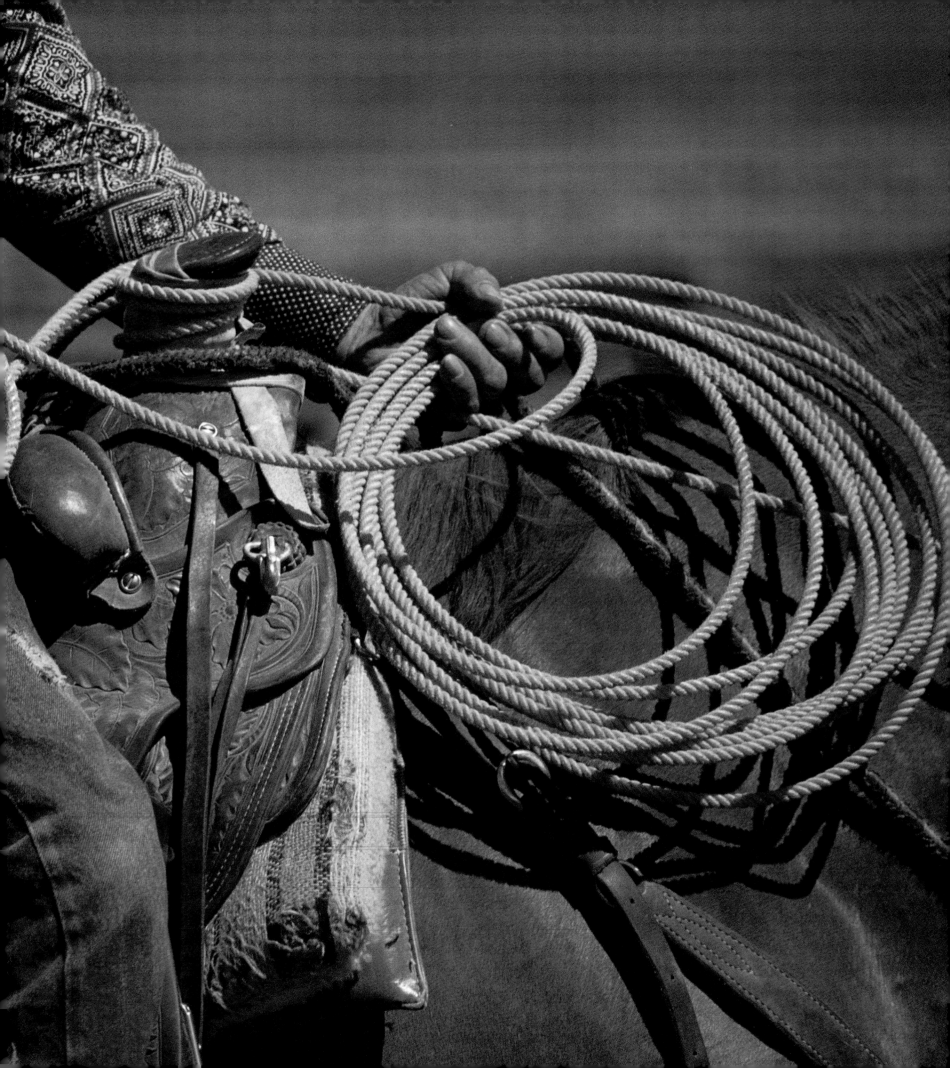

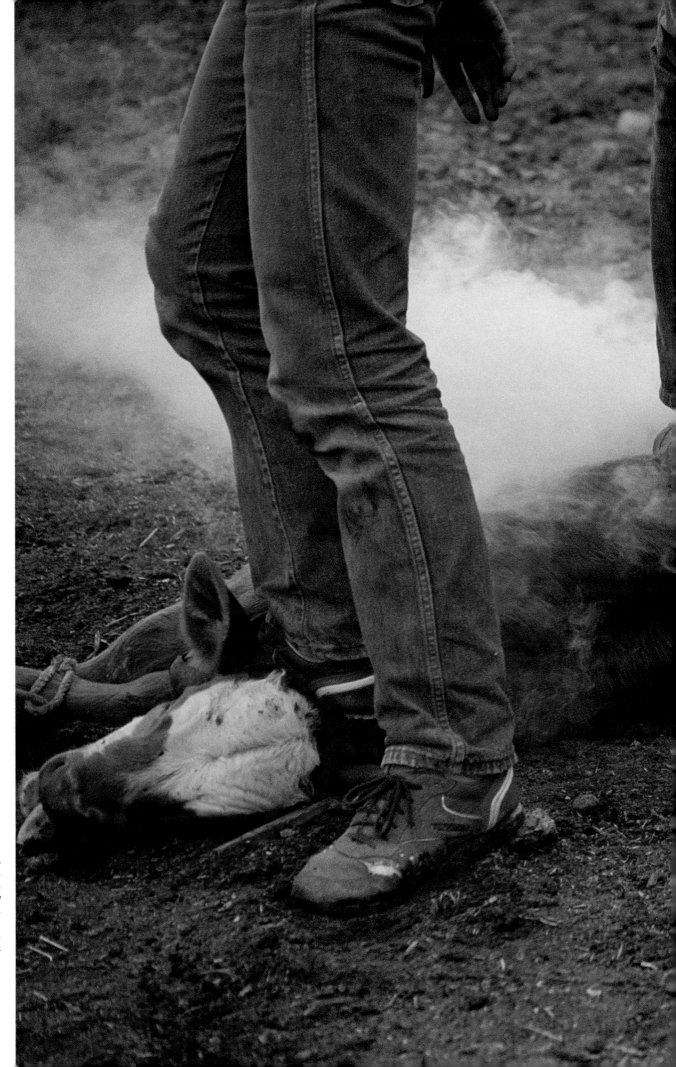

SUMMER BRANDING
The branding iron, like much of the cowboy's equipment, is of Spanish origin. Calves are marked with distinctive brands signifying ownership. Contemporary ranchers still tell of rustlers preying on their herds.

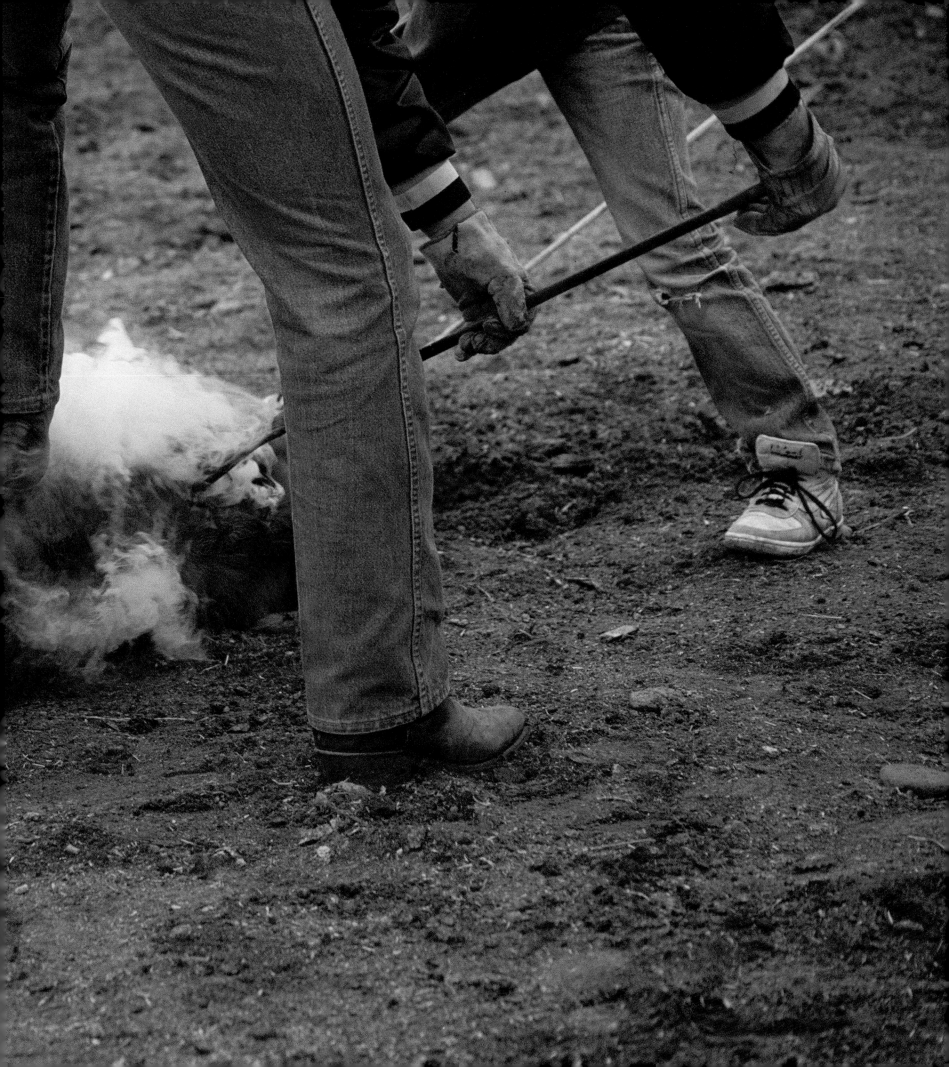

FIRE AND

With the subtlety of summer lightning, the West reminds us of our vulnerability, fanning the flames of our dreams, but warning us not to fly too close to the fire.

ALL IN A DAY'S WORK
Skilled working cowboys (Jack Pascale and Kenny Bahem), their wide-brimmed hats sheltering their eyes from the hot Oregon sun, patrol the corral—selecting calves to be identified, branded, and vaccinated.

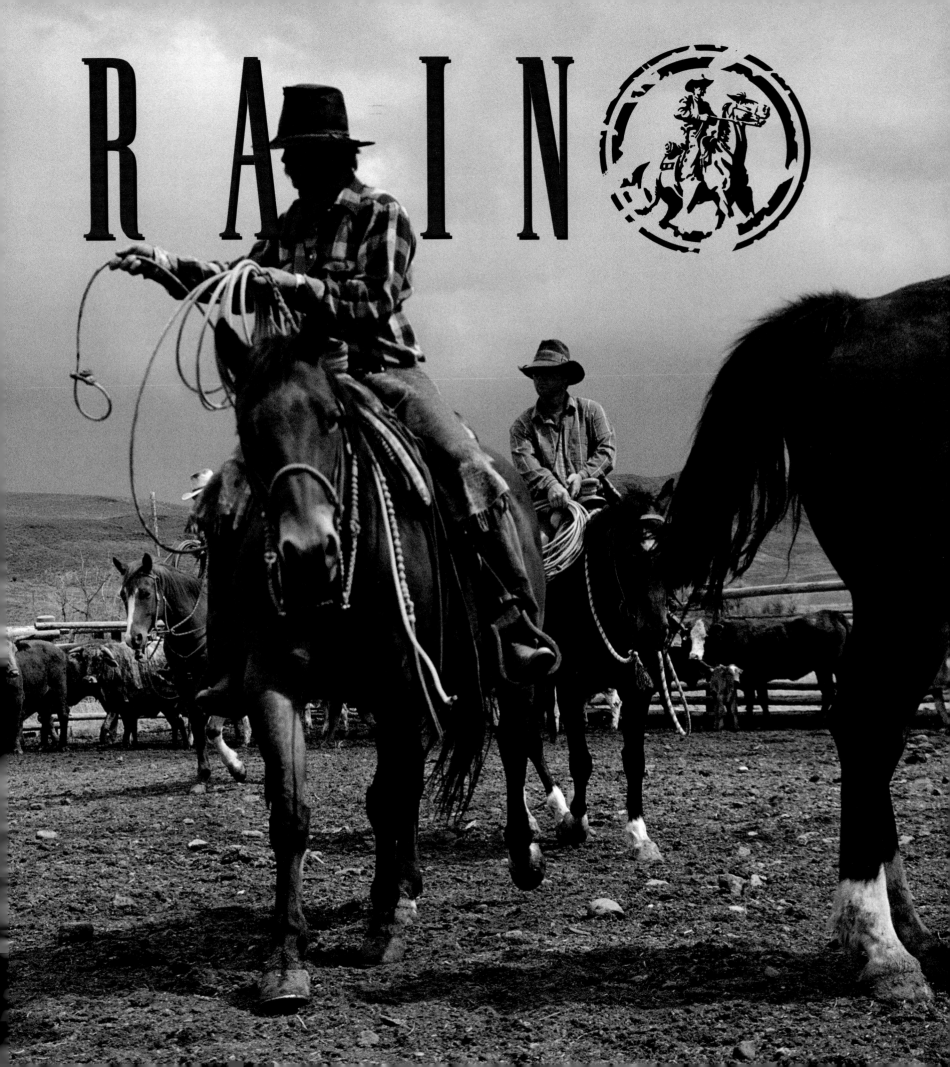

RAIN

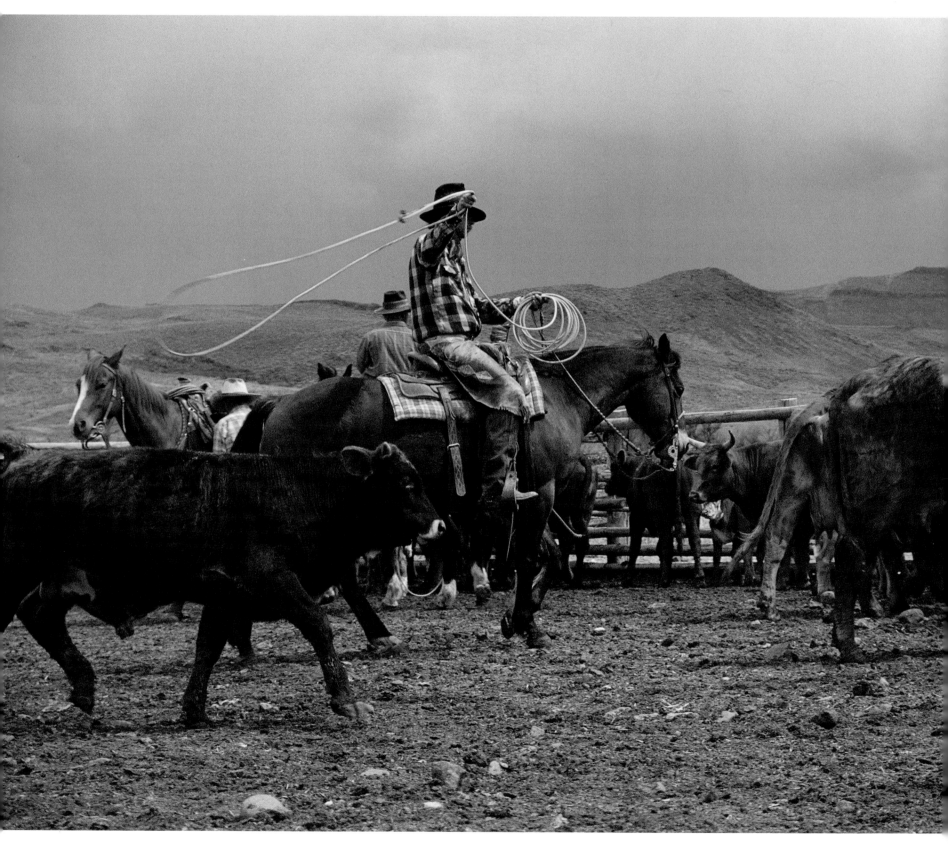

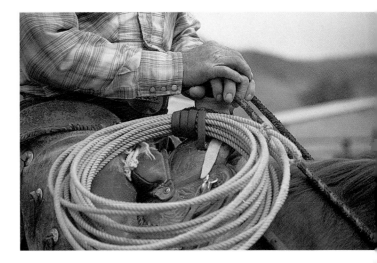

ROUNDUP
Adrian, Oregon.

Left: With the Owyhee Mountains stretching across the horizon, buckaroo Jack Pascale swirls a wide loop at a summer roundup near the Oregon-Idaho border.

THE HANDS OF EXPERIENCE
Above: Veteran Oregon cowboy Bob Davis.

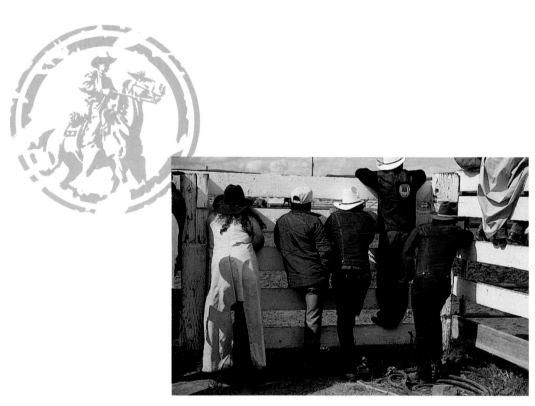

BEHIND THE SCENES
*. . . at Oregon's Jordan Valley
Big Loop Rodeo, near
the Nevada border.*

RODEO

Caldwell, Idaho.
"The high church of the
Contemporary West."
Shawna Roberts carries the
colors to open the Caldwell
Night Rodeo.

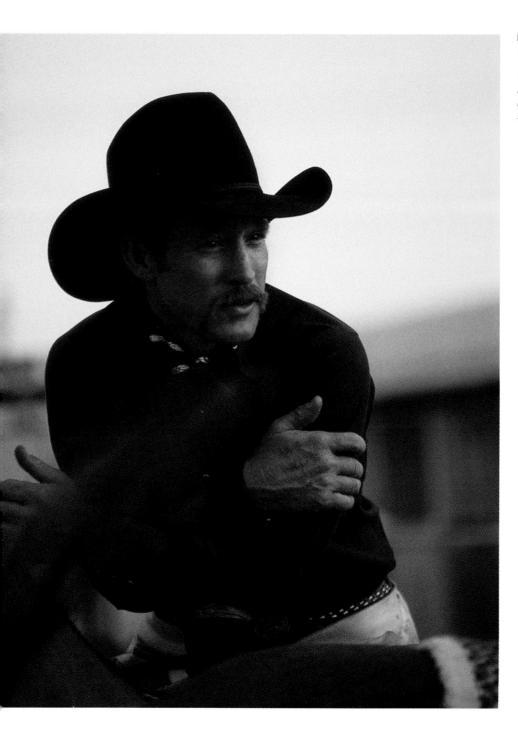

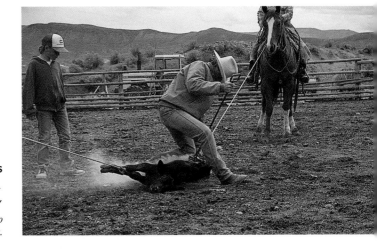

ROUNDUP IMAGES
Adrian, Oregon.
RODEO ROYALTY
Oregon's Nyssa Night Rodeo
Princess Shannon Hancock.

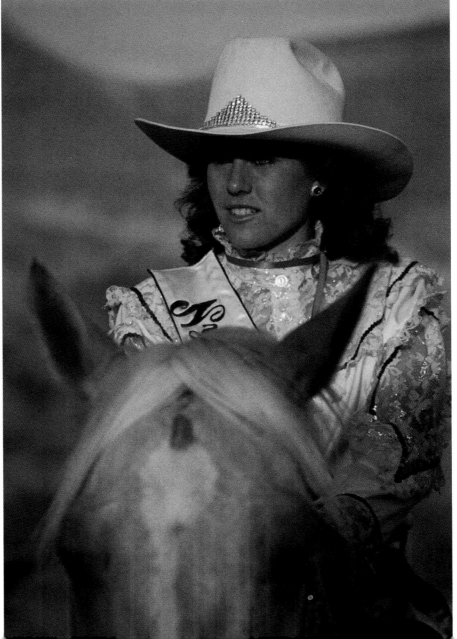

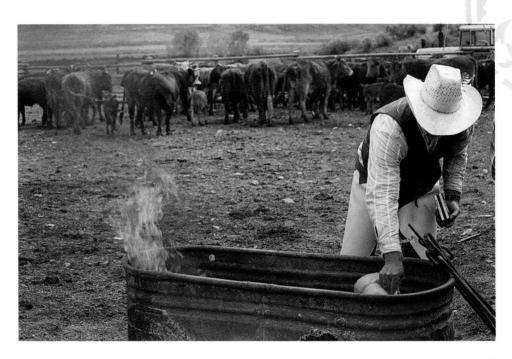

ROUNDUP IMAGES
Adrian, Oregon.

A WISP OF SMOKE
Adrian, Oregon.
Branding preparation and activities
at Springs Beefmaster Cattle Ranch.

Above: Rancher Dick Springs.

Left: Brandon MacArthur and Judy
Pascale, neighbors, lend a hand.

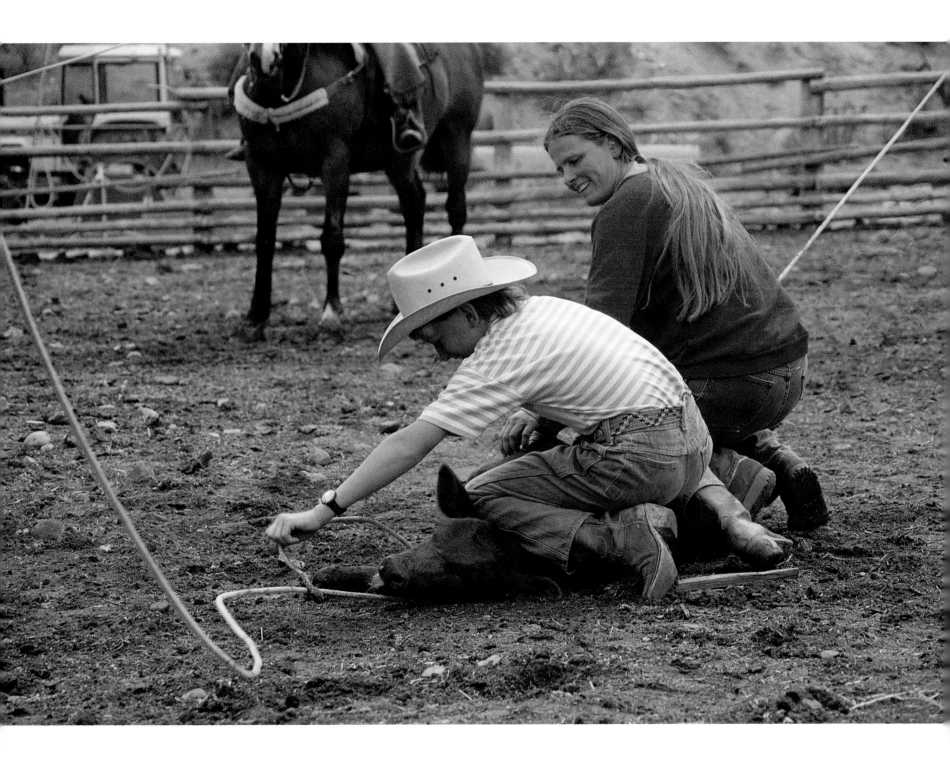

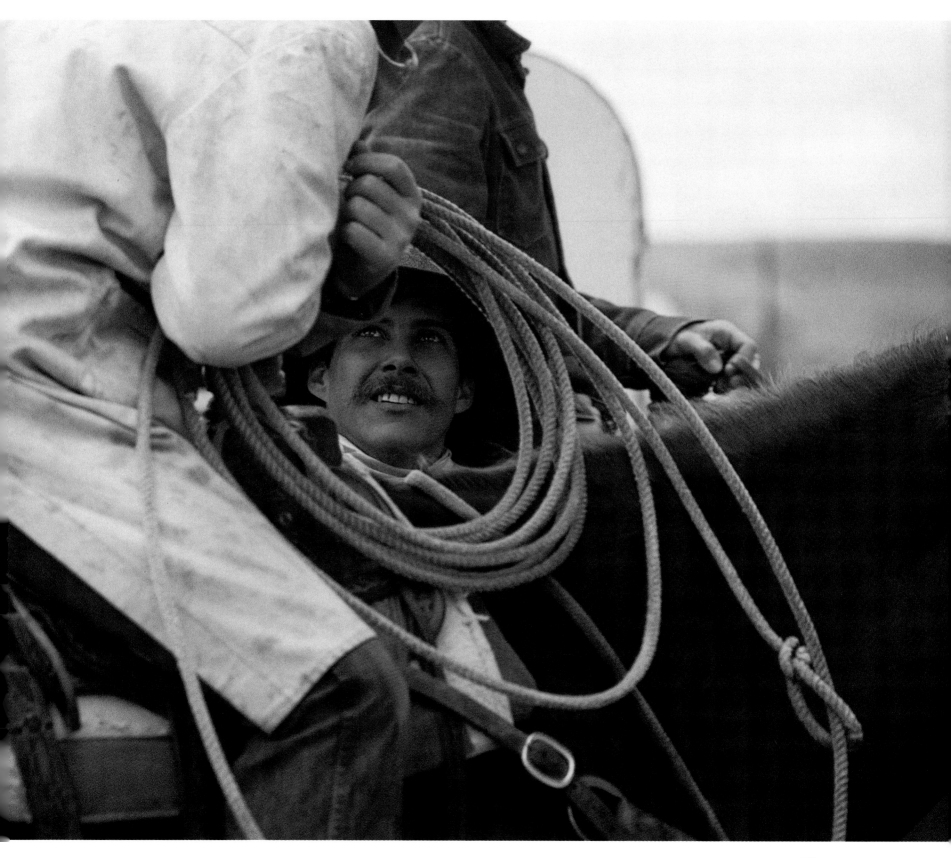

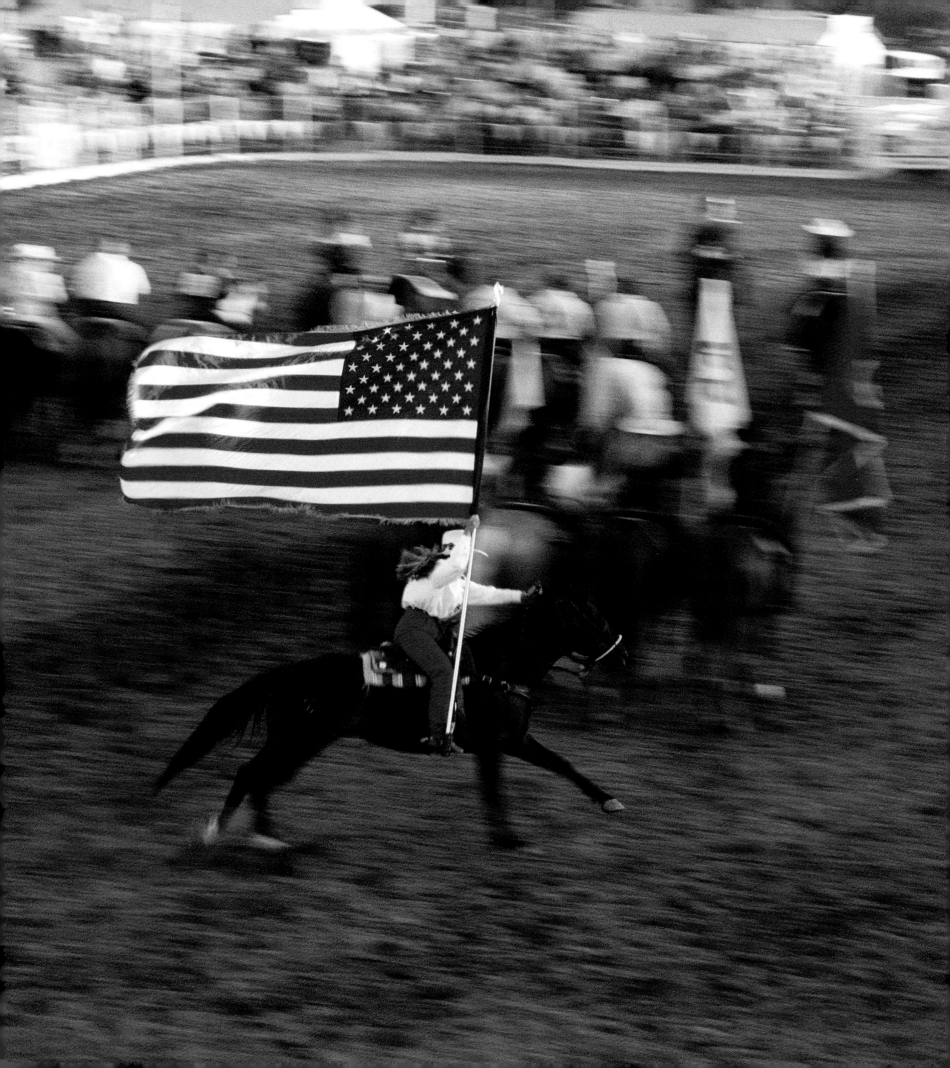

ED GUTHERO

FIRE & RAIN

I *once ate dinner with Wyatt Earp. I was five years old, but I still remember the evening as if it were yesterday. I sat diagonally opposite him at the end of a long table—at least it seemed long. When you are five years old, your sense of proportion varies. As expected, he was dressed in black coat, white shirt, and black tie. I remember his distinctly chiseled features, tanned skin, dark hair and eyes. He seemed rather quiet, though he smiled occasionally at three girls sitting near him.*

I recall looking down that long table and silently hoping he would say something to me. Earlier, he had placed a large box in my hands. Inside were a small black jacket, pin-striped pants, a gun-belt holster with white-handled replica six-shooters, and a distinctive

flat-brimmed black hat.

People were smiling and

clapping as a newspaper

photographer stepped forward

to take our picture.

Wyatt Earp put his

strong hands on my shoulders

as I stood, slightly bewildered,

in front of him. My head

barely reached his waist.

The girls pressed in close on

either side of us, and we were

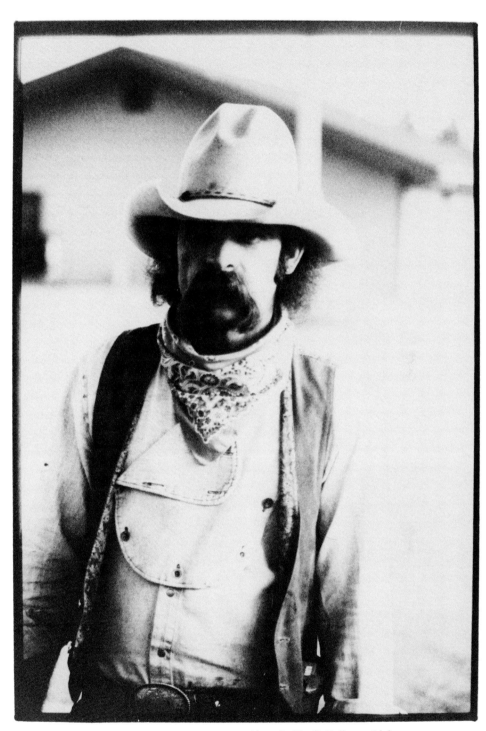

THE GENUINE ITEM *Glenn S. Haufe, Bellevue, Idaho.*

momentarily dazed by the camera flash. I still have the newspaper page. It's getting dog-eared,

brittle, and yellowed, yet there we are—me and Wyatt Earp!

The caption underneath misspelled my name, but it had his right.

I slowly ate my dinner, glancing occasionally down the long table. I was beginning to feel

a little left out. There had been talk that Wyatt might let me ride in the saddle with him on

his stately brown horse when he was introduced at the city stadium the following night.

I wasn't the type of five-year-old who would climb down from my chair, walk over and

tug on Wyatt Earp's sleeve. Yet I don't think I was intimidated by him. When you are five years

old, you are really not intimidated by anything; rather, you seem to be on a perpetual venture

of observation and analysis. At any rate, down at the other end of the table, Wyatt appeared

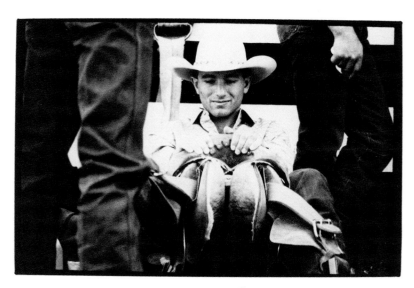

more distant as the evening progressed.

Maybe it was because he wasn't wearing

his trademark black flat-brimmed hat.

Wyatt always wore his hat. Where was his

flashy gold-spotted vest with the watch chain

BRONC RIDER *Pendleton, Oregon.*

dangling from the pocket? And where were the long-tailed black frock coat and ribbon tie? He

was wearing black, all right, but something seemed different. Where was his badge—the silver

star that flashed with authority against his black attire? Finally, where were his famous white-

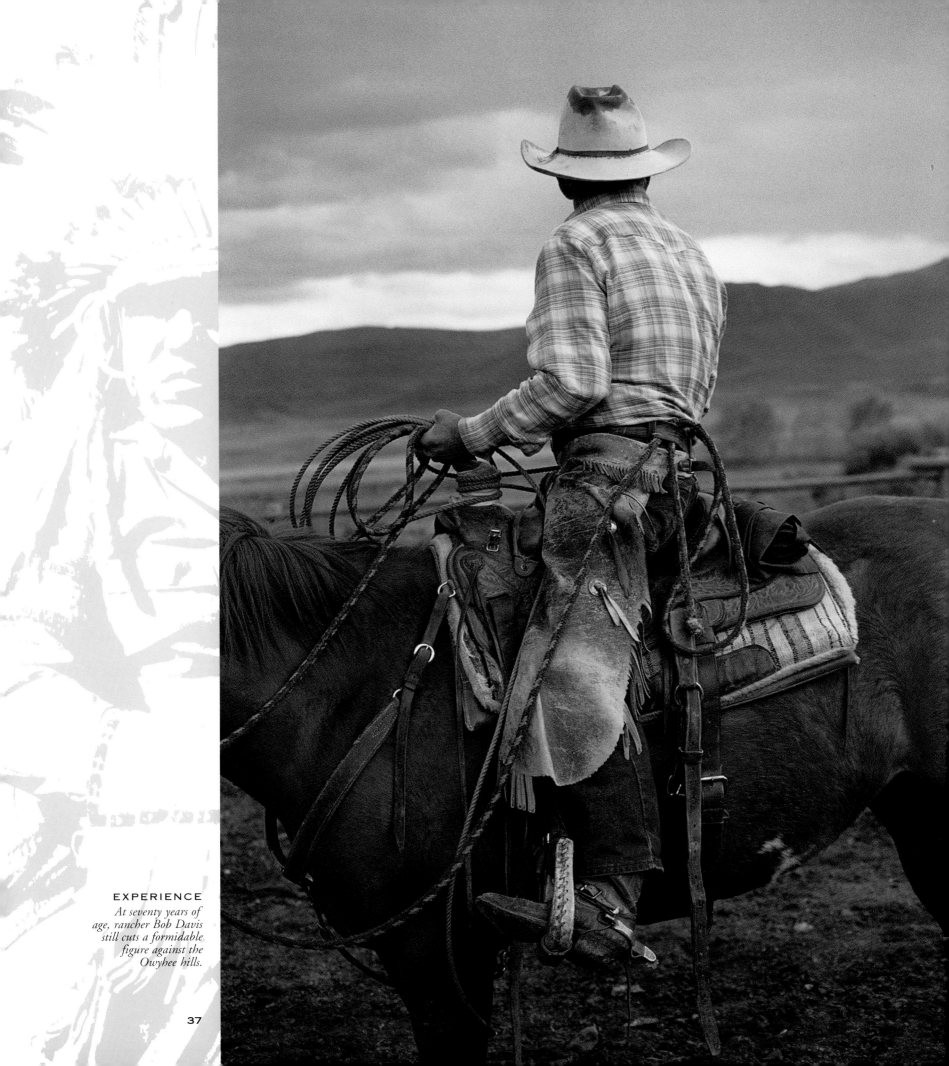

EXPERIENCE

At seventy years of age, rancher Bob Davis still cuts a formidable figure against the Owyhee hills.

37

handled six-shooters? Somehow, Wyatt didn't look quite the same as when he had

patrolled the streets of Tombstone, striking fear and respect into the hearts of any who crossed

the fine line of the law. But it was him. He had that same determined look and square jaw

that I'd seen vanquish countless desperadoes on my parents'

television screen. This was definitely the same guy—but

something wasn't right.

Maybe the problem was that the man at the table was

actually actor Hugh O'Brian and not Wyatt Earp, the

frontier marshal. Or was it? Weren't they really one and the

same? A legitimate question—and not just from

a five-year-old.

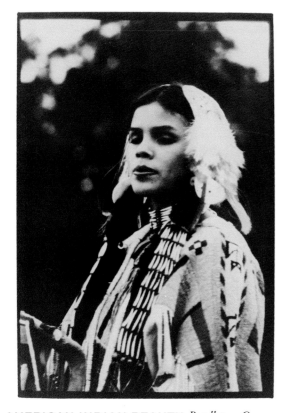

AMERICAN INDIAN BEAUTY *Pendleton, Oregon.*

Every once in a while I unfold the old newspaper page and stare at the photo of Wyatt

and myself. In the background, to our left, hangs a child's drawing of Earp in a more familiar

setting. The drawing is slightly obscured, but the details are easily recalled.

The drawing was the reason Wyatt Earp and a wide-eyed five-year-old boy met. O'Brian

was in my town to promote

the annual Shrine Circus, and

the school system had held a

citywide poster contest.

It was my good fortune to

win the primary division; the

two girls in the photo with

Wyatt and me were the junior

and senior high school

winners.

In my poster, gallant

Wyatt and his spirited steed

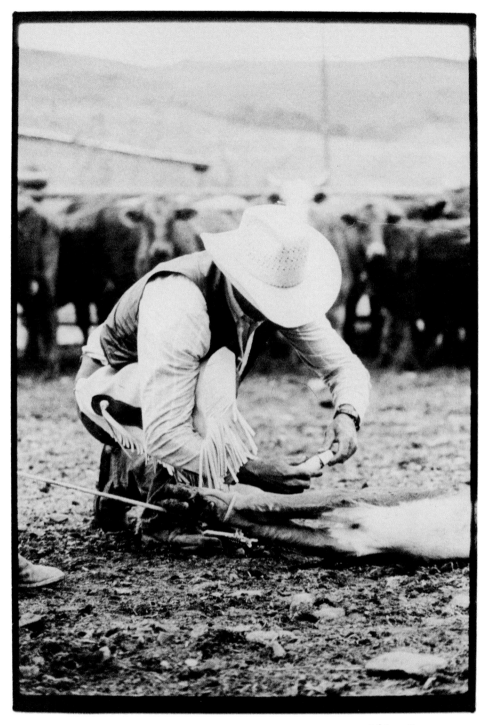

ROUNDUP AT SPRINGS BEEFMASTER CATTLE RANCH *Adrian, Oregon.*

are charging across the landscape. The wide hat, black jacket, and pin-striped pants are all

very much in evidence. In one hand , his white-handled six-shooter is blazing, while the other

firmly grips the fiery horse's reins.

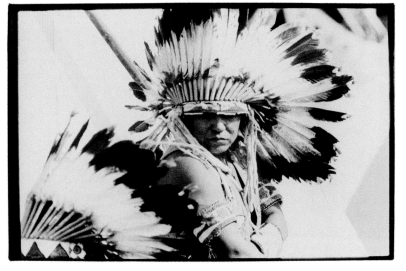

EYES OF THE EAGLE *Pendleton, Oregon.*

Riding dangerously near Wyatt in equal fury is the menacing form of a mounted Indian warrior, clad in feathered headdress and fierce war paint.

In my young eyes, the West was uncomplicated: there were good guys, and there were bad guys. It wasn't hard to figure out which group Wyatt was in.

The real Wyatt Earp died in Los Angeles in 1929. He is best known as a heralded gunfighter and lawman. Wyatt also had a fondness for gambling. The boundaries of frontier law were often blurred, and it wasn't surprising that cardsharps and gunfighters could double as lawmen.

At Tombstone, Arizona, in 1881, Earp gained further notoriety when he and his lawmen brothers, Virgil and Morgan—along with the hard-drinking Doc Holliday—gunned down Billy Clanton and the McLaury brothers during the infamous "Shootout at the O.K. Corral." The gunfight climaxed a feud between a local rustler/cowboy faction and the Earps.

RAIN

In later years, the old frontiersman spoke little of his past. Gray-haired "Uncle Wyatt" was considered a model citizen as he and his wife, with their team of mules, mined claims in Southern California.[5, 6, 7]

An intriguing photo, taken shortly before Earp's death at 80, shows a dignified, elderly gentleman. Stern, intense eyes that witnessed a turbulent era peer out above a thick white mustache. He remains a celebrated, yet controversial, figure—his legacy, like that of

HAND TO THE PLOW *Old-Time Days, Murphy, Idaho.*

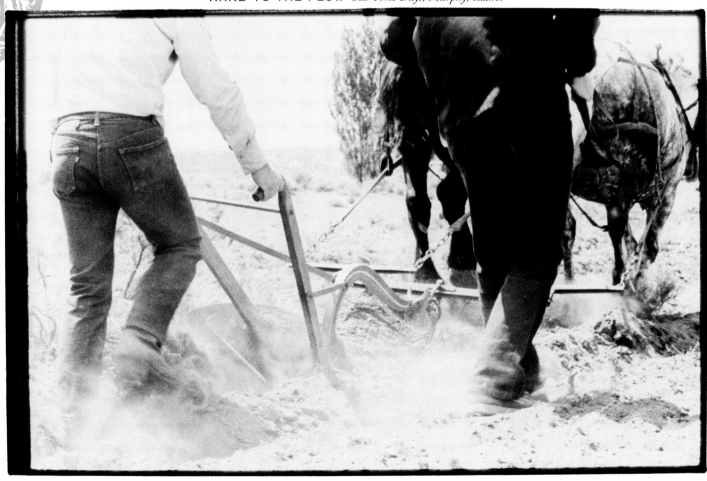

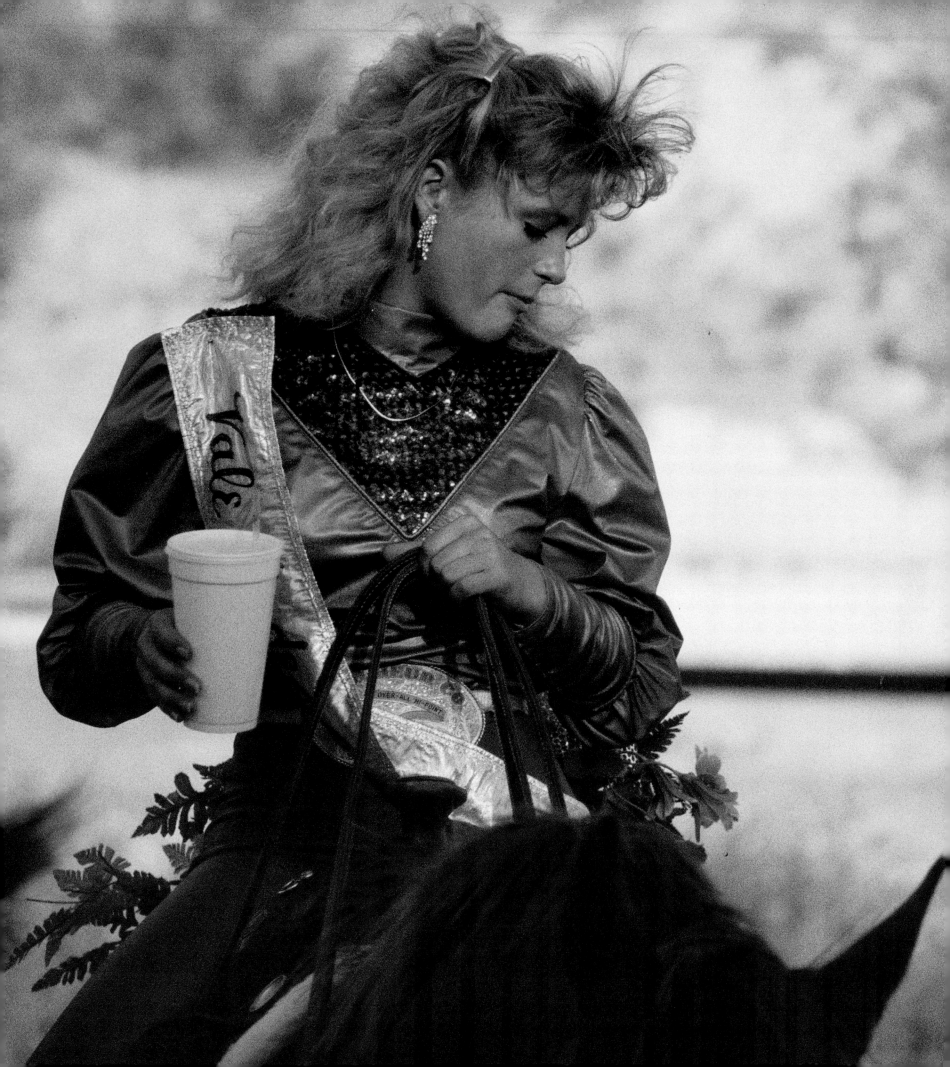

many of his contemporaries, a strange blend of reality and sensationalism.

The Lone Rider

The Contemporary West is a prisoner of its own myths and stereotypes. Often it is difficult

to determine exactly where the myths end and reality begins.

*P*lenty of ranch hands have read pulp Westerns in the bunkhouse and got up

walking and talking like Hopalong Cassidy," says Wallace Stegner in his essay, "Who

Are the Westerners?" [8]

Yet, we believe the

myths and perpetuate them.

Perhaps in a time of

crowded urbanization,

with its accompanying

restrictions and vices, we

need such myths.

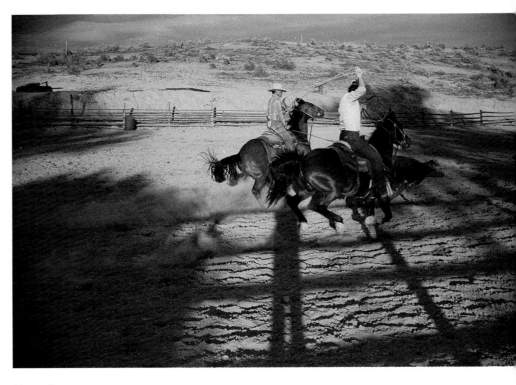

Above: Oregon team ropers.
Left: A contemplative moment for Vale, Oregon, rodeo Queen Kim Smith.

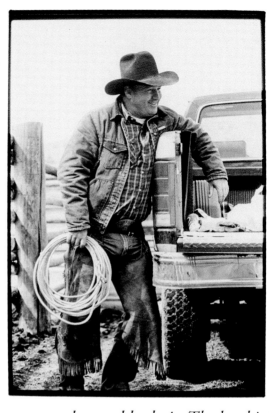

IDAHO COWBOY
Pete MacArthur, Marsing, Idaho.

The lone rider silhouetted against the horizon . . . a renegade knight of the purple sage . . . his very mobility reinforcing the illusion of independence. The quiet, romantic individualist, emanating supreme self-confidence, courage, and a keen sense of justice. He knows no fear—at least none he would admit. The land is both his ally and his enemy. In a strange way it leases him his

*E*ven at the mercy of this temperamental landlord, the lone rider is glorified in

sense of security and independence, but it can be quick to snatch it back.

his self-reliance and defiance of the odds.

Russell and Remington immortalized him on canvas. Owen Wister and Louis L'Amour

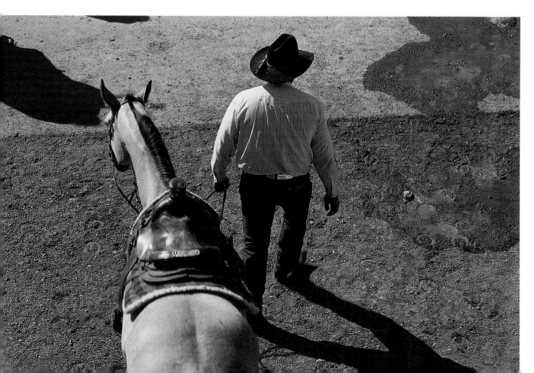

defined and shaped his legend in literature. He has become bigger than life, yet strangely impersonal.

A thousand storybook

heroes, each the image of

another, form a numbing

cookie-cutter parade, crowd-

ing out reality.

There are white hats, and

there are black hats. There are

no gray hats. Justice becomes

synonymous with self-interest,

and the lone rider himself

becomes the law. The vastness

of the Western environment—

those endless realms of open

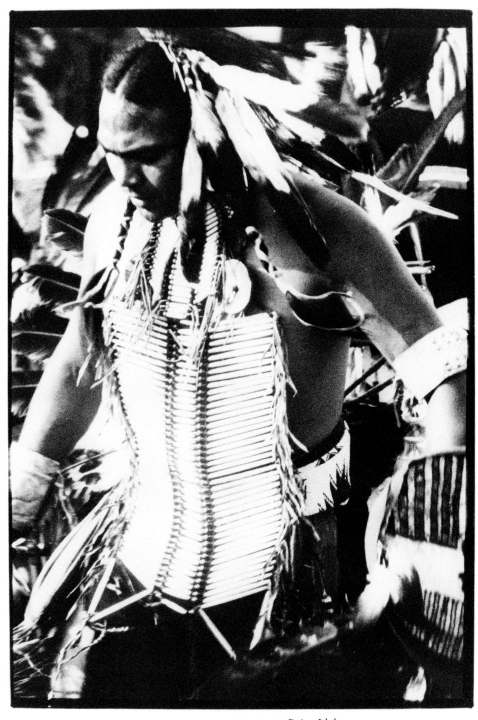

CELEBRATION DANCER *Boise, Idaho.*

space—somehow seems to justify this strange self-righteousness. Away from structured society,

our Western hero is free to create his own moral code. There is little room for introspection in

this world that walks a fine line between myth and reality. The doubts and fears that most of

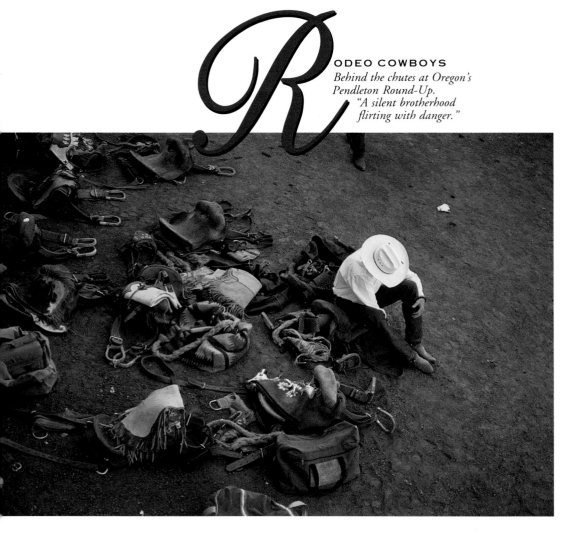

RODEO COWBOYS

Behind the chutes at Oregon's Pendleton Round-Up. "A silent brotherhood flirting with danger."

The opening of the West has long fueled our imaginations, appealing to our sense of adventure and curiosity. Colorful characters, often parodies of themselves, parade through the history of the American West, refueling their own legends and blurring the lines of reality.

The greatest concentration of recorded Western history involves a turbulent thirty-year period between 1860 and 1890. From that fascinating era essentially all the great myths of the West emerged. [9]

Tales of fearless mountain men and fur traders . . . hardy steamboat pilots . . . cool-handed gamblers peering over their cards in smoke-filled saloons . . . ruthless outlaws and steel-nerved gunfighters . . . missionaries and harlots . . . dashing cavalrymen . . . schoolmarms and homesteaders.

Their struggles have been romanticized and stereotyped in countless pages of pulp Westerns and reels of celluloid.

The Eastern public was eager to embrace these new heroes who constantly lived on the precipice of danger in an untamed land. Whether the entire truth was told wasn't really the issue.

The West was cloaked in high drama, and its lure was intoxicating.

As the prolific nineteenth-century dime novelist Ned Buntline once said, "If the public wants it that way, why not?" [10]

The white and black hats were in business.

Later, the film industry found the theater of the West to be fertile ground as well. The cowboy became the ultimate white knight—a Sir Lancelot in a Stetson, rescuing maidens in distress and triumphing over evil before riding off into the sunset. More recent decades have seen the appeal of the lone rider as anti-hero—a man with a mysterious past who writes his own rules, operating outside the system.

In reality, that thirty-year period was "an incredible era of violence, greed, audacity, sentimentality, undirected

us wrestle with—those special pains that are uniquely human—are somehow crowded out. Everyone must wear either a white or a black hat. Time and existence are somehow frozen in this mythical concept of the West.

The lone rider is suspended in a perpetual confrontation between good and evil—a never-ending series of crises. It is an enduring myth that continues even today. The setting may be the numbing inner city, painted in the pulsating glow of neon. Screeching tires and high-speed chases replace pounding hooves, but the lone rider is still there. And he's still up against seemingly insurmountable odds, a system that doesn't understand him, and a multitude of interchangeable evils lurking in the shadows.

The white and black hats have not disappeared; the setting has simply changed. The entertainment industry reinforces the myth, and we accept it readily. Life is strangely simpler that way.

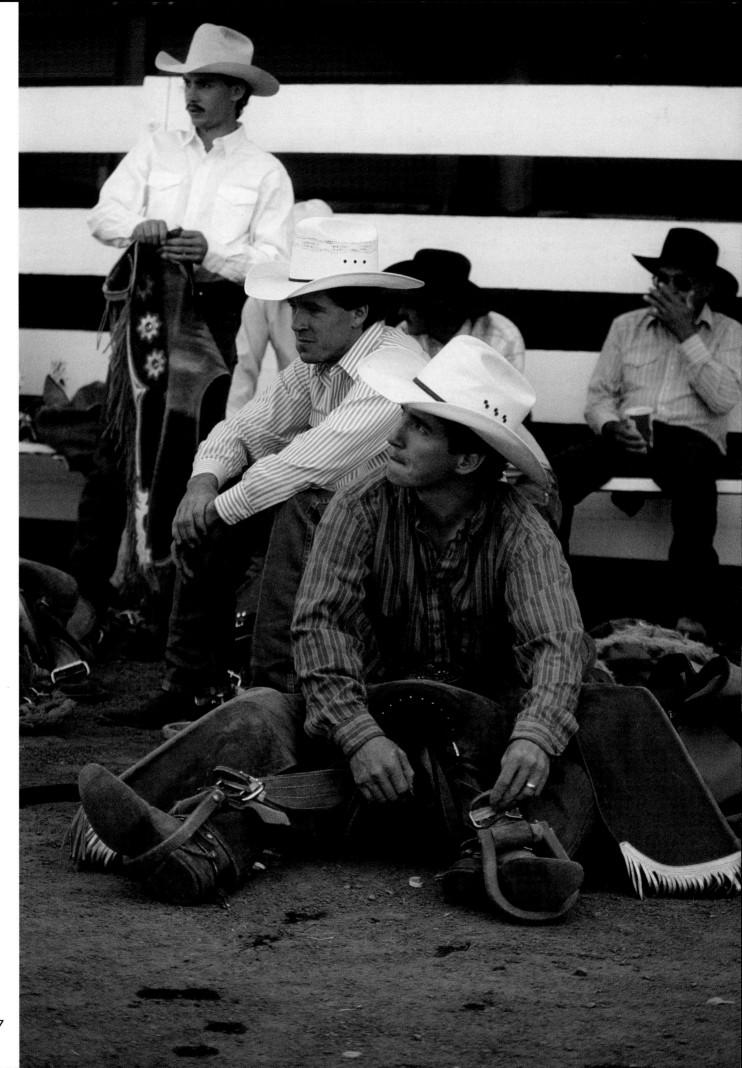

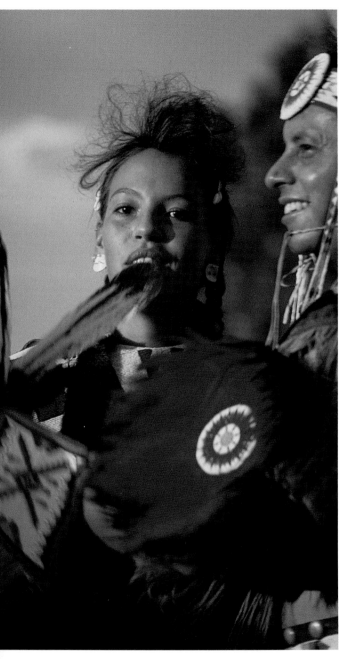

exuberance, and an almost reverential attitude toward the ideal of personal freedom for those who already had it." [11]

For others, whose freedom grew perilously fragile, the era held other images.

It is the winter of 1868. The scattered bodies of Cheyenne women and children lie silent along the snowy banks of the Washita River. A bewildered child clutches the buckskin robe of his fallen mother, his world obliterated in a lightning barrage of mounted blue thunder. The sounds of gunfire and screaming echo in his ears.

There had been no warning. Out of the fog, four columns of cavalry descended upon the slumbering village of the peace chief, Black Kettle. The daybreak "Battle of the Washita" was over in minutes, and 103 Cheyenne were dead. Only eleven warriors could be confirmed among them. [12, 13]

The stark reality of such events has been obscured by the romanticized notion that the settling of the West was a struggle between brave pioneers and noble savages.

Caught in an overwhelming whirlwind of westward expansion, the American Indians found themselves trapped in a rapid succession of events that threatened their very existence. Between 1860 and 1890 the original Americans faced the climactic chapters in a long saga of broken trust, shattered treaties, misunderstandings, and disillusionment. To say the American Indians were mistreated is a gross understatement. To note that their plight was the result of a mind-numbing blitz for land and mineral treasures (fueled by the prevailing Manifest Destiny doctrine of that era) does not excuse the injustices.

In retrospect, it disturbs and sobers us to realize that sometimes our heroes wore the black hats.

Fire and Rain

In her thought-provoking book *Legacy of Conquest,* Patricia Limerick notes: "If Hollywood wanted to capture the emotional center of Western history, its movies would be about real estate. John Wayne would have been neither a gunfighter nor a sheriff, but a surveyor, speculator, or claims lawyer." [14]

Like a soft wind, the West beckons. Seductive and temperamental, it lures us with savage splendor and the promise of new beginnings. We are awed by the sheer expanse of its regal mountains and sprawling desert, rich with the aroma of sage. Yet in the grasses of paradise dwell both wildflowers and vipers.

With the subtlety of summer lightning, the West reminds us of our vulnerability, fanning the flames of our dreams, but warning us not to fly too close to the fire.

A land of thunder and silence . . . innocence and exploitation . . . exuberance and caution. A place of fire and rain, where man, the great meddler, alternates between reverence and manipulation.

We admire the wild freedom of the West but cannot resist the urge to subdue it . . . build a fence around it . . . conquer it. Perhaps by doing so, we subconsciously hope we can transfer its traits to ourselves. In the same way, original dwellers of the land sought the kinship and wisdom of the wolf and his brothers.

The vastness of the West, with its abundant cache of natural resources, has constantly drawn settlers, miners, and businessmen. For more than a century and a half, the clutching fingers of civilization have attempted to redesign the landscape, erecting fences and boundaries and astounding the Indians, who respected the land as a universal trust. To dissect the land and declare ownership of this trust was blatantly presumptuous in their eyes. Railway tracks and asphalt highways crisscross the plains, blast through the rugged mountain chains, and snake across the deserts. Strip mining tears at the land, and developers threaten the forests. We dam the slashing rivers and seek to harness their power.

APPALOOSA

Below: The distinctive spots of an Appaloosa horse— originally bred by the Northwest Nez Perce—seen at Oregon's Pendleton Round-Up parade.

Right: Competition ropers during the Pendleton Round-Up.

Bottom right: Cowgirls, Coca-Cola, and chaps at Idaho's Caldwell Night Rodeo.

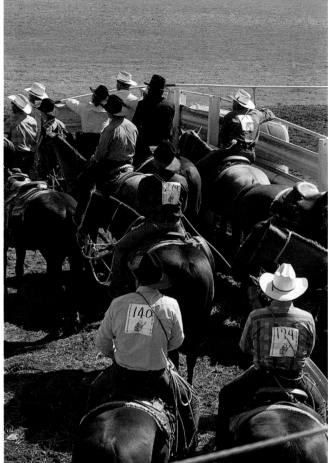

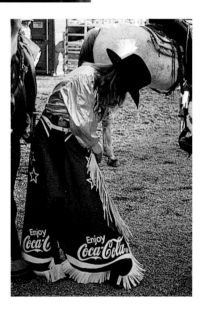

outdistanced her nearest rival by $45,000 in 1988, winning nearly $150,000. By the early 1990s, they were calling her the "Million-Dollar Cowgirl." In spite of her modest low-key approach, Charmayne is a virtual legend in modern rodeo circles. She is often seen talking to young admirers outside the long silver trailer that carries her and Scamper to such diverse locales as Preston, Idaho, and the national rodeo finals in Las Vegas, Nevada.

Behind the pomp and pageantry of modern rodeo, the basic spirit of the lone rider still roams the land. There are the familiar undercurrents of man against man, man against animal, man against himself. Along with the color and glitter, a very real and palpable tension can be sensed.

Photographing an indoor winter rodeo, I spent a considerable amount of time behind the chutes watching the riders. Amid the apparent disorder of saddles, straps, and sundry equipment, it struck me how quietly the cowboys were going about the business at hand. They were cordial and supportive, often shaking hands when spotting an acquaintance in the crowd milling around them through a maze of saddles and leather.

However, not much was said. Off in the corner, one rider appeared to be in silent prayer. Others were quietly focusing, mentally rehearsing their techniques in advance. Some were stretching and doing calisthenics; some were taping their hands. A silent brotherhood, flirting with danger.

"You can always tell the old ropers when you shake their hands," a retired rodeo cowboy told me. "They have no thumbs." He smiled good-naturedly. I noticed he still had his thumbs, as he explained how roping a calf could sever a man's finger or thumb, should one unfortunately get tangled in the swirling rope near the saddle horn.

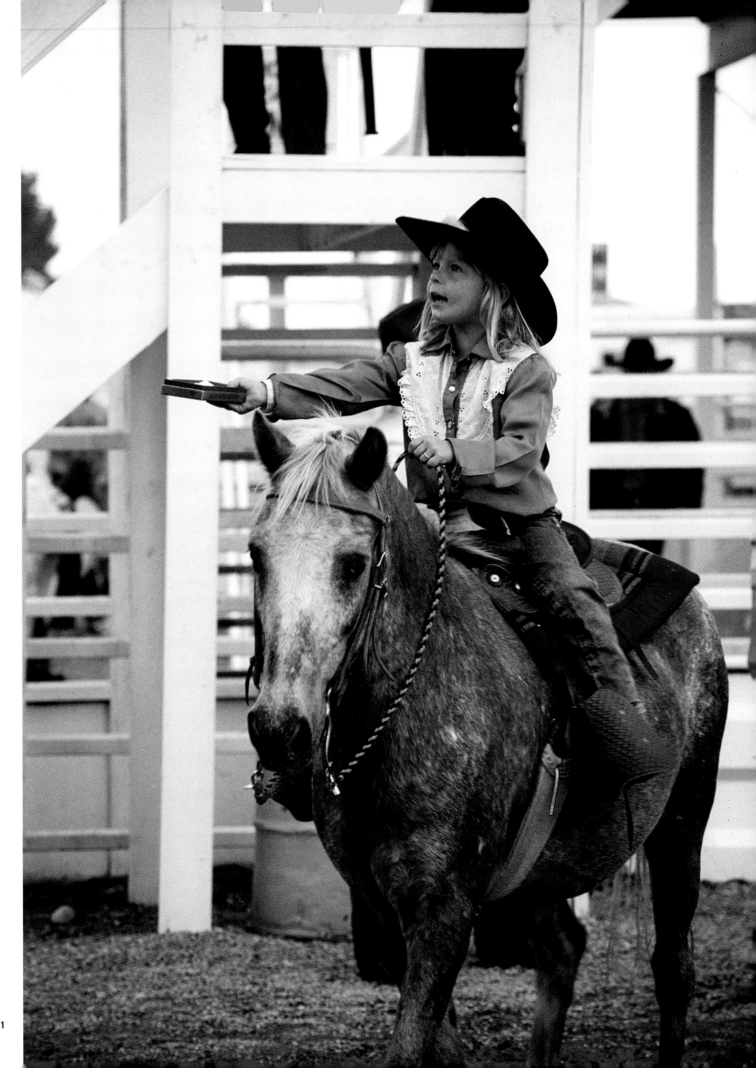

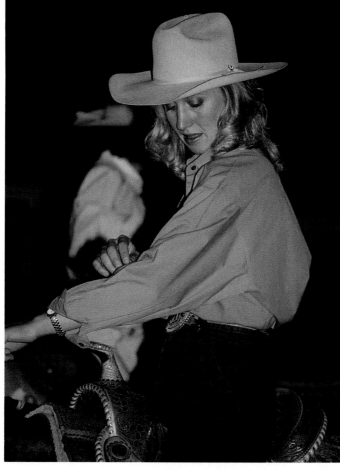

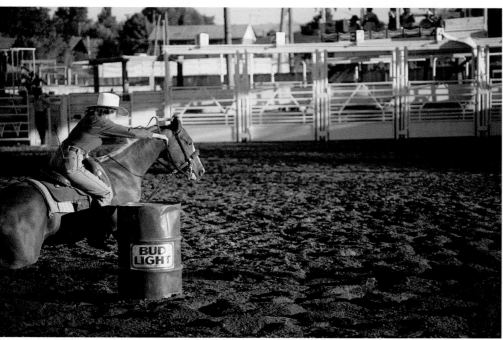

THE BARREL RACERS

Top: Charmayne Rodman—the "Million-Dollar Cowgirl"—rodeo's dominant barrel racer.

Above: Cowgirl DeAnna Dever rounds the barrels at a Homedale, Idaho, competition.

Right: Starting early, an Idaho youngster looks for her mother's approval and proudly presents her prize.

bursting with civic pride.

Driving into Preston, Idaho (population 3,710), in anticipation of photographing the town's Famous Night Rodeo, I found the late afternoon streets buzzing with excitement. Bright banners hung brashly across the town's main street, which was neatly lined with vendors and displays. Posters proclaimed the evening festivities from the well-scrubbed windows of the local drugstore and hardware store, as well as from the doors of a row of small shops so typical of American country towns.

White picket fences and carefully trimmed yards graced the adjacent residential streets—the type of place and people Norman Rockwell would have painted if he had lived in rural Idaho rather than Rockport, Connecticut. Somehow I think Norman would have felt at home in Preston that afternoon.

Shortly, those pristine streets would be crowded with a living train of mounted riders, glamorous rodeo queens, local politicians, 4-H Club devotees, and enough equine souvenirs to keep Preston's street cleaners working their longest day of the year.

"This was the first night rodeo in America," a proud security guard told me at the contestants' gate. Regardless, the Preston rodeo is of sufficient reputation to draw the likes of wunderkind barrel racer Charmayne Rodman and her fabled horse, Scamper. The soft-spoken New Mexico woman had won over a half million dollars in competition by her eighteenth birthday, and she currently dominates her sport. The only comparison that comes to mind is that of hockey's Wayne Gretzky. Gretzky has made a shambles of the record books in recent years, continuously setting new standards of excellence in his sport. Charmayne has done much the same thing in the fast-paced world of barrel racing, where fractions of a second can mean the difference between a paycheck or nothing at all.

Subdued, focused, almost stoic before a race, the blonde-haired rider

Yet, despite these efforts, the West remains a formidable adversary, reveling in its wildness and playful majesty.

I remember my first drive through Utah. Emerging from the hustle and bustle of Salt Lake City, with its typical urban freeway system, I eventually found myself on a wide-open road bordered by curious buttes and plateaus that reflect mystical images in mirror-like lakes. The mood was strangely quiet and surreal.

Suddenly, two stately bald eagles—all-seeing guardians of a rocky domain—swooped down near the road's edge, paused, and then departed as quickly as they had appeared. The magnificent image of their coal-black wingspan against the dusty orange backdrop remains vividly etched in my memory. I knew I had entered a very different and still untamed land.

The High Church of the West

If the seemingly endless land is the cathedral of the Contemporary West, then the modern rodeo is its high church on display—a celebration of Western-ness equally honored in the largest cities and smallest country towns.

From spring through September, multitudes of rodeos occur throughout the Western states, reaching a high point in July and August. Often held in conjunction with county fairs and agricultural festivals, rodeo has its origins in the early gathering of ranch hands who congregated occasionally to test their skills at roping and riding.

Throw in the flamboyant show-manship of the legendary William F. Cody, alias Buffalo Bill (whose drama-tized Western extravaganzas toured extensively through the United States and Europe near the turn of the century), and you have the roots of the modern rodeo.

Towns take their rodeos seriously, often transforming themselves virtually overnight from quiet oases on the West-ern landscape to colorful showcases

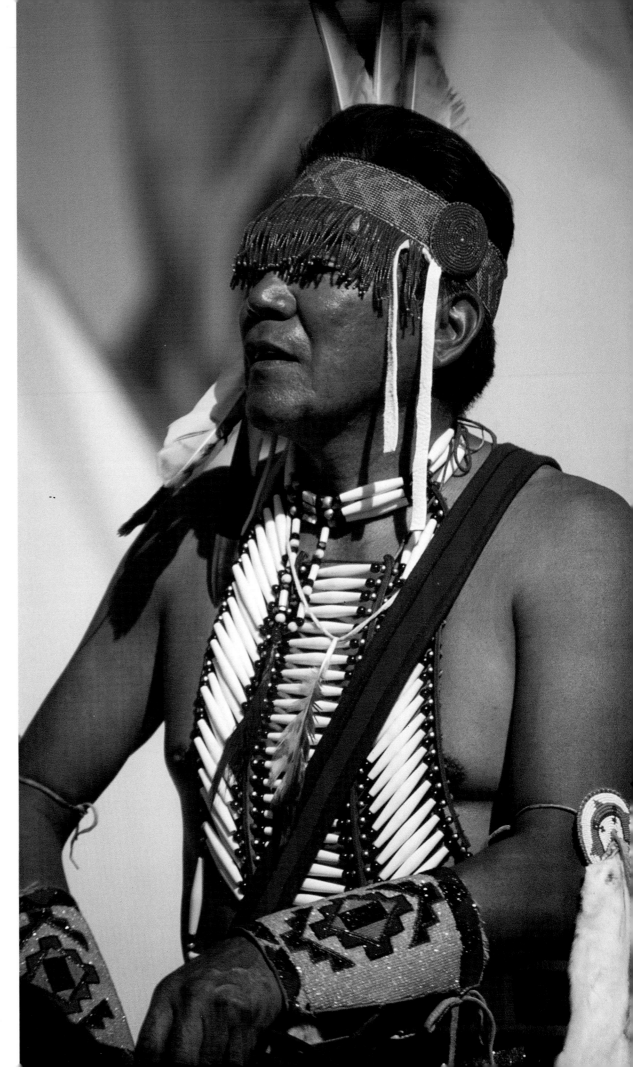

49

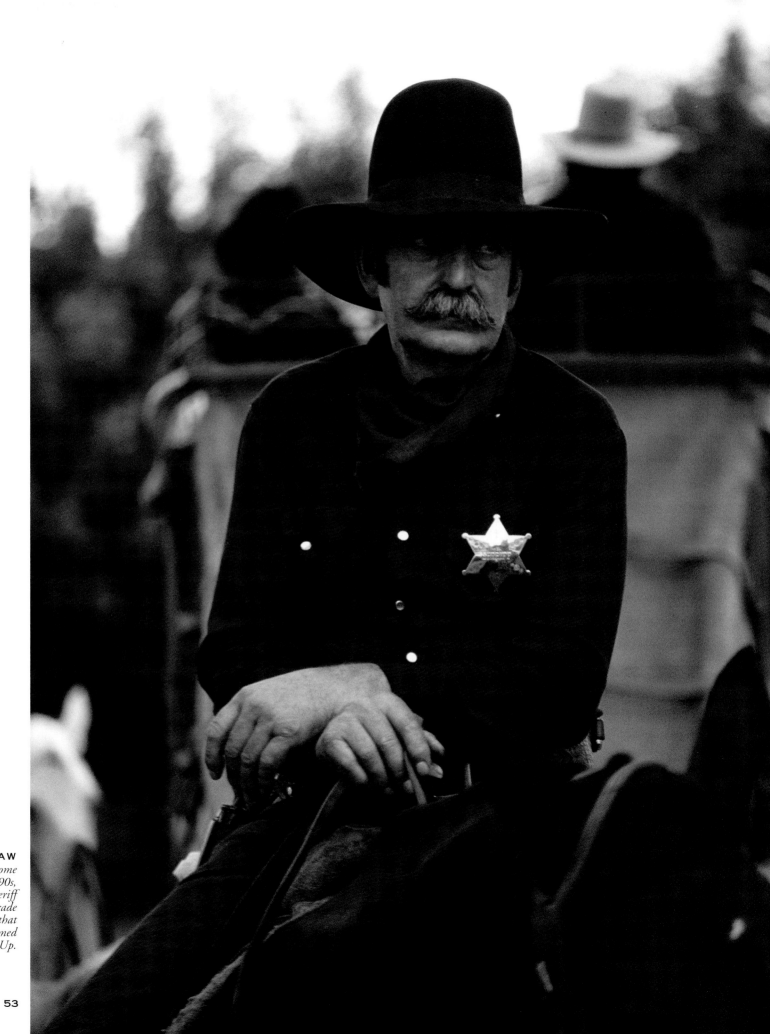

THE LAW
*Looking equally at home
in the 1890s or the 1990s,
an actual Western sheriff
pauses during parade
preparations that
accompany Oregon's famed
Pendleton Round-Up.*

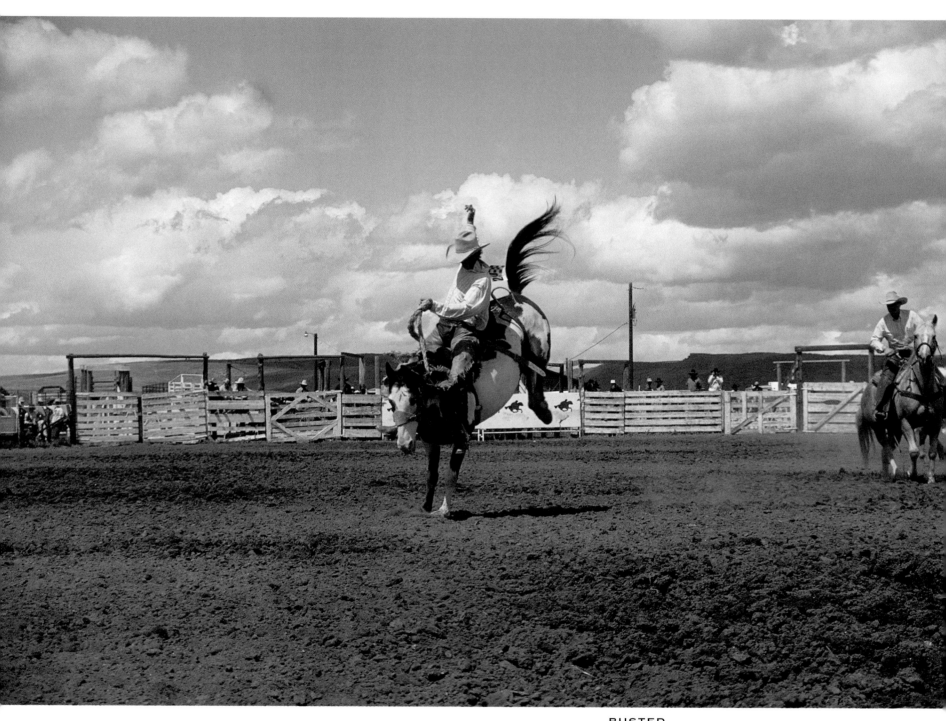

BUSTED

*Above: A classic bronc rider at Jordan Valley,
Oregon's Big Loop Rodeo.*

*Right: A fallen rider reflects the pain of the profession
during Oregon's Pendleton Round-Up.*

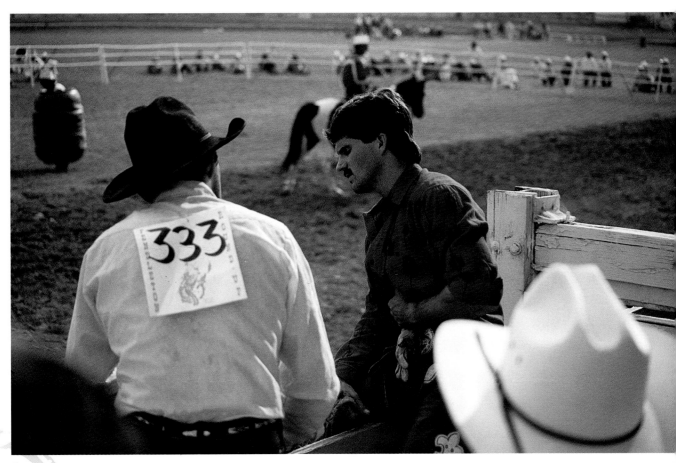

A popular country song warns, "Mamas, don't let your babies grow up to be cowboys." There's more than a little wisdom in that refrain; being a rodeo cowboy can be a decidedly dangerous occupation.

The images are disturbing and hard to erase. . . .

On a stretcher, a young bronco rider, lying hauntingly still, is carried past a hushed crowd. The reality of his situation stands in sharp contrast to the colorful surroundings. For a few seconds, time is frozen, and the excitement of the day means nothing.

In the shadows, away from the bright arena lights, the open doors of a parked ambulance await a fallen bull rider. Minutes before, he had been thrown and then stepped on by 1,500 pounds of twisting fury.

Elsewhere, during an early-morning conversation at a service station, a fellow customer confides that his knee is pinned together compliments of his abbreviated career as a rodeo rider—a man too young to be crippled. "You have to watch them closely," a paramedic behind the chutes tells me amid the quiet bustle of pre-ride activity. "They won't admit they're hurt; they try to hide it."

Later that night, a veteran cowboy staggers out from among the silhouettes of his fellow riders and slowly crumples to the dirt. Thirty minutes later, he is still there, until paramedics feel it is safe to move him by stretcher to a waiting ambulance.

Sadly, from Wyoming comes the sobering news. Lane Frost, regarded as perhaps the best bull rider in rodeo, has turned his back on a bull and been fatally gored. Lane Frost was twenty-five years old.

Of Conquistadores and Vaqueros

The life of a real working cowboy is not accompanied by cheers from the rodeo arena.

Often acted out in lonely isolation amid harsh weather, his days involve hard work—mending fences, doctoring cattle, and the never-ending routines of ranch maintenance.

As Teresa Jordan writes in her book *Cowgirls*: "For all its romantic appeal, life on the land is terribly, terribly hard. Accidents happen frequently. Biddy Bonham saw her father killed when his horse stepped in a gopher hole. Martha Gibb's brother caught his foot in his rope and was dragged to death by his horse. Linen Bliss's daughter had her skull crushed by a horse and lost an eye." [15]

During a typical workweek, the contemporary cowboy probably rides in a pickup truck or four-wheel-drive vehicle more often than on a horse.

Though his numbers may be dwindling, he is still here—a timeless symbol of the Contemporary West.

The roots of authentic "cowboy culture" reach back to the New World feudalism of sixteenth-century New Spain. [16]

The conquering Spanish forces, under Cortez and Villalobos, introduced horses and cattle into what today is Mexico. These horses were Andalusians—a Spanish breed that combined bloodlines of old Spanish and Moorish origins. The horse would prove to be a key player in the dramas that lay ahead, becoming a virtual symbol of the West. Militarily, mounted conquistadores were images of terror in the rapid subjugation of New Spain.

By 1540, the business of raising cattle had exploded to almost unbelievable proportions south of the Rio Grande. A powerful subculture ruled by Spanish cattle barons emerged with enormous herds needing protection and control.

This "rancher aristocracy" began hiring "laborers on horseback," and the ancestor of the "vaquero" (or Mexican cowboy) was born.

Sometimes these early cowboys were

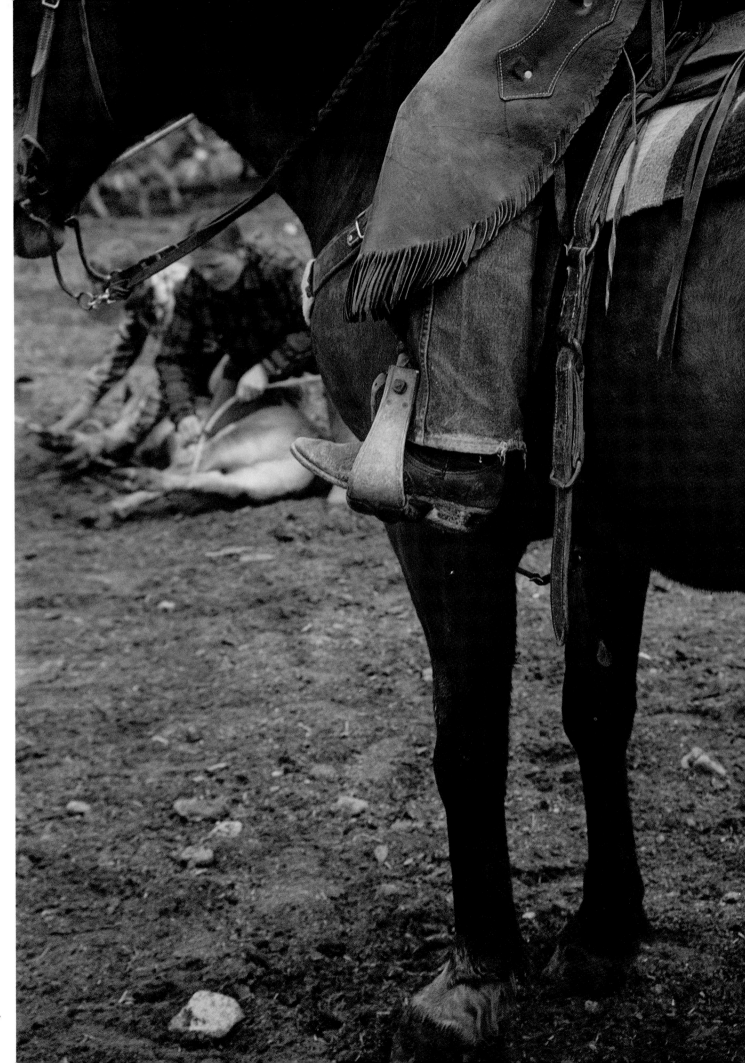

FAMILIAR FACE

Far left: Looking like you'd expect him to, an Idaho cowboy observes the action at the Homedale, Idaho, rodeo.

Right: Neighboring ranchers help out at an Oregon summer roundup.

57

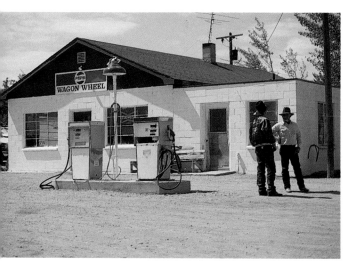

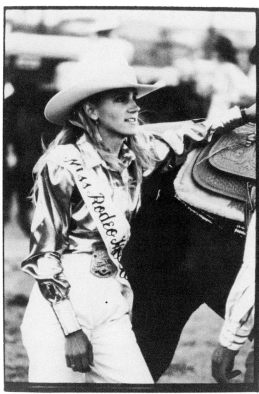

"mestizos" (mixed Spanish and Indian heritage) or "mulattos" (mixed black and white heritage). Their lives were far from romantic, as sixteenth-century colonial Mexico still reflected the stark feudal structure of Old World Europe. [17]

It seems surprising to many that a monolithic cattle industry developed so quickly in New Spain, centuries before the familiar image of the American West, with its ranches and cattle drives, was established in the late 1800s.

To put this in perspective, consider that when Spanish culture flourished in New Spain, on the Eastern New England coast, the pilgrims had yet to get off the boat, so to speak. The great Northern plains that lay westward still thundered with the hooves of countless wild buffalo herds. This untouched wilderness, which today we revere as the heartland of our traditional Western frontier, had yet to see a horse or a cow.

The Western American Indians acquired horses after contact with Southwestern tribes and Spanish traders in the seventeenth century. [18] By 1690, the Idaho Shoshones had acquired formidable herds, but previously all Indian hunting, warfare, and travel were conducted on foot. American Indians became outstanding horsemen—the Northwest Shoshone, Cayuse, and Nez Perce in particular. The exceptional equine skills of the Nez Perce were evident in their development of the magnificent spotted Appaloosa horse. The Cayuse became so well known as horsemen that their tribal name was often used as a nickname for the animal.

The Spanish cattle industry gradually made its way northward into what is now Texas, New Mexico, Arizona, and California.

Today's cowboy equipment and clothing show marked evidence of the early Spanish influence in style, craftsmanship, and flair.

The lariat, or rope (its sixteenth-century predecessor being a large lance, and later a pole with a loop on the end), the spur, stock saddle, saddle horn, and branding iron are all of Spanish origin. The leather leggings, or chaps, of modern-era cowboys have their roots in the "chaparreras" of mounted Spanish soldiers who discarded metal armor in favor of leather, because of the hot climate of New Spain. [19]

Originally, two sections of cowhide hung from either side of the saddlebow, protecting the rider's legs from cactus and thorny brush.

A thriving "ranchero" community developed in California, ruled by domineering cattlemen, or "dons," far from the eyes of the Mexican government.

By 1840, the old mission system of land ownership had dissolved, and the private ranches became even more prosperous. [20]

In Texas, the infusion of American settlers from the East resulted in the development of a distinctly Texan cattle breed. This sturdy product of Spanish and American livestock would become known as the Texas longhorn, destined to become an enduring symbol of the West.

In time, the cattle industry would push upward into the Western states, even as pioneering settlers from the East moved increasingly westward across the prairies.

Cattle drives, in which ranchers forced large herds of cattle to new locations, would become a legendary ingredient in Western lore. At the heart of the exploding cattle industry was the hard-working vaquero, whose skill and presence would become synonymous with ranch life.

The cattle business, driven by economics, was often a battleground of conflicting interests.

The cattle barons grew in prosperity, controlling vast areas of land and coming into conflict with each other as well as with farmers and sheep ranchers.

Initially, the herds roamed the open

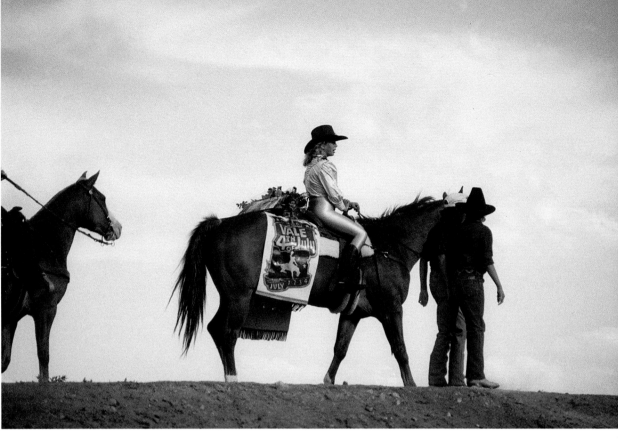

range, this arrangement relying on cooperation among ranchers. However, the 1873 invention of barbed wire fencing, nicknamed "the devil's hatband," signaled the end of the open range era.

By the 1860s, the Union Pacific Railroad was rumbling through Nebraska, heading west in a cloud of smoke. The iron horse, carrying supplies and settlers as it thundered across the prairies, would play a pivotal role in reshaping the country.

In 1885, the Golden Spike was driven at Promontory Summit, Utah, to complete the merging of East and West rail lines. The West would never be the same.

The New Frontier

In researching background for this book, I came to realize the sobering complexity of the West. Its past far exceeds any simple stereotypes. It is a heritage of deep human drama—a bittersweet mixture of triumph and tragedy for all participants, revealing the best and worst in the hearts of those concerned.

It reflects an intricate combination of cultures and values whose realities are often more fascinating than the myths that grew around them. Its history is so recent that its survivors were still around to tell their stories well into the current century.

The cowboy remains a symbol of the multiple perceptions we hold of the West. Some say such a sentimental image obscures the objectivity needed to face the contemporary problems of the region.

The physical presence of the West can be overwhelming, with majestic forested hills and mountains giving way to sage-covered deserts stretching to the horizon.

It has always seemed timeless and eternal. Yet America's "mythic land" has undergone a whirlwind of change.

Today, industry, loggers, ranchers, miners, tribes, and environmentalists are promoting their visions and agendas for

the West. The voices are growing in intensity, and the issues are complex. The West has always been the land of romance, new frontiers, and bottomless natural resources. We assumed they would always be there.

A recent *Newsweek* magazine article addressed the question of a dramatically changing West and ended with this poignant quote from novelist Wallace Stegner: "When it [the West] fully learns that cooperation, not rugged individualism, is the pattern that most characterizes and preserves it, then it will have achieved and outlived its origins. Then it has a chance to create a society to match its scenery." [21]

Today, the image of the lone rider still silhouettes the landscape of the West. Fueled by a tumultuous past and enduring myths, it is a powerful image, cloaked in a romanticism that has become its own reality.

Entwined in the legend are sobering lessons from the past, a work-ethic spirit, and an enduring dream of new beginnings—not bad tools to have in one's saddlebag.

Perhaps it is not yet quite time for the lone rider to ride off into the sunset.

HORIZONS

Young Westerners near Vale, Oregon, during its annual Fourth of July Rodeo.

SOURCES

1. James Larpenteur Long (Assiniboine), *Great Documents in American Indian History* (New York: Praeger Publishers, Inc., 1973), 62.
2. *The Indians* (New York: Time-Life Books, 1973), 167.
3. Evan S. Connell, *Son of the Morning Star* (San Francisco: North Point Press, 1984), 135.
4. Connell, 167.
5. *The Gunfighters* (New York: Time-Life Books, 1974), 15-34.
6. Glen G. Boyer, *Suppressed Murder of Wyatt Earp* (San Antonio, Texas: The Naylor Company, 1967), 54, 56-58.
7. Stuart N. Lake, *Wyatt Earp, Frontier Marshal* (Cambridge: Mass.: Houghton-Mifflin Company, 1931[special edition, 1955]).
8. Wallace Stegner, "Who are the Westerners?" *American Heritage*, Dec. 1987, 39.
9. Dee Brown, *Bury My Heart at Wounded Knee* (New York: Simon and Schuster [Pocket Books], 1981), xi.
10. Russell Nye, *The Unembarrassed Muse, The Popular Arts in America* (New York: The Dial Press, 1970), 199.
11. Brown, xi.
12. Brown, 164.
13. Connell, 187.
14. Patricia Nelson Limerick, *The Legacy of Conquest, The Unbroken Past of the American West* (New York: W.W. Norton and Company, 1987), 55.
15. Theresa Jordan, *Cowgirls, Women of the American West* (Garden City, New York: Doubleday and Company, Inc. [Anchor Books], 1984), xxx.
16. David Dary, *Cowboy Culture: A Saga of Five Centuries* (Lawrence, Kansas: University Press of Kansas, 1989).
17. Dary, 13.
18. *The Indians*, 45.
19. Dary, 45.
20. Dary, 56.
21. Tom Mathews, "The Custer Syndrome, What's the Right Answer to 'Who Owns the West'?" *Newsweek*, Sept. 30, 1991, 35.

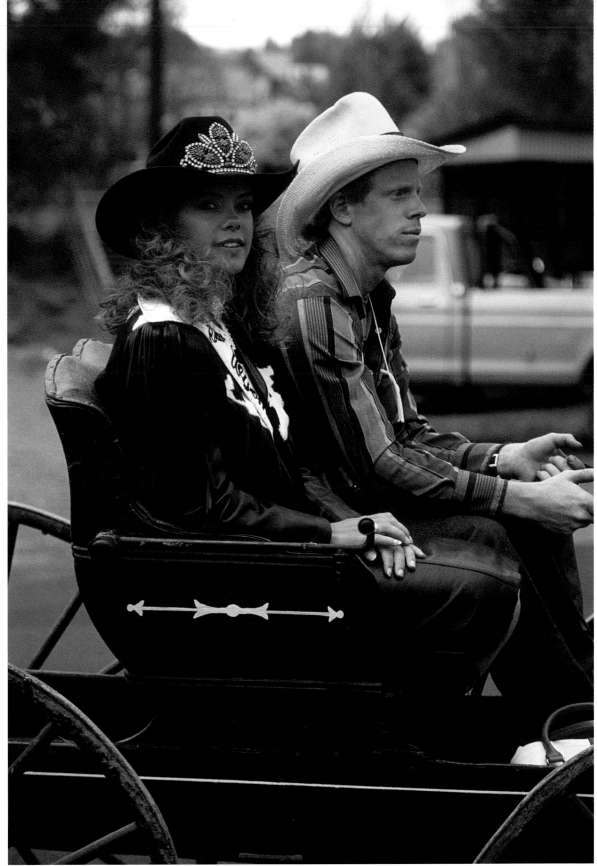

NOSTALGIA

Right: Massive draft horses evoke memories of the past at Murphy, Idaho, Old-Time Days.

Above: A young cowboy taxis Miss Rodeo Wyoming Stacey Talbott (a Miss Rodeo America title winner) in a classic open carriage during the Pendleton Round-Up parade.

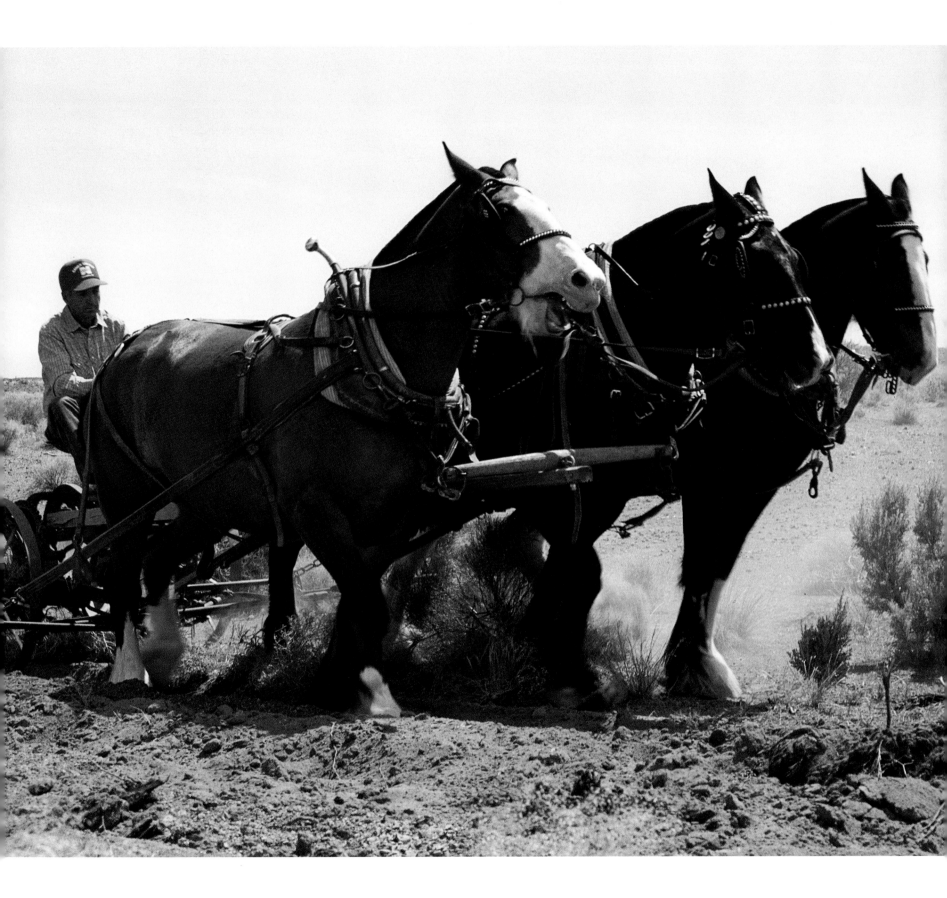

LARIAT
The coiled rope has become synonymous with the West.

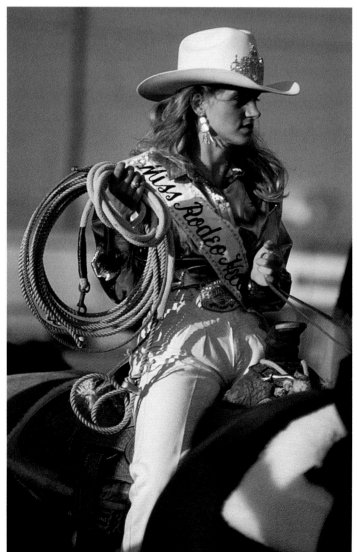

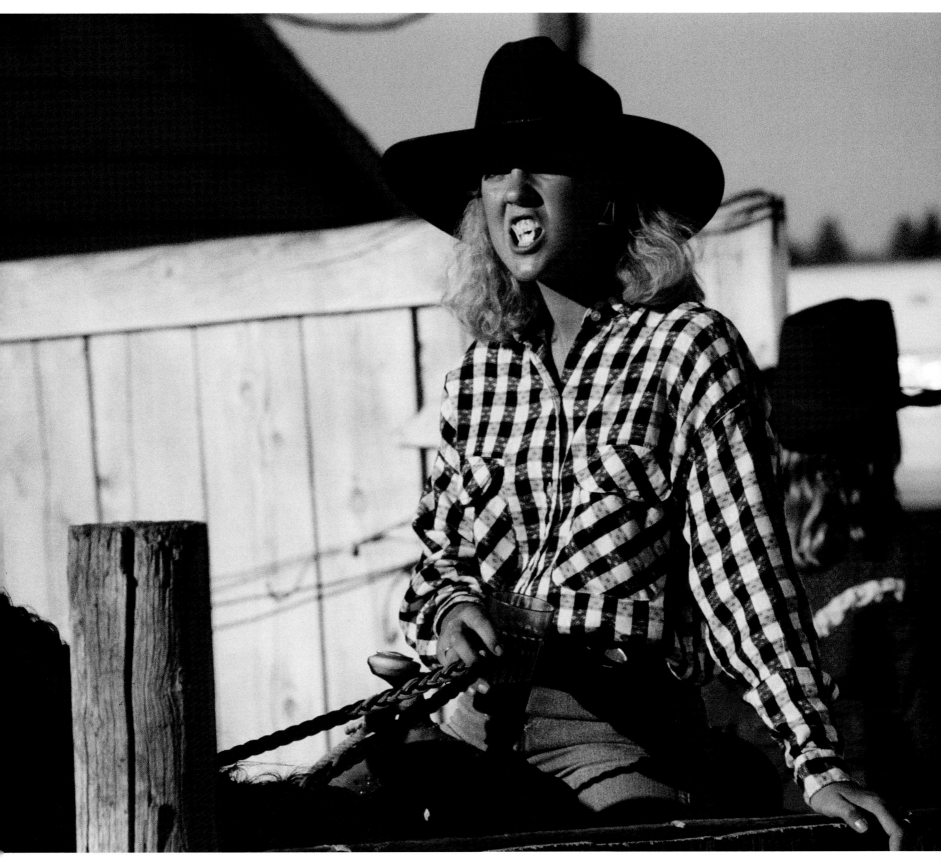

BARREL RACER IN THE WINGS
Homedale, Idaho.
A spirited cowgirl waits her turn in the chutes.

A TOUCH OF CLASS
Contemporary Idaho rodeo queens Courtney Crowe (below) and Andrea Schlapia.

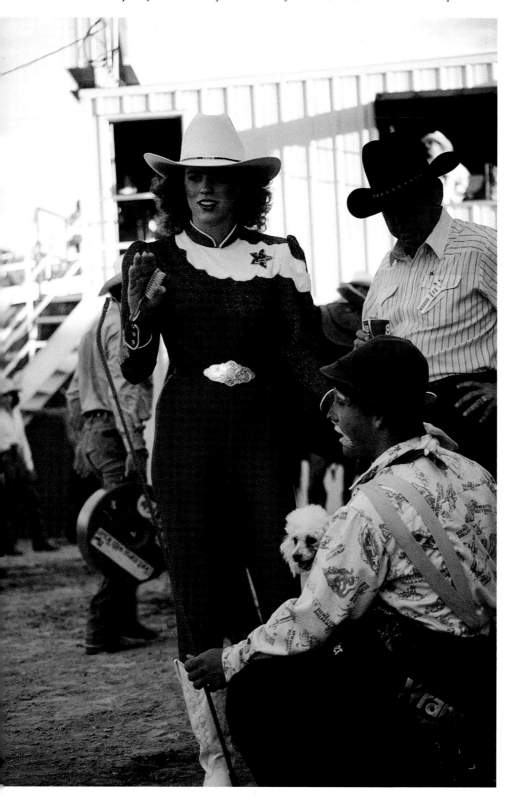

THE ORIGINALS

*Y*ou can come watch us," she said, with a hint of mis-

chief in her dark eyes, "but you will never understand us."

The words of the gray-haired Indian woman caught me off

guard. It was a loaded statement, and her smile could not hide

the unspoken thoughts.

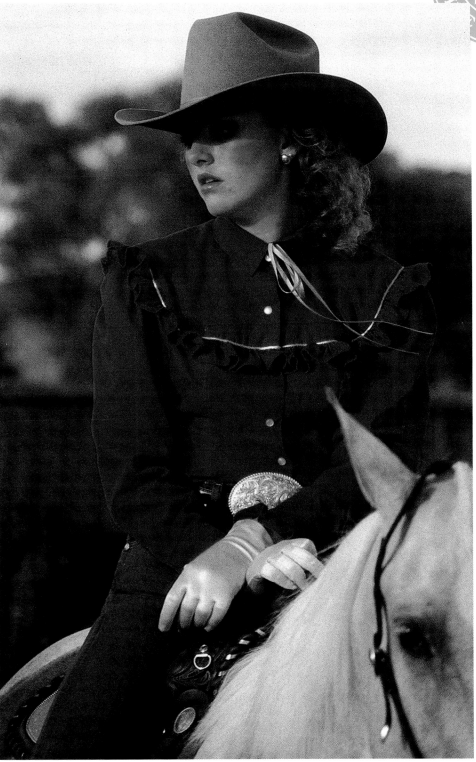

COWGIRLS

Far left: Rodeo Director Melda Roberts of Idaho's popular Caldwell Night Rodeo.

Left: The evening sun catches Vale, Oregon, rodeo Queen B.J. Ruckman.

Right: Red Riders, a women's riding club, at Oregon's Pendleton Round-Up parade.

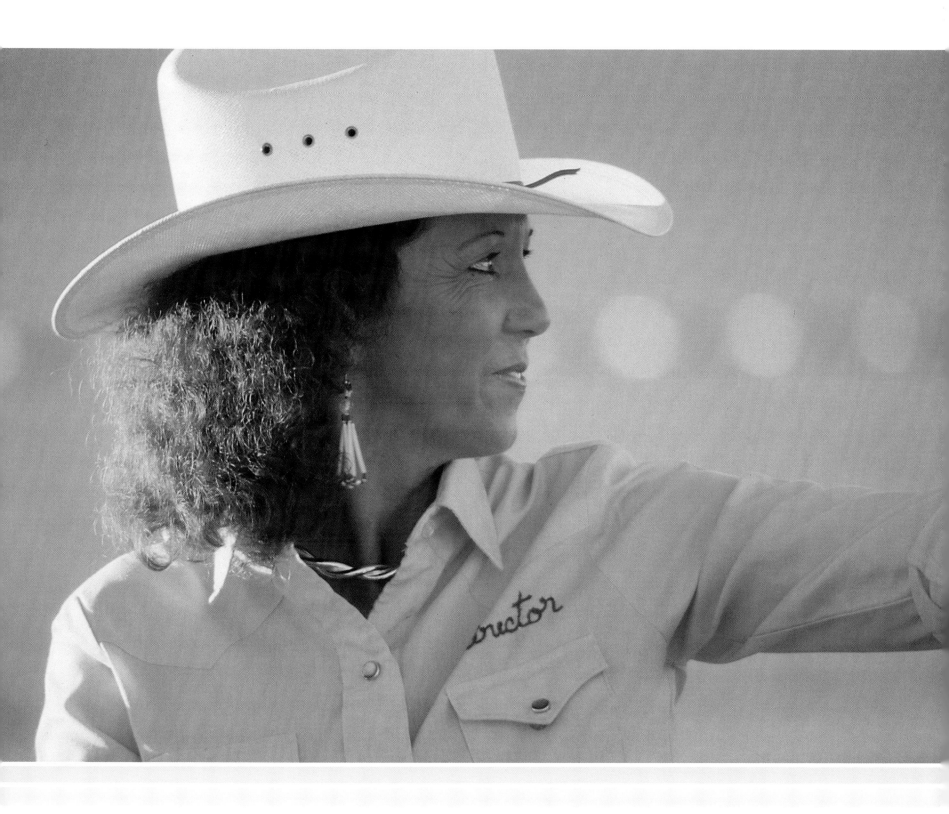

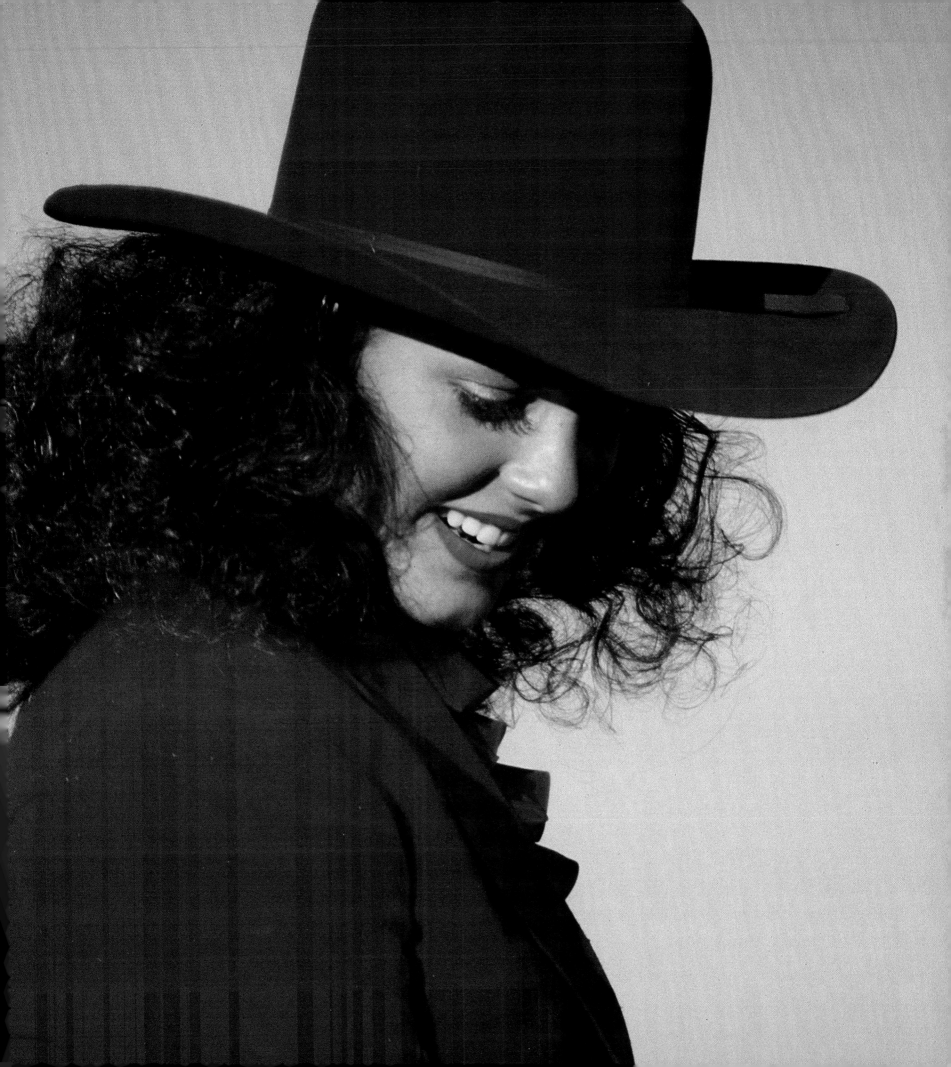

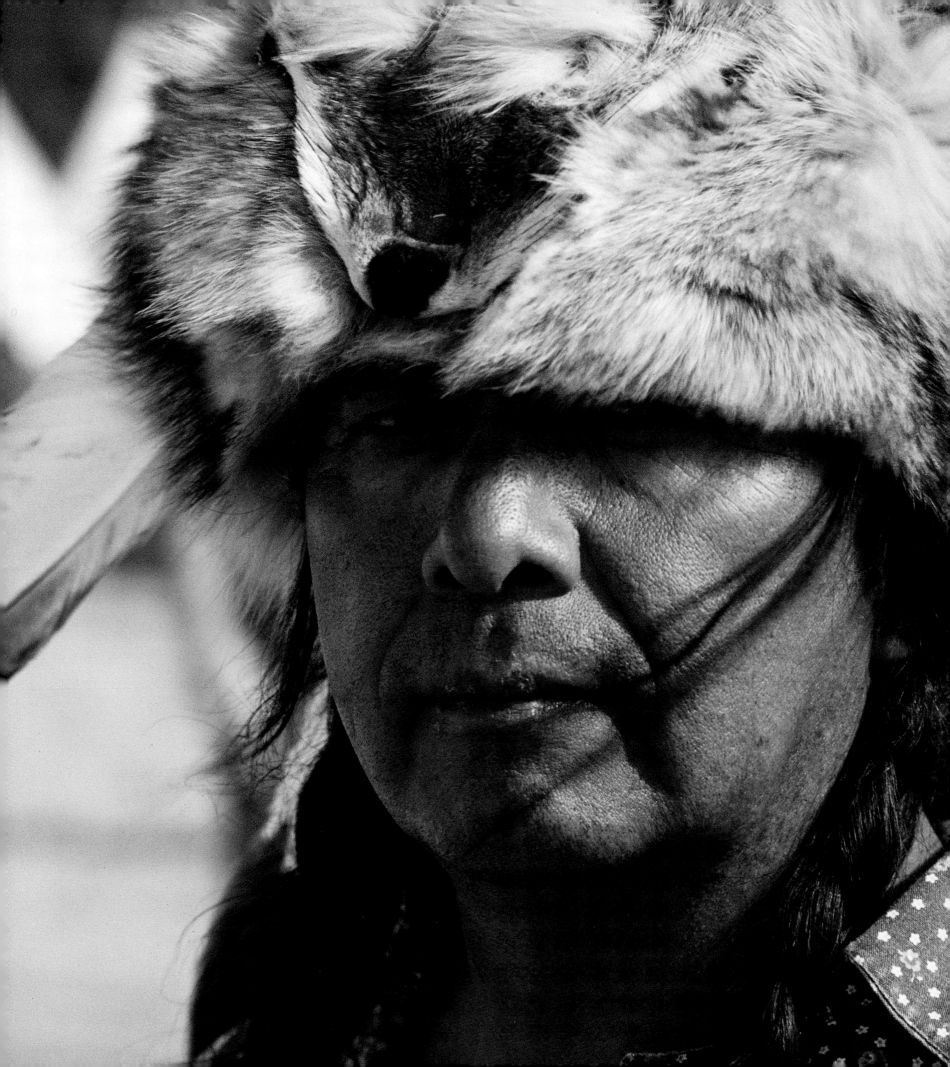

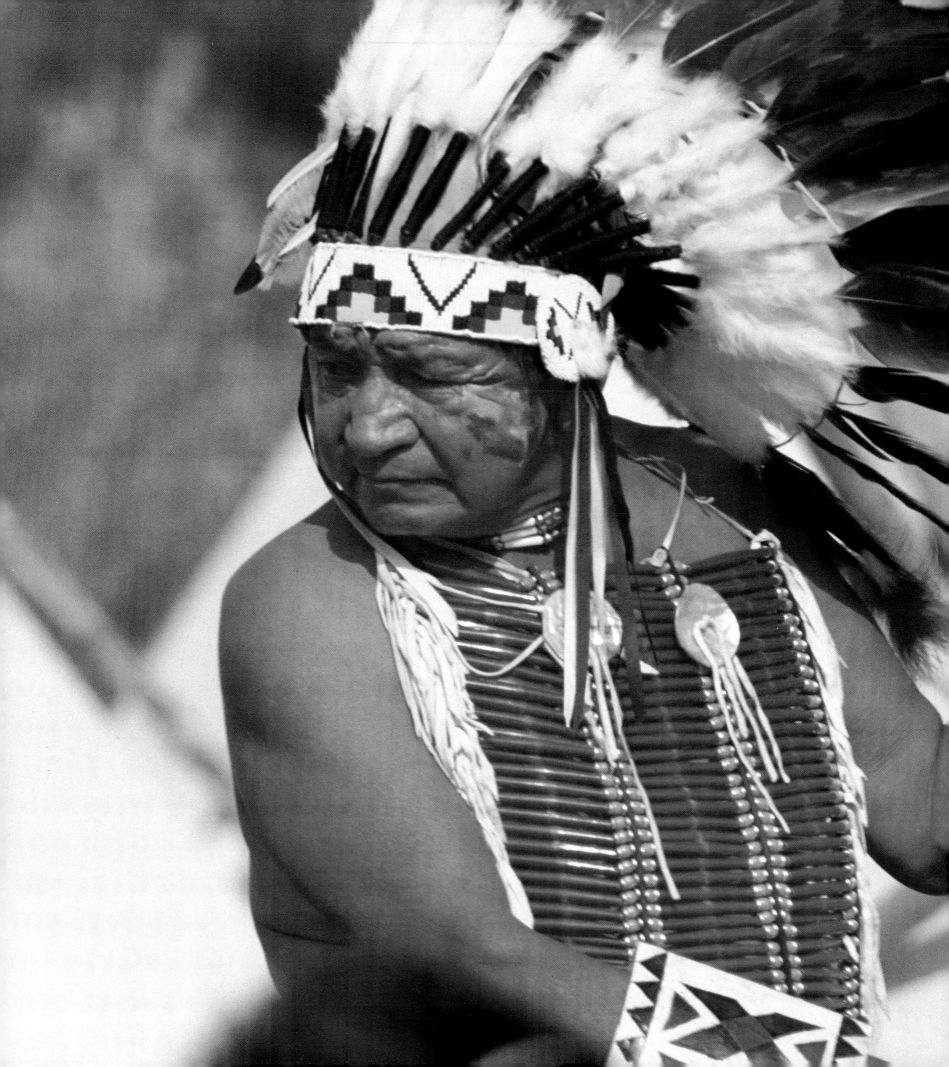

Left: Horseman Leonard Cree in full regalia
at the Pendleton Round-Up.
Previous page (close-up): Marvin Martinez.

"Why do you say that?" I asked, sensing her conviction. She looked right at me and replied, "Because you're not an Indian."

She was right. I could focus my telephoto lenses and capture the swirling colors of the dances, hear the haunting voices and pounding beat of the dance-arbor drummers, record the rich pageantry of the costumes on film, but I could never fully understand. American Indians have always been able to say so much in just a few words.

They are a tolerant people, who hold the land in utmost reverence—yet their history is one of struggle and misunderstanding. Their trust was rewarded with broken promises

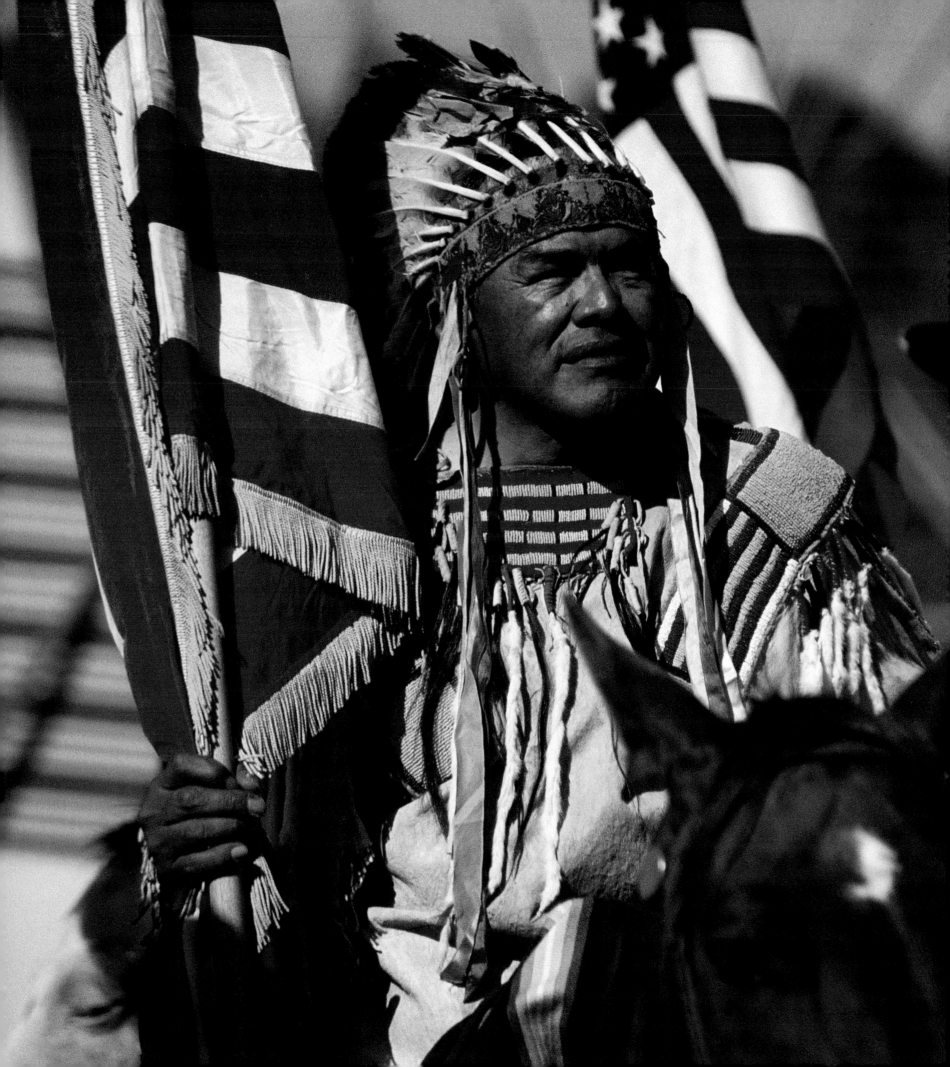

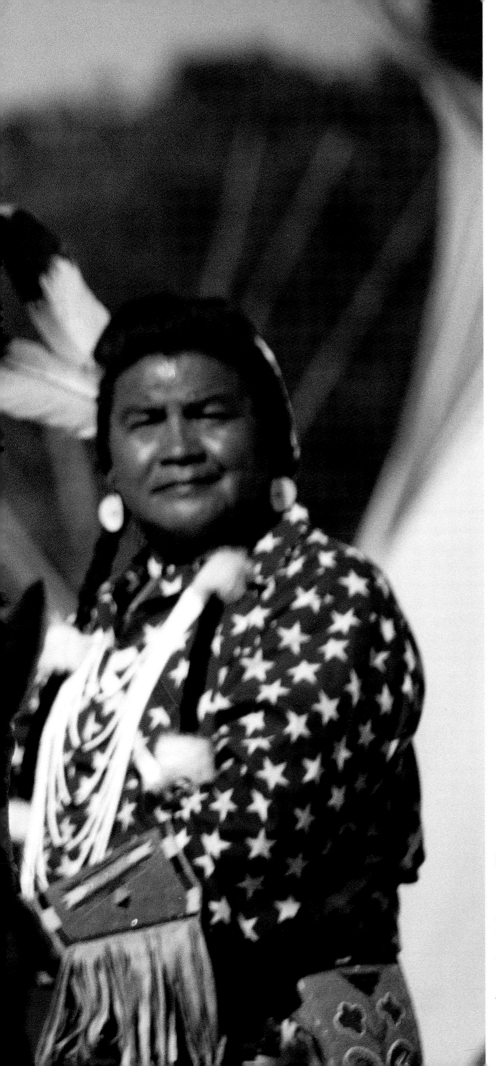

AMERICAN INDIAN PRIDE

The Umatilla, Walla Walla, Yakima, Nez Perce, and Cayuse put on a spectacular display annually at Oregon's Pendleton Round-Up.
The nightly Happy Canyon Pageant offers an extravagant mini-history of the West. Rows of tepees border the rodeo grounds throughout the week.

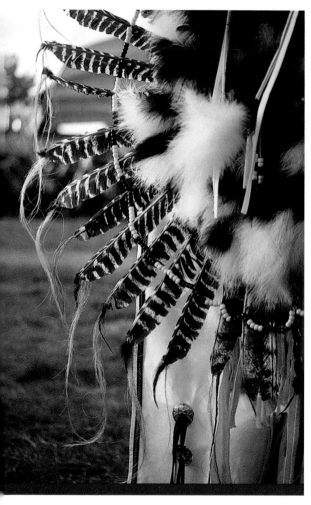

and disillusionment. Caught in a whirlwind of European colonization, with its resulting lust for gold and treasures of the earth, the American Indians found their world in upheaval.

Even in the face of injustice, the insight of the American Indian cuts through years of conflicting cultures and turmoil. Nearly a hundred years ago, a Blackfoot chief, upon being asked for his signature to one of the first land treaties in his territory, declared: "Our land is more valuable than your money. . . . It will not even perish by the flames of fire. As long as the sun shines and the waters flow, this land will be here to give life to men and animals. We cannot sell this land." [1]

I attach my telephoto lens. The circular dance arbor is awakening with the slow, steady

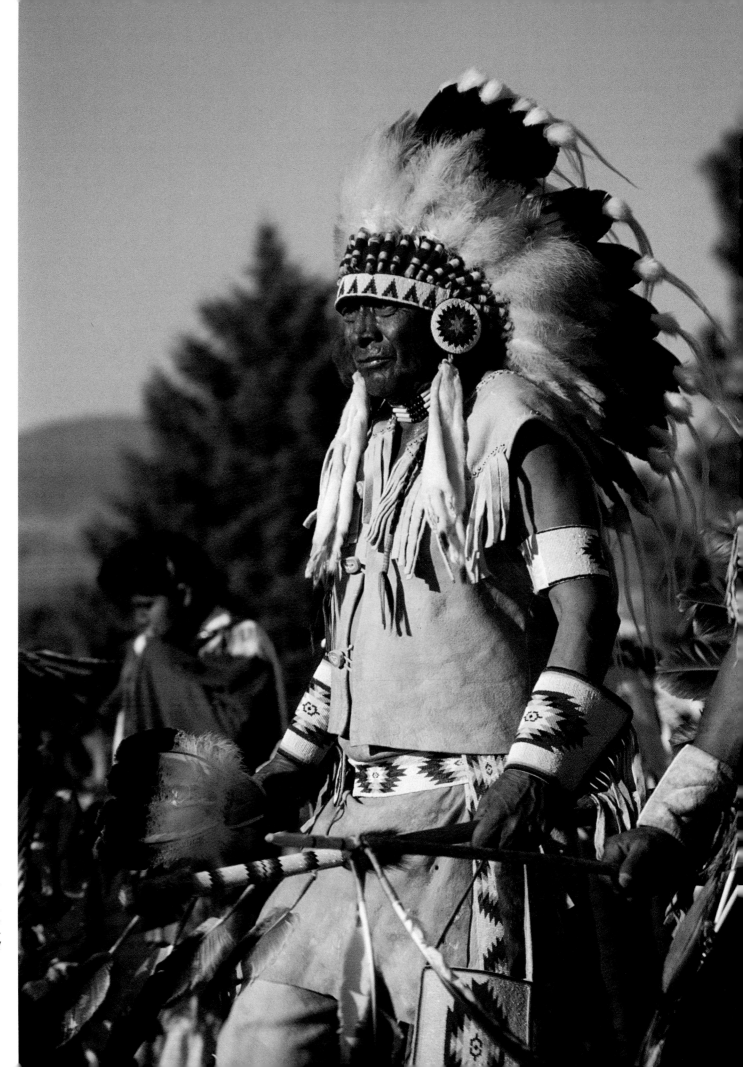

STANDING TALL
*Boise, Idaho.
A proud figure of com-
manding presence stands
tall in the dance arbor
during an Idaho centennial
gathering of tribes.*

75

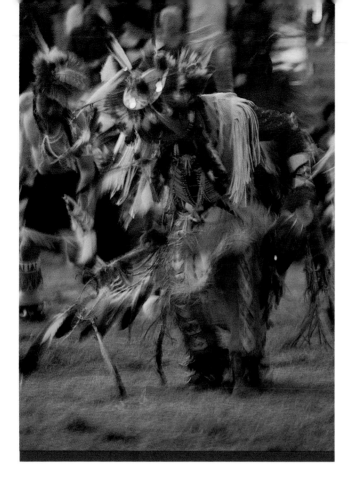

pounding of drums. The distinct voices of the singers rise steadily. A small, young American Indian girl takes her turn, dancing with intense energy . . . her dark blue shawl swirling, her colorful beadwork and feather flashing in the afternoon sun. It is said she is a descendent of the great Sioux chief, Crazy Horse.

Crazy Horse—a name that looms larger than life. The mere mention of it conjures up intriguing images of the past. It was Crazy Horse, the revered Oglala Sioux chief, who played a major role in the 1876 defeat of Gen. George Armstrong Custer's Seventh Cavalry near the grasses of Montana's Little Big Horn River more than a century ago. It was the last great American Indian victory in a tragic era that found the original Americans in a life-and-death struggle to preserve their way of life.

The young girl in the blue shawl, a solitary feather in her black hair, holds my attention.

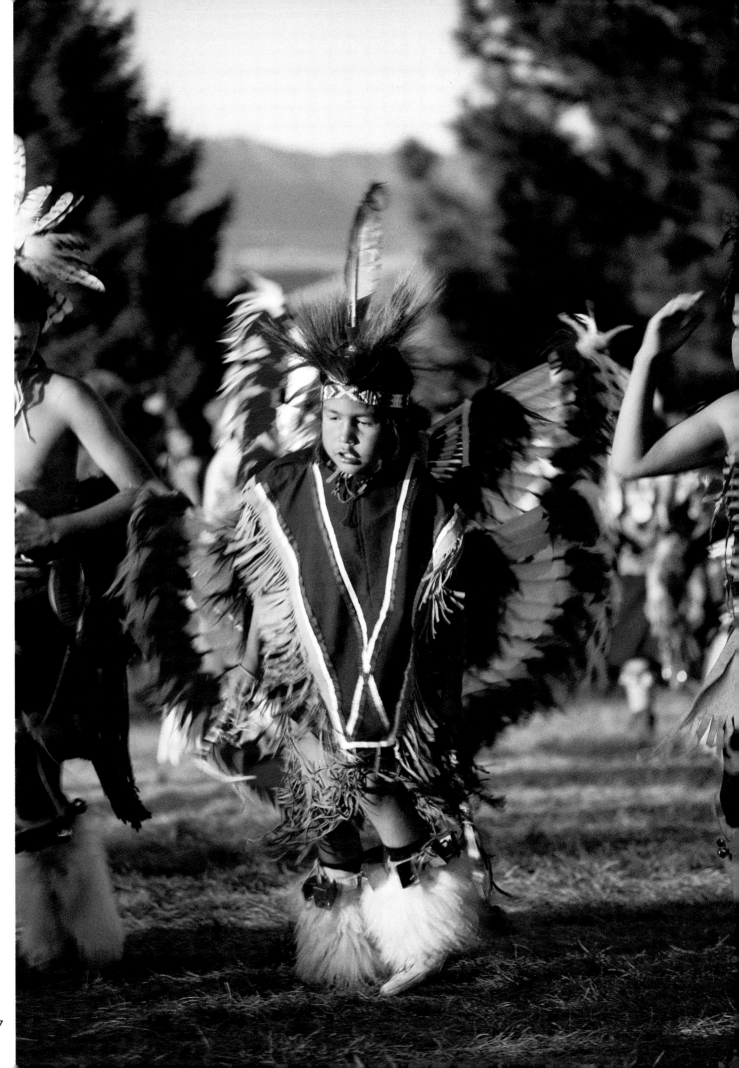

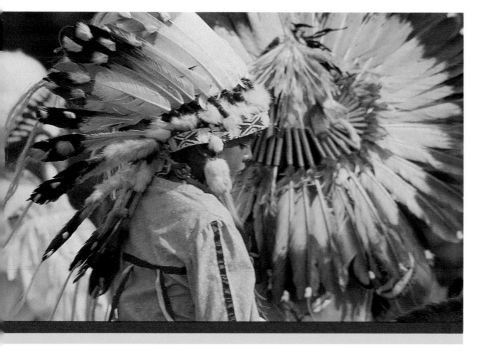

It's riveting to realize the implications.

She is only a child, unaware of the

emotions the name of her ancestor arouses.

Yet, she is both a symbol of the past and

future of her people.

To this day, no confirmed photograph

of this mysterious Sioux chief exists. "My

friend, why should you wish to shorten my life by taking from me my shadow?" [2] *was the reply*

of Crazy Horse to adventurous early photographers who wished to capture his image on film.

The attitude only added to his legend.

Many of his contemporaries, such as chiefs Sitting Bull, Red Cloud, Spotted Tail, and the

Nez Perce Joseph, were photographed in the late 1800s. Years later, their dignified faces still

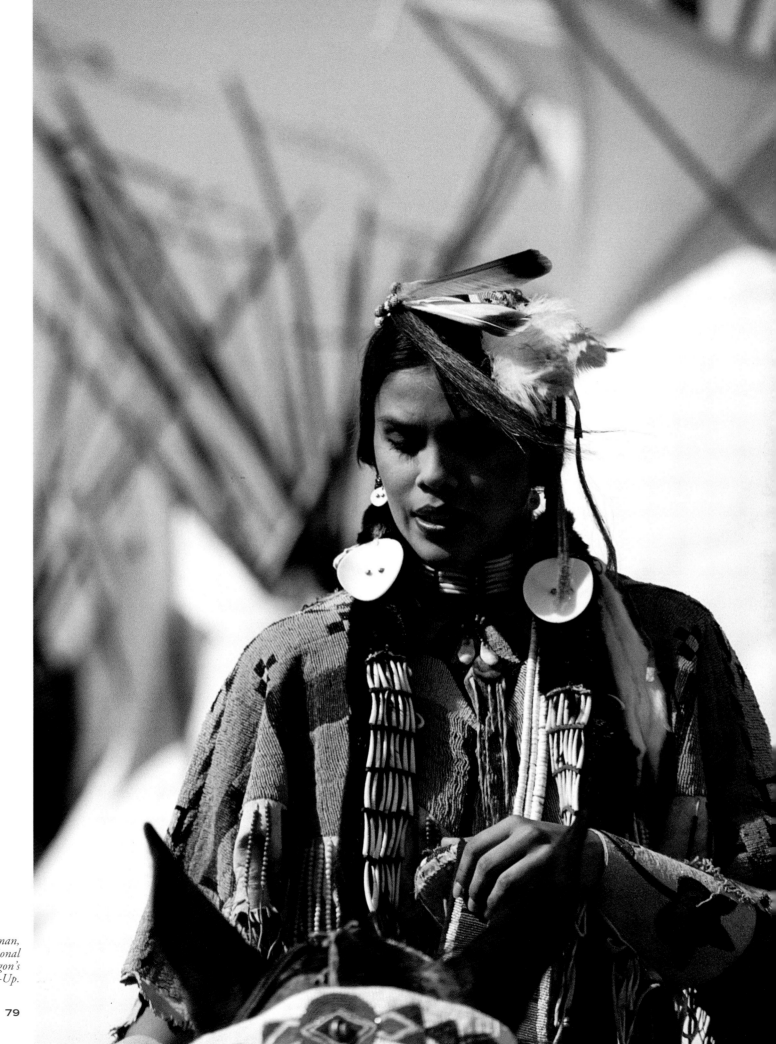

A beautiful young woman, adorned in traditional finery, at Oregon's Pendleton Round-Up.

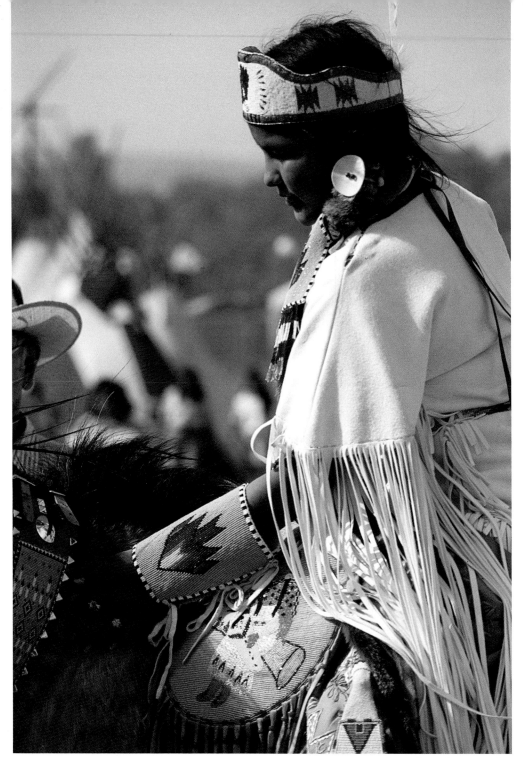

INTRICACIES
Pendleton, Oregon.
The acclaimed skill of American Indians in detailed leather and beadwork is evident in these photos taken at the American Indian Village on the grounds of the Pendleton Round-Up.

stare at us, reminders of a gallant people surrounded by overwhelming odds, their lives in turbulent transition. Time has not diminished the strength and pathos of these early photographs or of what they represent.

It was the Western plains Indians who most captured the imagination of the world during the throes of the mid- to late-nineteenth century. Their nomadic way of life depended on following the great herds of buffalo, which thundered across the plains by the millions. These herds were lifelines for the tribes, which

relied on the buffalo for food and clothing, utilizing virtually the entire animal for practical purposes. The tough hides of the buffalo were also used for the conical tents, or tepees, which served as portable dwelling places.

Skilled warriors engaged in great hunts, charging alongside the massive animals before grounding them with a lance, arrow, or—later—rifle fire.

The names of these tribes—Cheyenne, Arapaho, Crow, Blackfoot, Dakota Sioux, Kiowa—still evoke power and roll off the tongue lyrically, enforcing their aura.

Northwest tribes, such as the Nez Perce, Bannock, and Shoshone, also ventured into buffalo country on extended hunting expeditions.

The Nez Perce were exceptional horsemen and undertook marathon hunting trips in search of buffalo, sometimes roaming bison country on two- to five-year hunting excursions.

These long hunts enhanced the reputation of the Nez Perce as daring warriors because such ventures into the territory of the Crow and Blackfoot tribes left them open to attack. [3]

Realizing the vital dependence of the plains tribes on the buffalo and that relationship in subduing the West, the U.S. Army did little to discourage the wanton destruction of the great herds by professional white hunters in the 1860s and '70s, who catered to Eastern demands for buffalo hides and tongues.

The great herds dwindled, and their migration patterns were disrupted, leaving the traditional life of the plains Indians extremely fragile.

It was against this backdrop, accented by broken treaties and continued encroachment on treaty lands by advancing settlers in search of gold and rich natural resources, that the original Americans faced the end of an era.

Just as the 1874 discovery of gold in the Black Hills of South Dakota led to climactic events for the Dakota Sioux, the 1877 realization of gold in the Wallowa Valley area of the Northwest

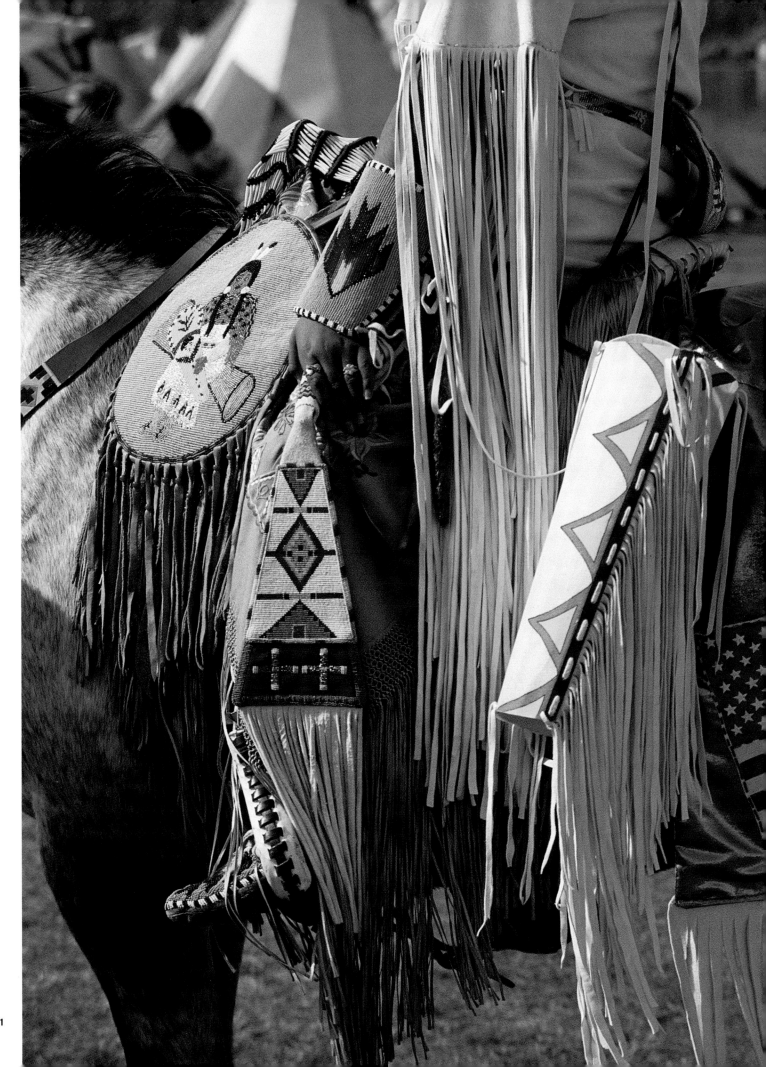

The tribe had a long history of peaceful coexistence with white settlers. Yet Joseph and his band were forced off their Washington land and told to relocate at the Lapwai reservation in Idaho. Unrest developed, and Joseph and 700 Nez Perce undertook a 1,700-mile,[4] four-month flight for freedom that has been called one of the greatest military maneuvers in history.

Only forty miles from the freedom of the Canadian border, Joseph's band—

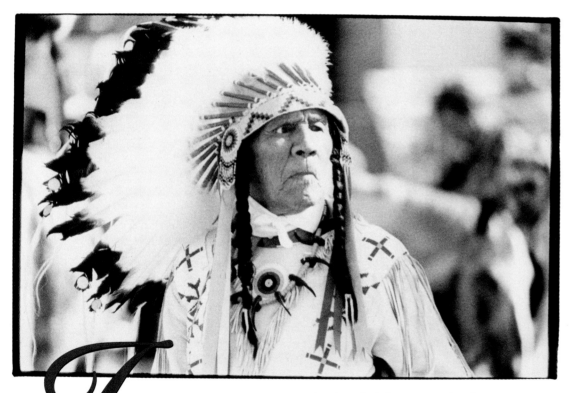

THE BRIDGE OF TIME

An intense young boy participates at an Idaho centennial gathering of tribes (right), while an aged Indian, whose face reflects the wisdom of the years, commands attention by his sheer presence (above).

having eluded two pursuing forces—was cut off by a third force of soldiers under Gen. Nelson Miles. Forced to surrender in the bitter winter cold, Joseph, who had not wanted conflict, eloquently delivered these now famous words:[5]

"I am tired of fighting. . . . It is cold and we have no blankets. The little children are freezing to death. My people, some of them, have run away to the hills and have no blankets, no food; no one knows where they are—perhaps

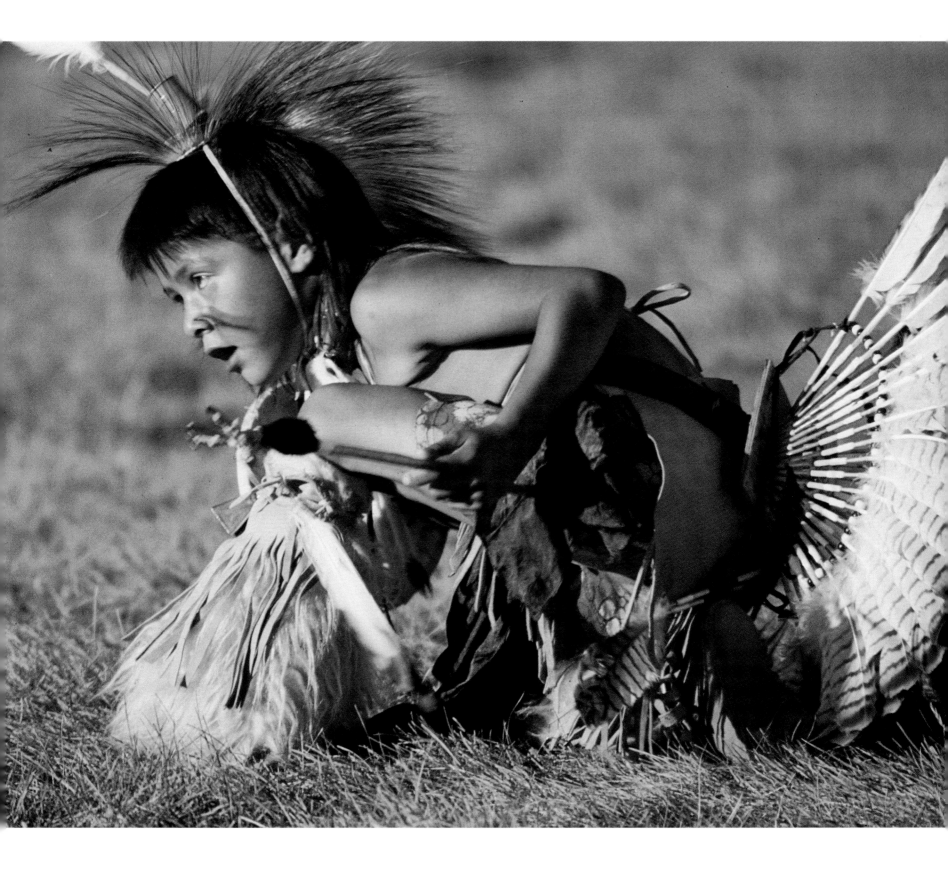

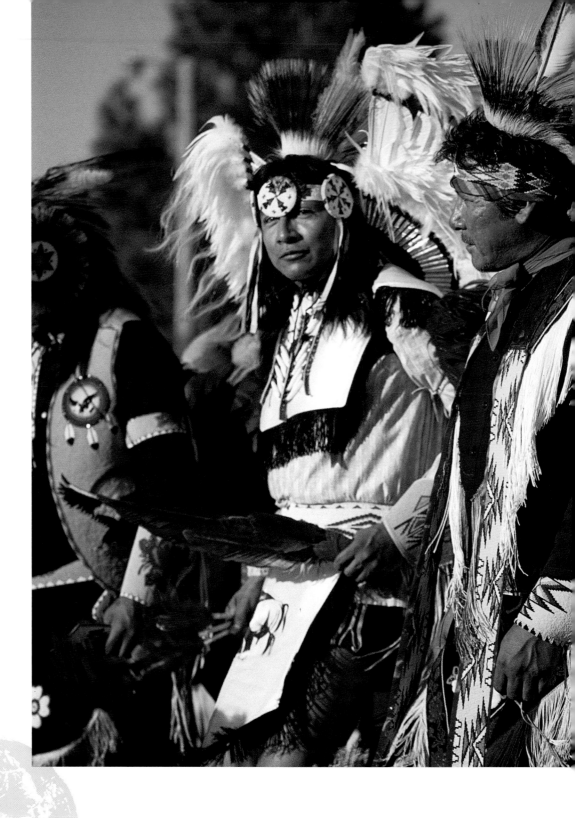

freezing to death. I want to have time to look for my children and see how many I can find. Maybe I shall find them among the dead. Hear me, my chiefs. I am tired; my heart is sick and sad. From where the sun now stands, I will fight no more forever." [6]

Just as the image of the cowboy has been wrapped in a mythical shroud that distorts, the perception of American Indians has consistently been reduced to stereotypes.

It's easy to lock the American Indian in a time warp—the noble warrior resplendent in feathered headdress, bands of colorful war paint streaked across his face.

It seems so congruent with our image of the West to leave him high up on the ridge, mounted on his spotted war pony, picturesque and timeless. Unfortunately, the stereotyping drowns out the very real and human problems of reservation life.

A personal experience puts the Contemporary West in perspective:

I had been attending a large gathering involving several Idaho tribes. For three nights I watched the dancers blending in a spectacular stream of color as they circled the dance arbor.

There were the rapid, acrobatic swirling of the young "fancy dancers," the steady gait of the traditional dancers with their controlled graphic motions, and the stately presence of the aged, moving regally amid the whirlwind of color.

The drums pounded, metal flashed, bells jingled, bone breastplates swayed, and feathers bobbed along to the rhythms as the haunting sounds of singing filled the evening air.

The scene was mesmerizing and transcended time; it easily could have been 120 years ago.

A middle-aged dancer particularly stood out. He seemed to be there every night, no matter which tribe hosted the festivities. His moves were those of a traditional dancer—not spectacular, but vivid in dignified consistency. His face was rugged and possessed a lived-in look that accented his presence. A solitary figure, proud in his transcendence of time.

The next day, after the drums had ceased and the dancing grounds were silent, I pulled into a gas station at the edge of town.

Different sounds were now in the air—the clanging of the gas pumps, the clicking of plastic credit cards, the sound of a pop can rattling down a drink machine, and the subdued squealing of tires as cars entered and left the area.

I purchased my fuel and climbed back behind the wheel of my car, the dance-arbor drums still ringing in my ears.

In the rearview mirror I caught a fleeting glance of a familiar face. It was the stately traditional dancer—without the feathers. His face still had that lived-in look, but he was clad in a windbreaker and slacks as he climbed into the front seat of an RV to join his family and friends.

I had wanted to leave him in feathered splendor, eternally circling to the beat of drums or perched on a war pony high upon a ridge.

The RV pulled out and merged with the flow of traffic—another family heading home after a weekend activity.

As they faded from view, I collected my shattered thoughts and smiled at the irony. That's life in the Contemporary West.

Photos: Images from a centennial gathering of tribes, Boise, Idaho.

The American Indian has endured and will continue to do so. His heritage is rich in survival and wisdom, his past and future contributions too valuable.

The landscape of the Contemporary West is wrapped in a multitude of fascinating elements. None is more compelling than the American Indian.

My thoughts go back to the young girl clad in the blue shawl, the blood of Crazy Horse flowing in her veins.

The pictures in this volume portray so many like her—people who form the mosaic of the Contemporary West, yet had no control over the events that preceded them. Living reminders of an intriguing past, these people of all colors must live today in a land that has survived dramatic change. The future is in their hands.

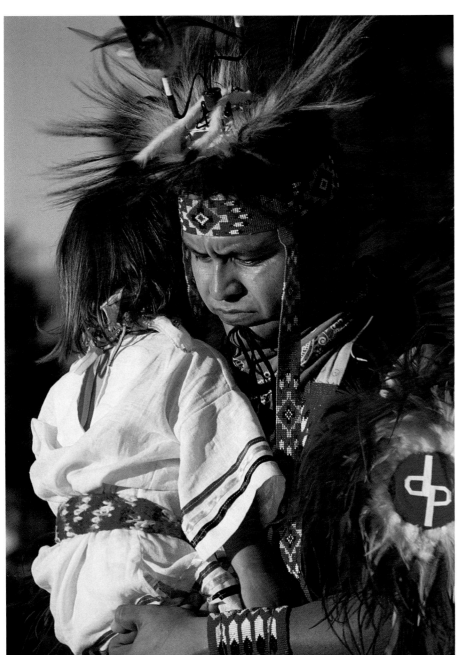

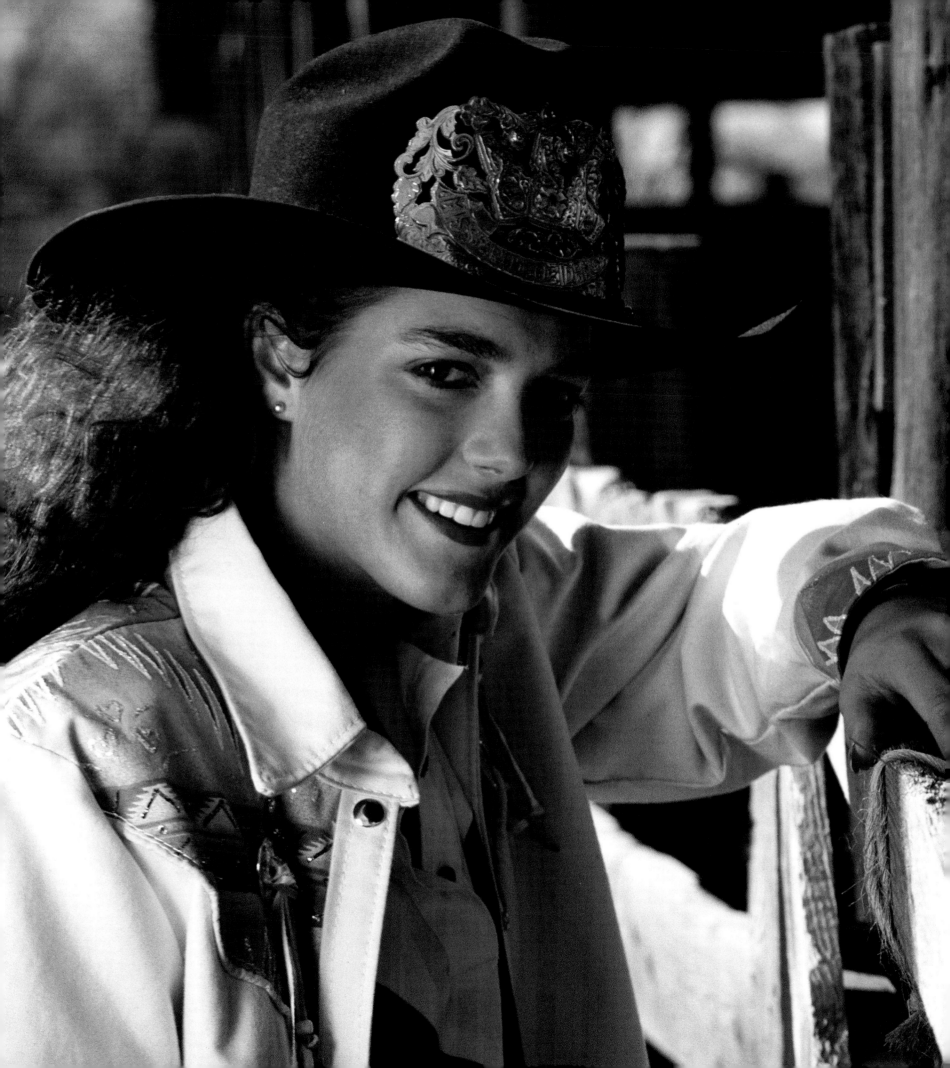

SWEETHEARTS OF THE RODEO

Cowgirls

ANDREA SCHLAPIA *(left)*, SHAYNE MASON *(above)*.

The pounding of a horse's hooves thunders in the dirt as the rodeo queen circles the arena. Her costume becomes a blaze of color, and the horse's nostrils flare as it gains momentum. The huge crowd, itself a pulsating mass of color, erupts in applause as she waves, all the while maintaining control of her charging mount. A victory lap—one of rodeo's most electric moments—is under way.

Suddenly, a young dark-haired girl, caught up in the excitement, runs parallel to the

arena fencing as the rider approaches. Impulsively, she reaches out her hand, and the queen clutches it in acknowledgment. For a brief, magic moment, the two of them are racing together on either side of the fencing.

To the young girl, the incident became a picture frozen in time.

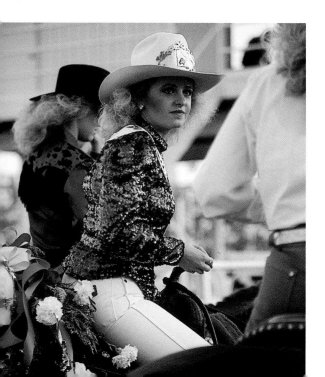

"Right then, I knew that's what I wanted to do," she would say years later.

Today, she spends much of her time on or around horses. She has traveled her state speaking to civic groups, classrooms, and youth clubs. Many times she has executed the colorful victory lap she so admired as a teen. Her name is Andrea Schlapia, and she is an enthusiastic and glamorous spokeswoman for professional rodeo.

Andrea was crowned the 1991 Miss Rodeo Idaho and represented her state in the Miss Rodeo America competition in Las Vegas, Nevada. The event coincides with the annual Pro Rodeo Cowboys Association (PRCA) National Finals Rodeo, the "superbowl" of the rodeo season. Narrowly missing the coveted title, she was named first runner-up.

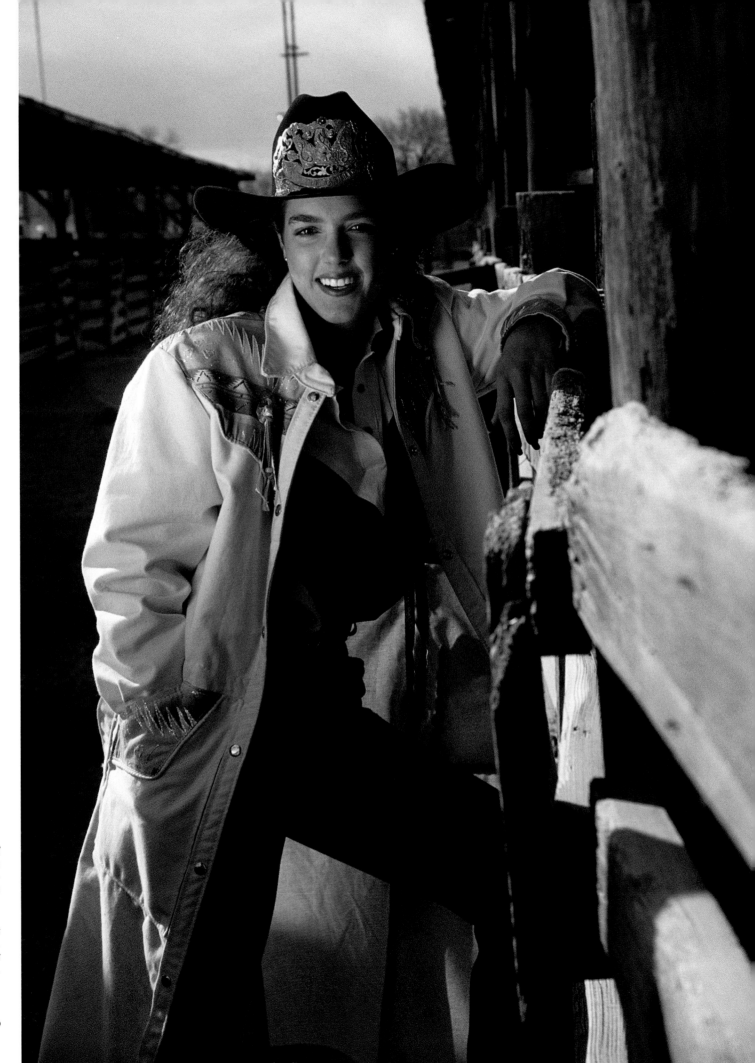

ANDREA SCHLAPIA

The stylish Idaho cowgirl has reigned as Miss Rodeo Idaho and as first runner-up for the coveted Miss Rodeo America title.

Far left: Idaho's Deneen Lammey, Caldwell Night Rodeo queen.

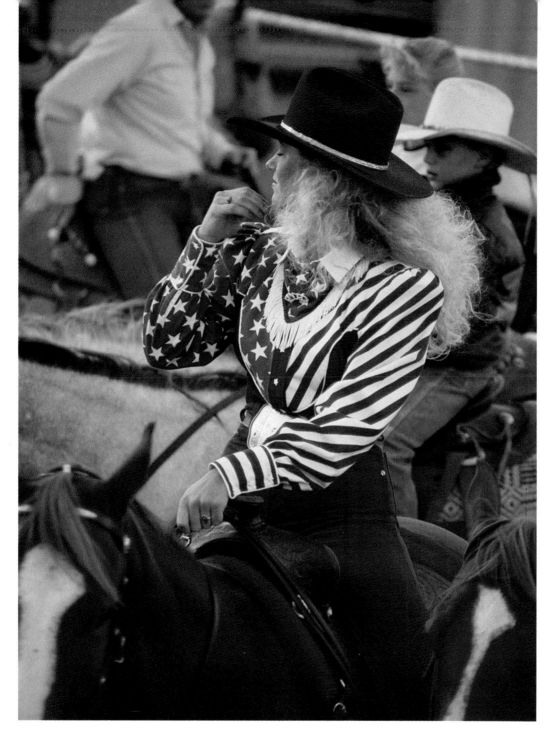

STARS AND STRIPES

Above: Caldwell Night Rodeo Queen Carrie Johnson makes a fashion statement.

Opposite right: Rodeo Queen Vixen Radford of Oregon's Chief Joseph Days Rodeo.

Cowgirls

Now in her early twenties, Andrea speaks fondly of her quest that culminated in the PRCA Miss Rodeo America competition.

"The bug got me," Andrea says with a laugh, referring to the moment rodeo Queen Val Eason reached out to clasp her hand years ago. There is nothing quite like the feeling of executing a successful rodeo "buzz," or presentation ride, she says.

"Your horse is running at full speed, and you can feel the wind pulling against your face. You tingle all over, and it's the same feeling every time. It's a natural high."

When Andrea Schlapia talks about her work as a rodeo queen, it's obvious she knows rodeo. This is her world, and she is very much at home in it.

She shows up for our meeting clad in a stylish long white duster, trimmed in Southwestern design motifs.

Her long dark hair is pulled back. A "roper" shirt, boots, jeans, and a silver Miss Rodeo Idaho buckle complete her casual Western outfit.

She looks every inch the consummate rodeo queen.

Belt buckles carry special significance to rodeo people, Andrea explains. "The buckles tell who they are and what they do."

She is refreshingly open and precise in her conversation—sometimes serious, sometimes reflective, sometimes animated. Her sense of humor frequently shines through. As we talk, it is apparent Andrea has a marked ability to focus on and commit herself to a goal.

This is a beautiful young woman who has been willing to work hard in pursuit of her dreams.

She looks directly at you when she speaks, and the radiant

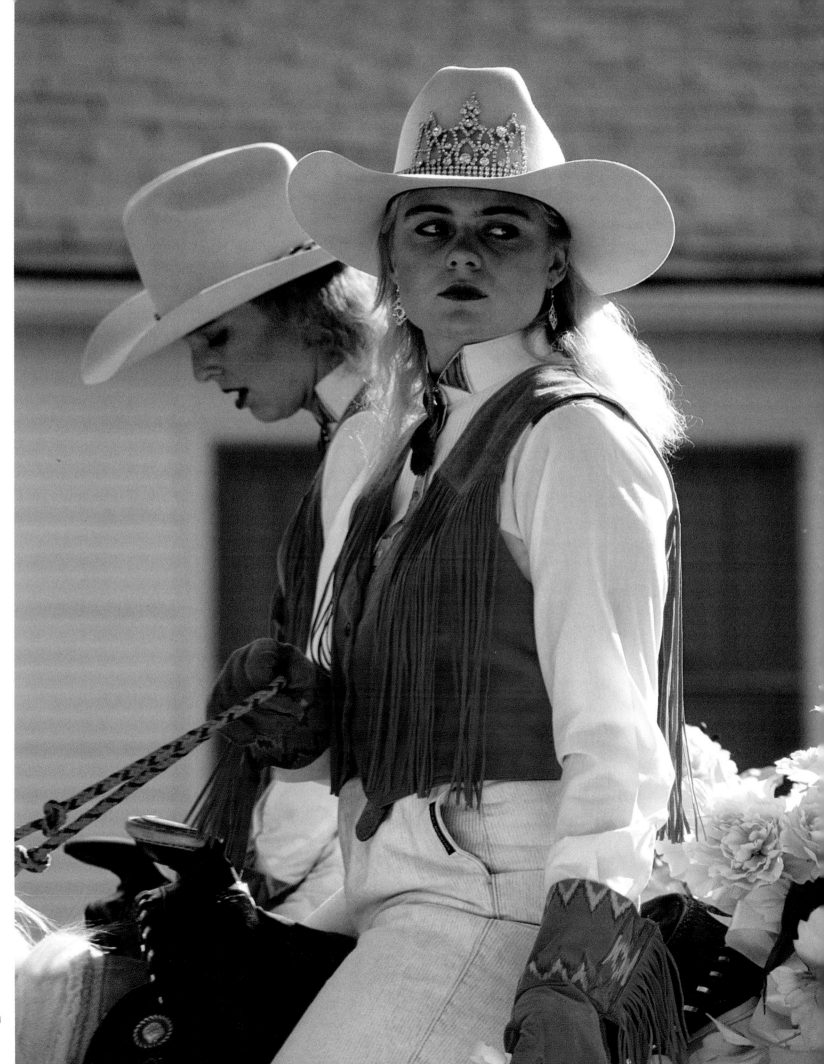

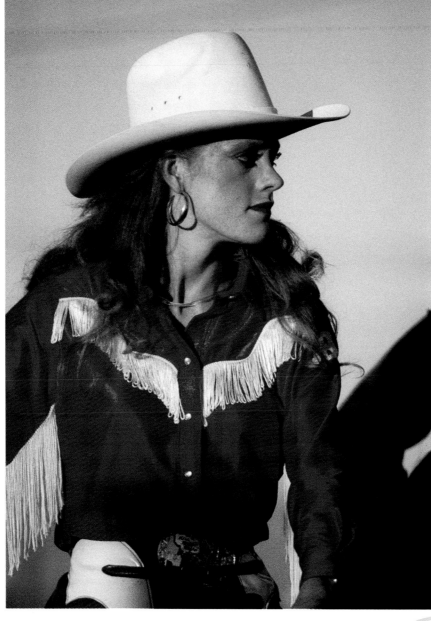

enthusiasm flashing in her dark eyes is infectious.

At one point, she slides her chair across the floor in an impromptu demonstration, diagraming the technique of "cow cutting" (the process by which a cow is isolated from the herd). In rodeo, this horsemanship event carries a 2.5-minute time limit and demands total coordination between horse and rider.

As a senior in high school, Andrea was the national junior women's cow-cutting champion. The previous year, bitten by the rodeo bug, Andrea became the Idaho high school state rodeo queen.

In her high school days, she also rode as a "hazer," or guide rider, in cowboy bulldogging competitions, but was forced to stop when rodeo judges ruled her participation too dangerous for a woman.

Regardless, Andrea thrives on challenges and is highly skilled in horsemanship.

"The only thing you fear is the unknown," the cowgirl says. In season, she has often worked three to four hours a day with her trainer while preparing for a rodeo.

Horses have been an integral part of Andrea's life since her years as a youngster participating in local 4-H Club events. She's shown them, groomed them, barrel-raced them, or ridden them in competition since she was eight.

"4-H was my life," the rodeo queen says simply. "I would never be without a horse."

Currently, she has two: her spirited competition quarter horse, Dr. Jay Linx, and an Arabian named Kizako.

"There's something about girls and horses," Andrea points out. "A horse has a personality and attitude. I know Dr. Jay knows when we're competing. . . . I would

A WINNING TRADITION

Idaho shares with Texas the honor of having more Miss Rodeo America title winners than any other state. Pictured here are two recent holders of the Miss Rodeo Idaho crown.

Above: Lisa Lemrik at the Caldwell Night Rodeo.

Left: Suzanne Tomtan, a first runner-up to the Miss Rodeo America title, at Nampa's Snake River Stampede.

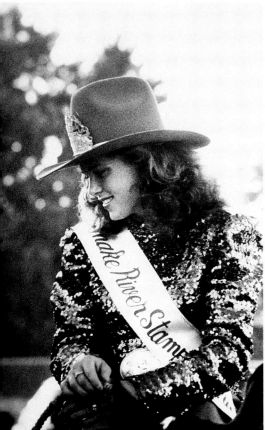

JONI JAMES

*A recent Miss Rodeo America who also hails from
Idaho, Joni carried on a family tradition in
winning the crown, as her mother had been named
Miss Rodeo America in the 1960s.*

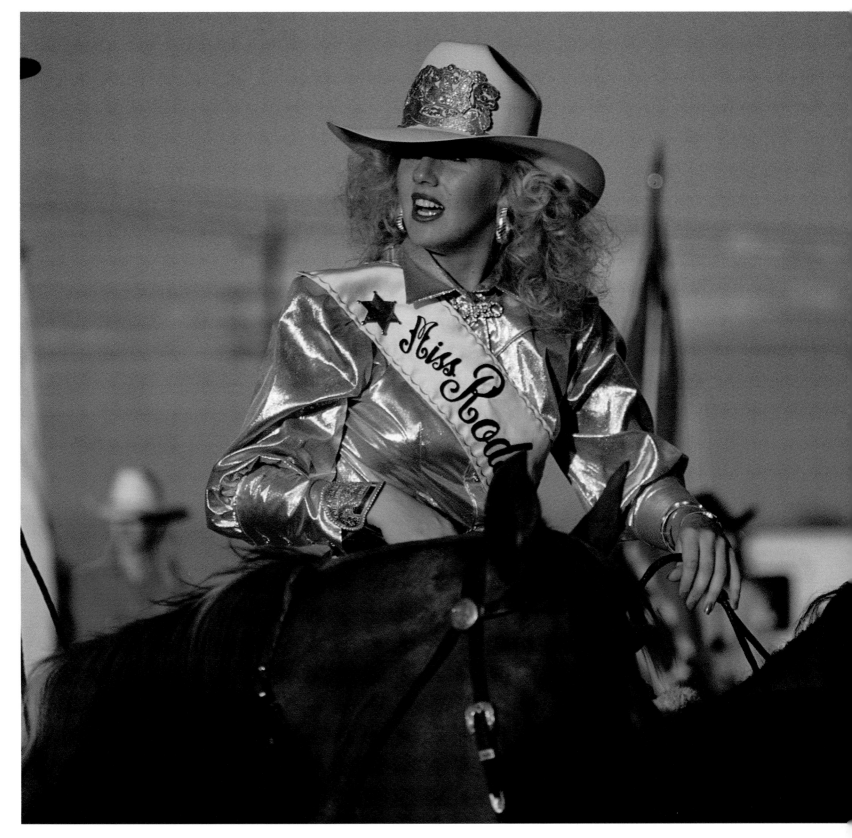

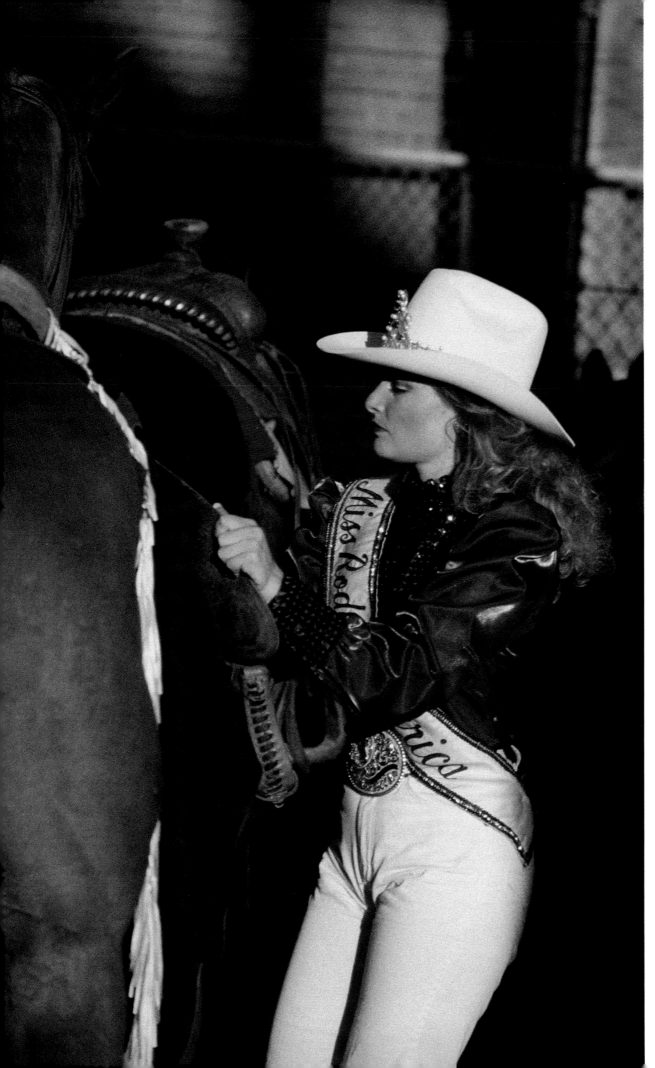

love to know what they say to each
other," she adds with a smile.

Andrea knows that a successful
working relationship between
horse and rider is built on mutual
trust.

"When you have the reins in
your hands," Andrea stresses,
"every emotion you feel, they feel
too—it just travels down the reins
into their mouths. If you're
nervous, they sense it."

On the surface, it's easy to
assume that the life of a rodeo
queen is all glamour and travel.
In reality, years of hard work,
dedication, disappointment, and
triumph accompanied Andrea on
her path to the national finals in
Las Vegas. It has been a demand-
ing quest, requiring personal
sacrifice, much preparation, family
support, and that special ability to
focus on a goal. Still, it is an
experience she treasures.

Regarding rodeo queen compe-
tition, Andrea says, "There is only
one title, but everybody is a winner.
You come away richer because of
the experience. I would never have
gone to the places I've been, or met
so many people."

Concerning her involvement
over the years, she says, "It has
opened so many doors and oppor-
tunities."

In the great Western states like
Idaho, rodeo and the Western
tradition are deeply entwined in
the culture. Countless unfulfilled
dreams have tumbled to the dirt in
the hundreds of rodeo events held
annually.

In many ways, successful
cowboys and cowgirls are regarded
in much the same fashion as young
people from large urban areas
respect baseball and football stars.
The rodeo queen is a high-profile
symbol of the rich heritage and
pageantry of the West.

The Miss Rodeo America

MEMENTO
*Hailey, Idaho, Days of the
Old West Rodeo Queen
Courtney Crowe signs an
autograph for a
young admirer.*

competition is judged in four areas—poise and personality, appearance, horsemanship, and speech. Finalists from all fifty states compete in this week-long event that precedes the National Finals Rodeo. The girls are quizzed on rodeo terminology, personal outlook, current affairs, and world events.

Their horsemanship ability is tested on their own mounts as well as on horses they've never ridden before.

All this is carried on under the considerable pressure of major media coverage and the discerning eyes of pageant judges. For Andrea, the event was the experience of a lifetime, and, she says, she "wouldn't trade it for anything."

"If you pursue your goal and strive to do your best, then people are going to remember you for that," she says.

Growing up in Nampa, Idaho, Andrea's family faced early hardship when her father was killed by a teenage drunken driver. She was only six at the time of the accident.

Looking back on why she began participating in 4-H and rodeo events, the cowgirl says, "I needed to fill up the space . . . of something that wasn't there."

Along the way, Andrea—the youngest of three daughters—and her mother, Carol, developed a special bond. Carol was a local 4-H leader, and she encouraged young Andrea to become involved.

"4-H became our time together," Andrea recalls. Carol's support continued through years of youth rodeo and queen competitions. "The best role model ever," she says of her mother. "She's so willing to give her time and energy. . . . I could never have done it without her . . . no possible way. . . . She's my mom, she's my best friend."

The past few years have been busy ones for Andrea. Not only did she fulfill a dream by becoming Miss Rodeo Idaho and then come within a whisker of being named Miss Rodeo America, she is set to graduate from college with a degree in public relations. She's also found time to substitute teach, model, and work as a radio station sales representative.

Andrea walks across the parking lot to her car; our interview is over.

Her stylish long white duster blows in the night air behind her. Still the rodeo queen.

Rodeo queens are by no means the only cowgirls riding across the Contemporary Western landscape. On the PRCA circuit, highly skilled barrel racers compete for major prize money. Barrel racing involves navigating one's horse at breathtaking speed through a cloverleaf pattern of three barrels. The fastest time wins, and women's barrel racing is always an audience favorite.

The current PRCA barrel-racing champion is Charmayne Rodman—the "Million-Dollar Cowgirl." Still in her twenties, she is already regarded as a legend in the sport. Charmayne often surpasses the top all-round cowboys in annual PRCA total earnings, solely on the merits of her outstanding barrel racing.

Though not as heralded as the PRCA, there also exists a Women's Pro Rodeo Association, in which women compete in a variety of events.

Also to be noted are the numerous skilled women who work on farms and ranches throughout the Contemporary West.

Age doesn't appear to be a barrier either. Often, riding clubs

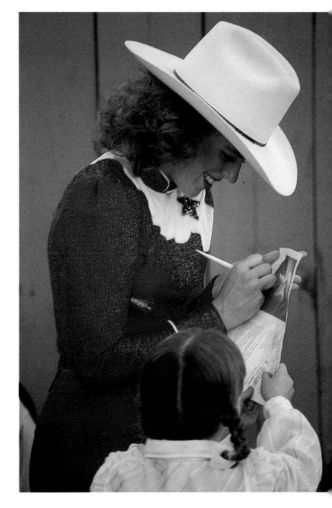

of smartly costumed women entertain at pre-rodeo ceremonies across the West, demonstrating considerable sophistication and pageantry in their formations.

It is not uncommon to see a wide spectrum of years among the members.

Julia Kooken captured the spirit when she wrote, "I want to live to be an outrageous old woman who is never accused of being an old lady."[7]

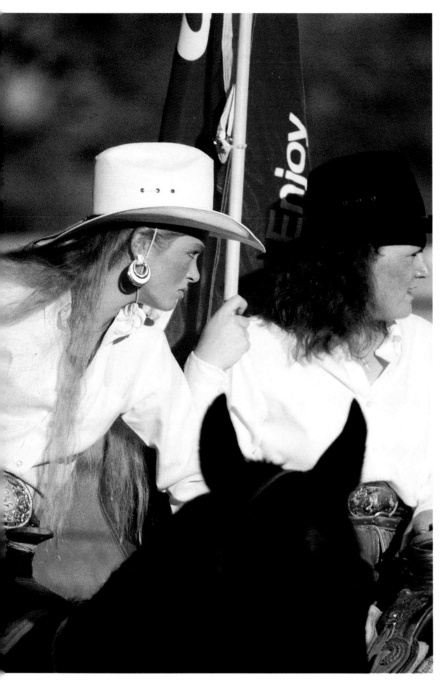

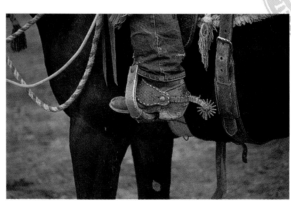

EXPECTATIONS
Nampa, Idaho.

Left: Flagbearers Audrey Eddy and B. J. Morrison, at the Snake River Stampede, reflect the anticipation of the rodeo's opening ceremonies.

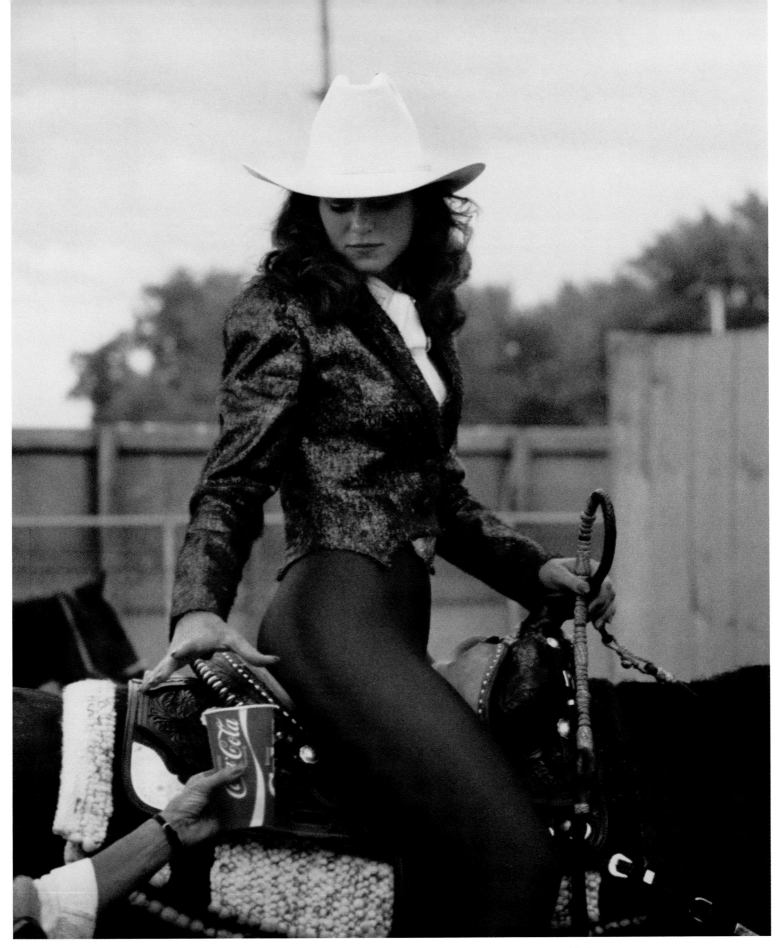

RODEO QUEEN, SNAKE RIVER STAMPEDE, NAMPA, IDAHO

Suzanne Tomtan, a former Miss Rodeo Idaho from Eagle, Idaho, and first runner-up to the Miss Rodeo America title.

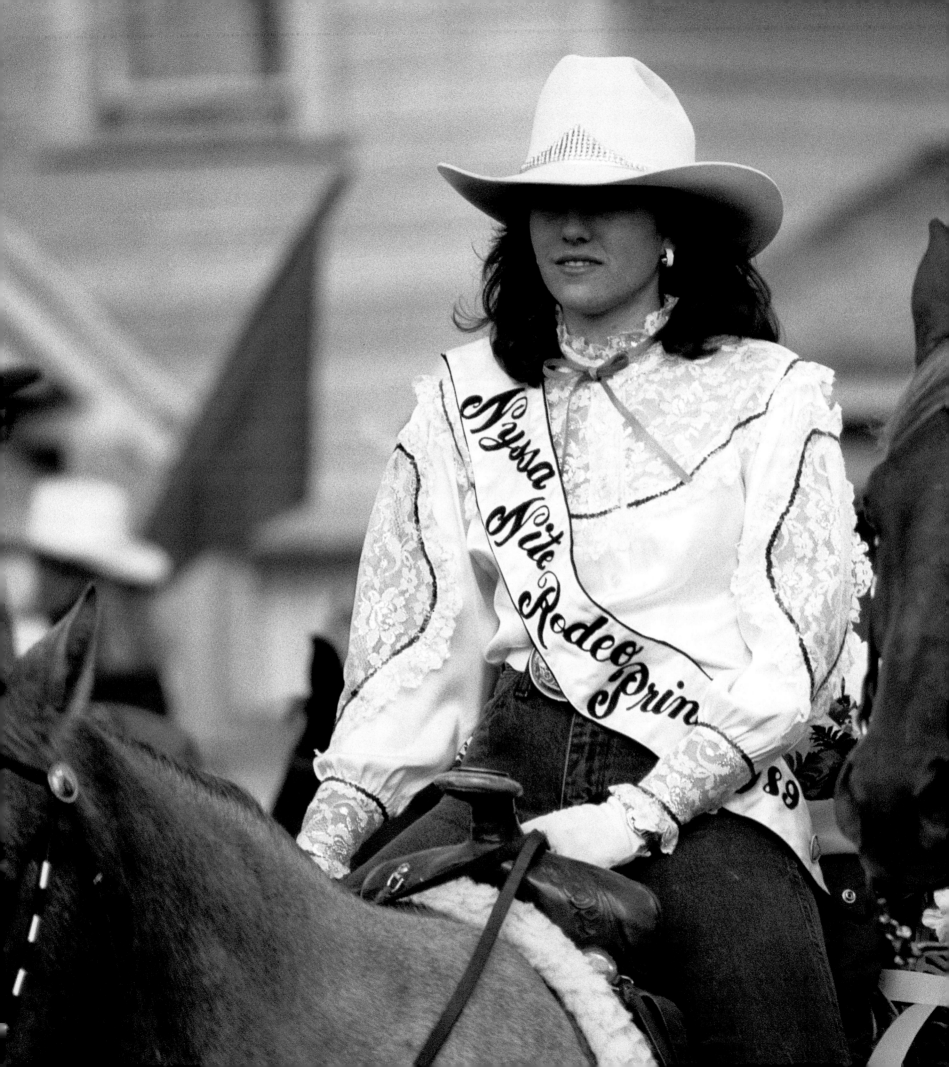

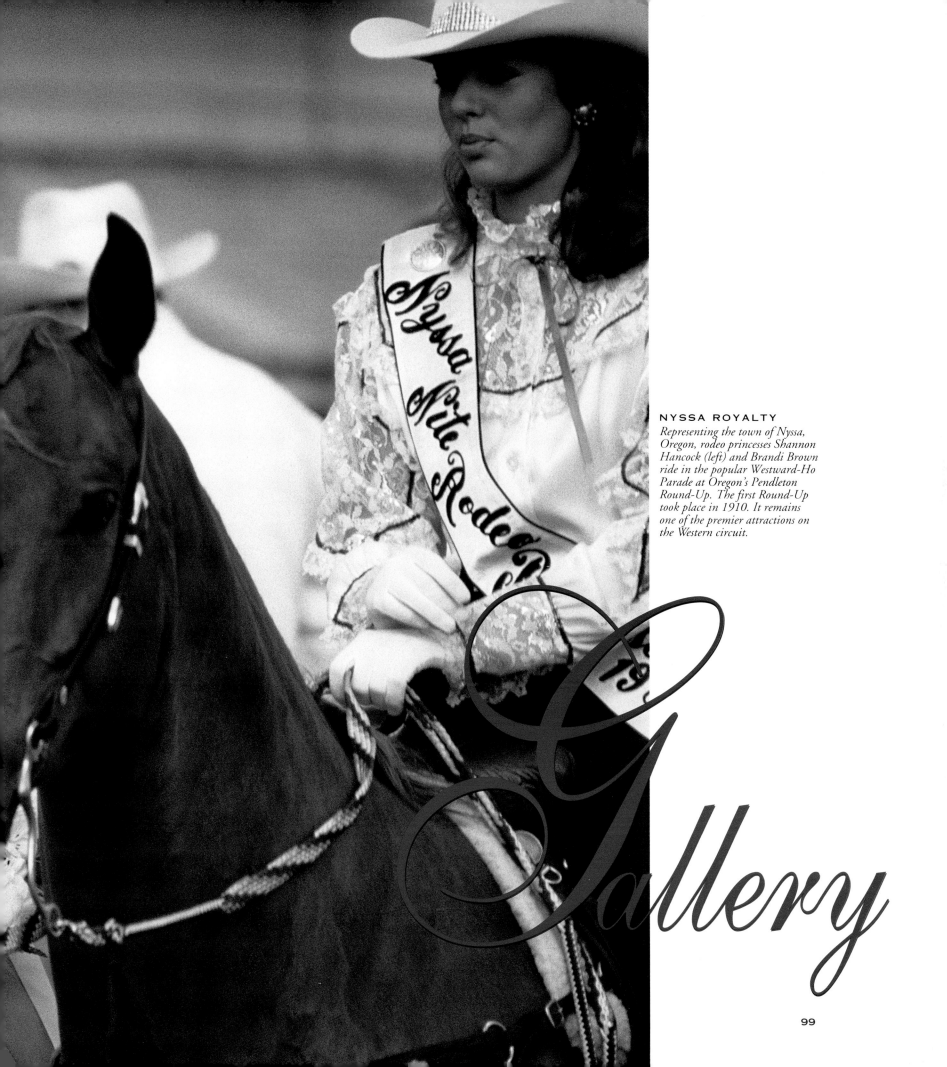

NYSSA ROYALTY
Representing the town of Nyssa, Oregon, rodeo princesses Shannon Hancock (left) and Brandi Brown ride in the popular Westward-Ho Parade at Oregon's Pendleton Round-Up. The first Round-Up took place in 1910. It remains one of the premier attractions on the Western circuit.

Gallery

"The old Lakota was wise. He knew that man's heart away from nature becomes hard; he knew that lack of respect for growing, living things soon led to lack of respect for humans too. So he kept his youth close to its softening influences." [8]
—Chief Luther Standing Bear

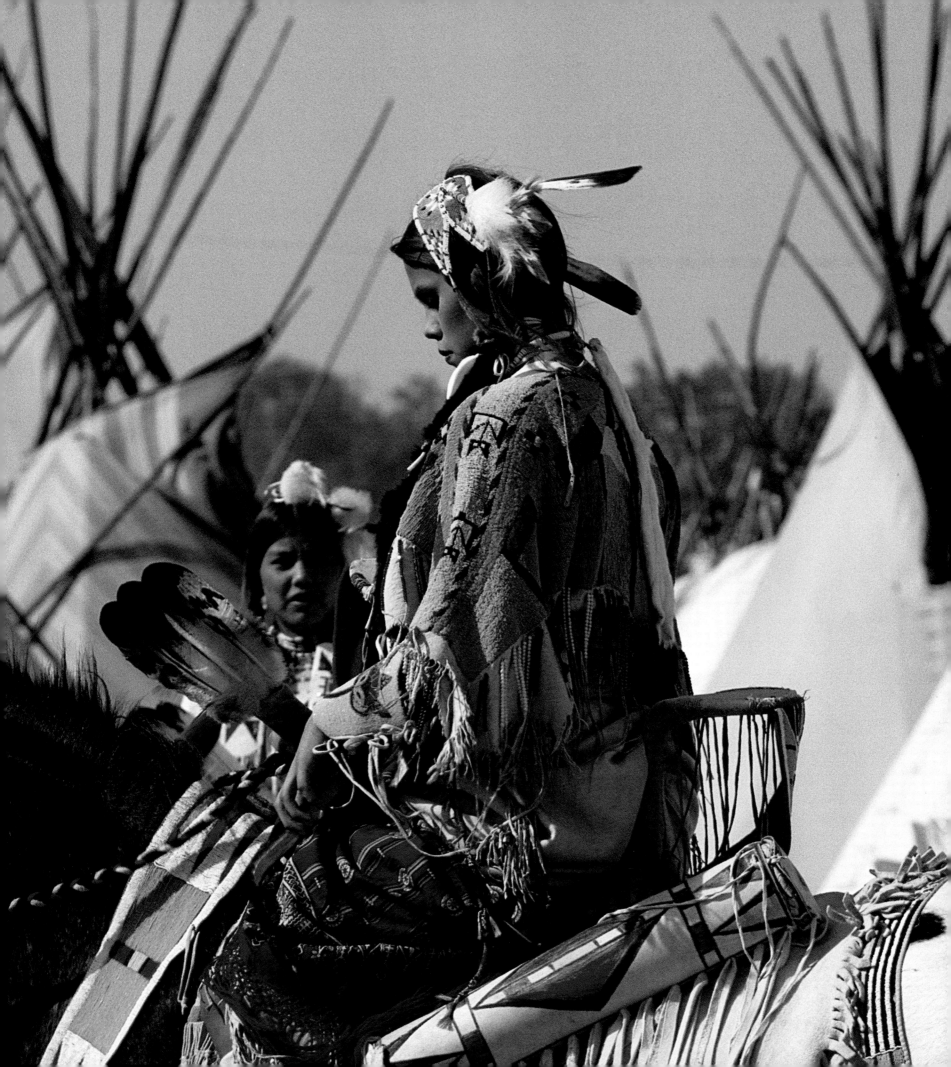

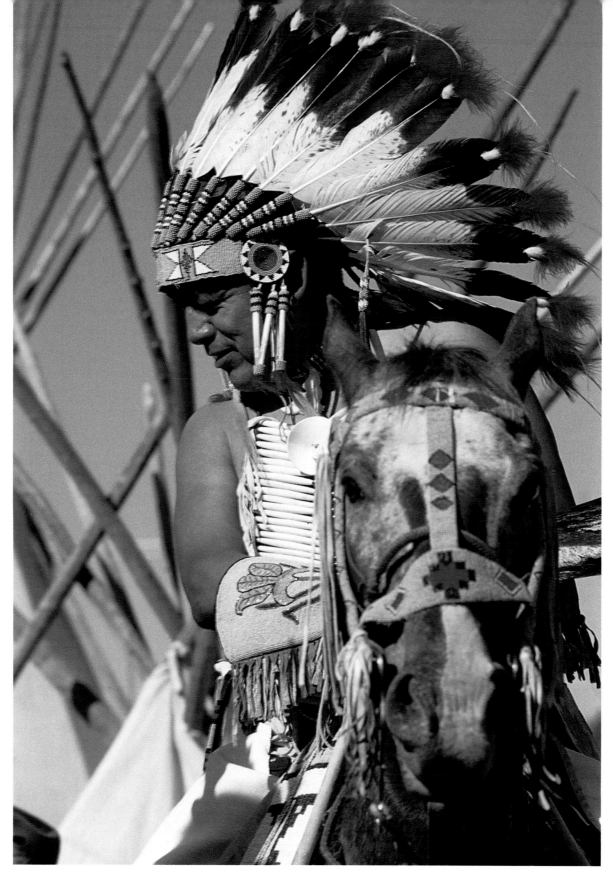

DETAILS
*Above and right: Feathers, leather fringes,
and beadwork adorn horse and rider alike
at Oregon's Pendleton Round-Up.*

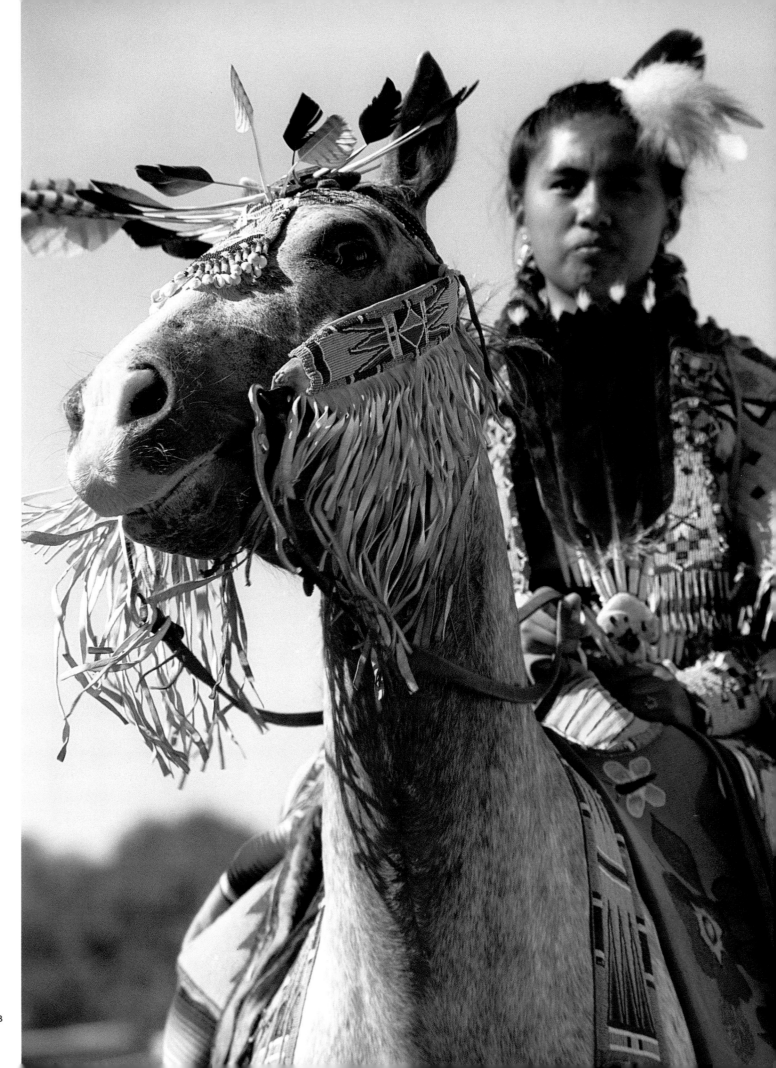

"... I am tired of fighting. ... It is cold and we have no blankets. The little children are freezing to death. My people, some of them, have run away to the hills and have no blankets, no food; no one knows where they are—perhaps freezing to death. I want to have time to look for my children and see how many I can find. Maybe I shall find them among the dead. Hear me, my chiefs. I am tired; my heart is sick and sad. From where the sun now stands, I will fight no more forever." [9]

—Nez Perce Chief Joseph, surrender speech, 1877

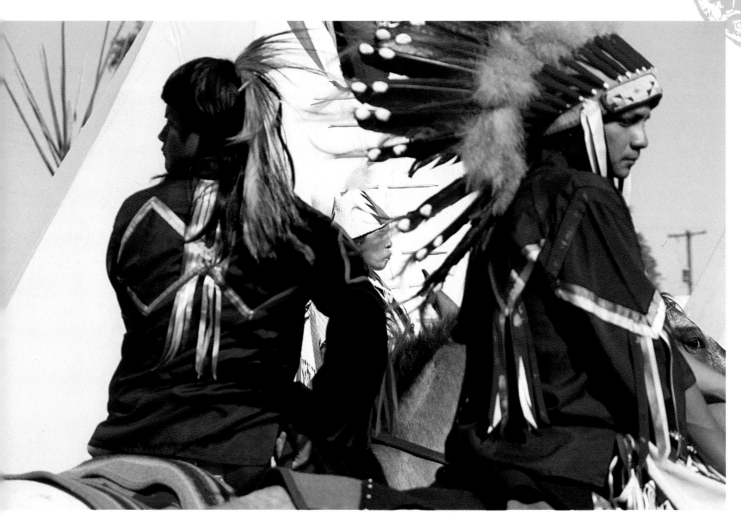

TRADITION

Above: Young horsemen pass at Oregon's Pendleton Round-Up.

Right: Dignity in the saddle: Fermore Craig reflects his proud American Indian heritage.

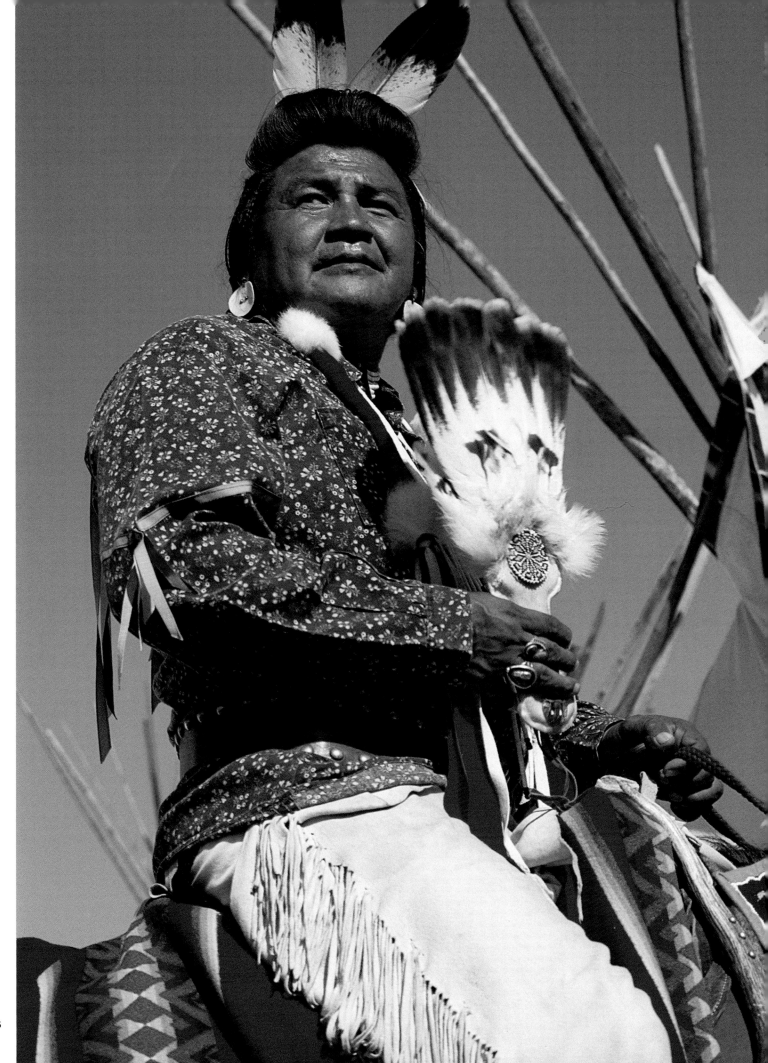

"We did not think of the great open plains, the beautiful rolling hills, and winding streams with tangled growth as 'wild.' Only to the white man was nature a 'wilderness' and only to him was the land 'infested' with 'wild' animals and 'savage' people."[10]

—Chief Luther Standing Bear, Oglala Sioux

Below: American Indian Village, Pendleton Round-Up.

Opposite right: Young dancer at a centennial celebration of Idaho tribes, Boise, Idaho.

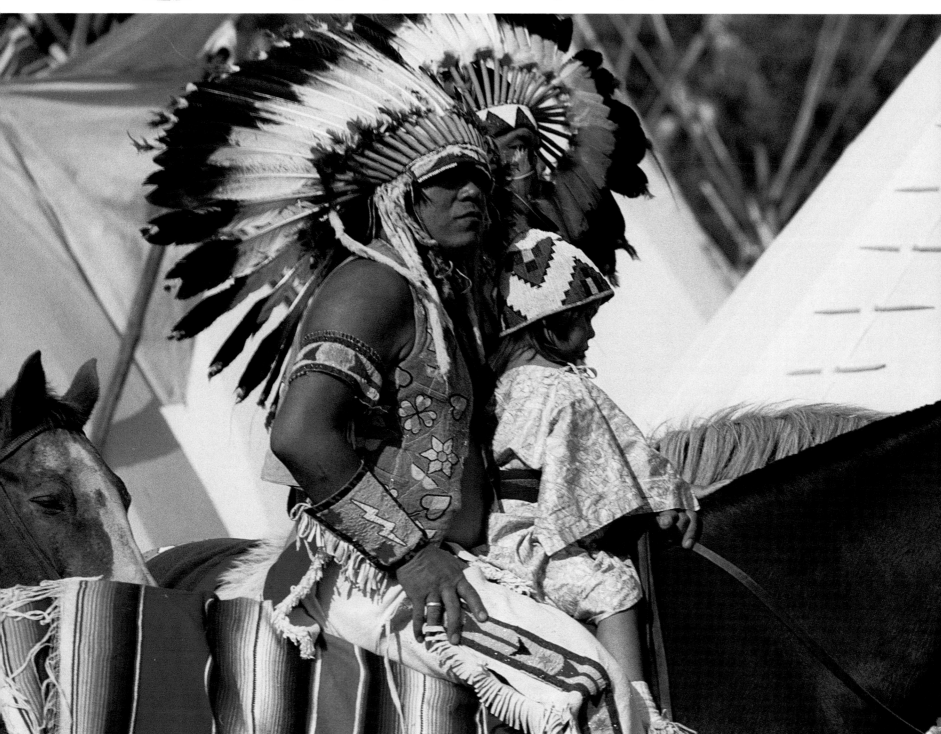

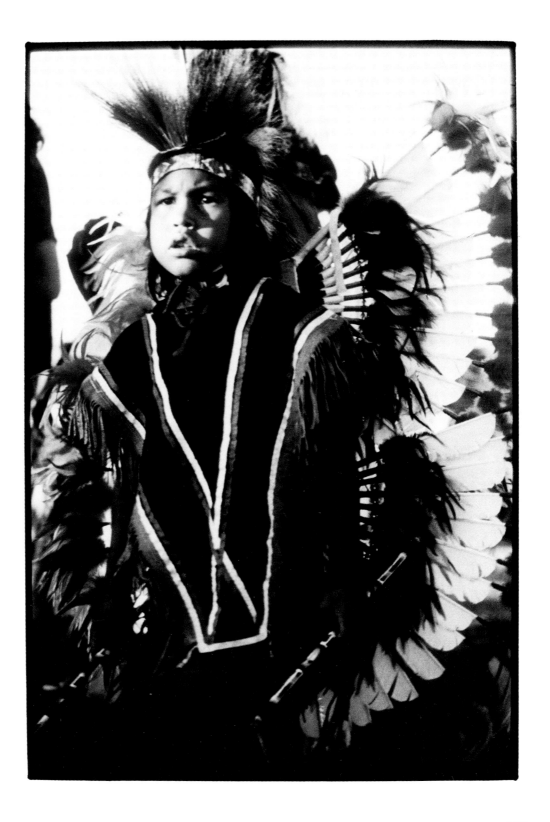

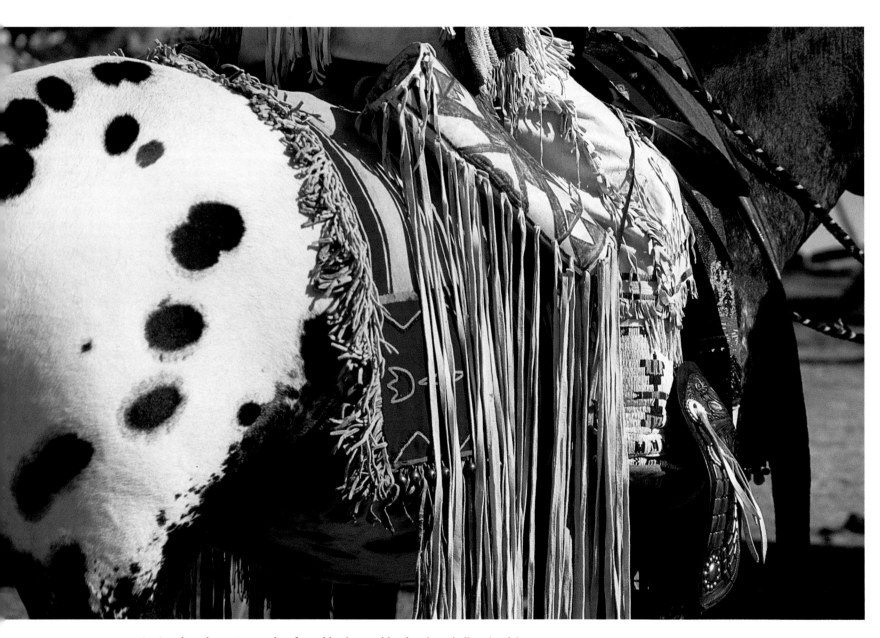

An Appaloosa horse, immaculate fringed leather, and beadwork are hallmarks of the Northwest Indians.

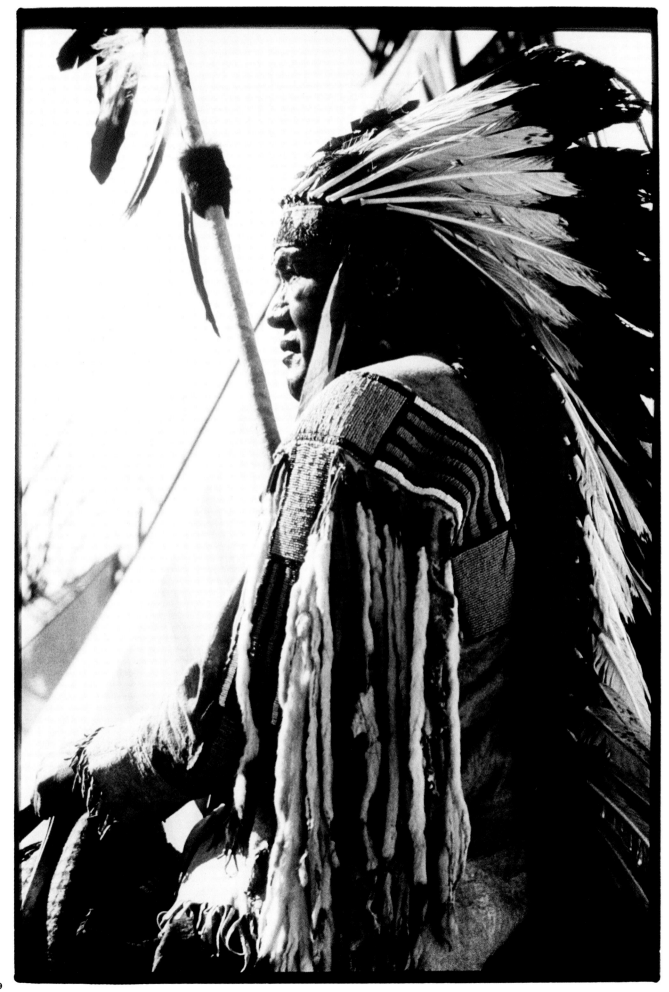

JOHNNY CASH

Outdoor concert, Boise, Idaho.

Music has always been an integral part of the West. Whether it is country music legend Johnny Cash, performing at the Idaho State Fair in Ada County, or the local tunes of Weiser, Idaho's Old-Time Fiddlers, country music reflects the struggles and triumphs of everyday people.

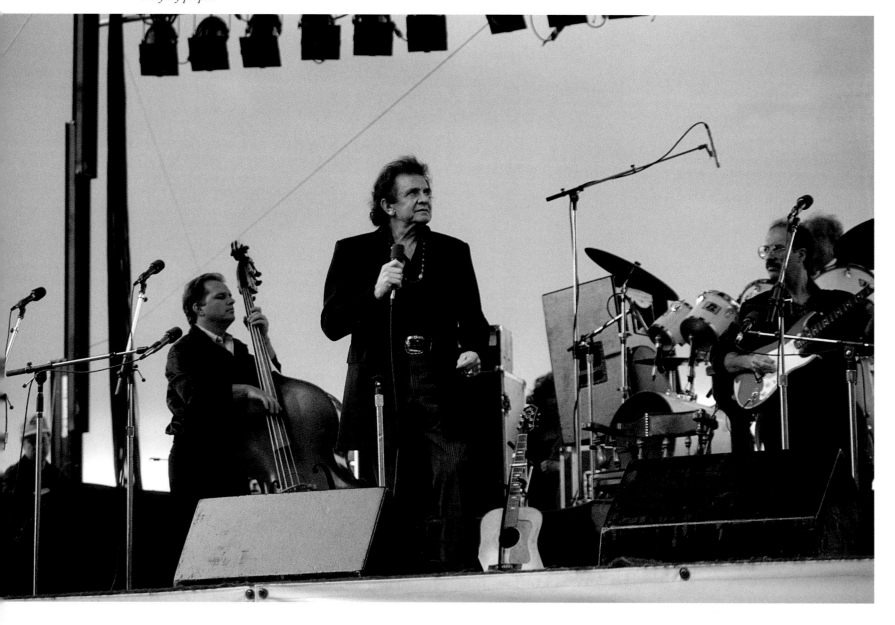

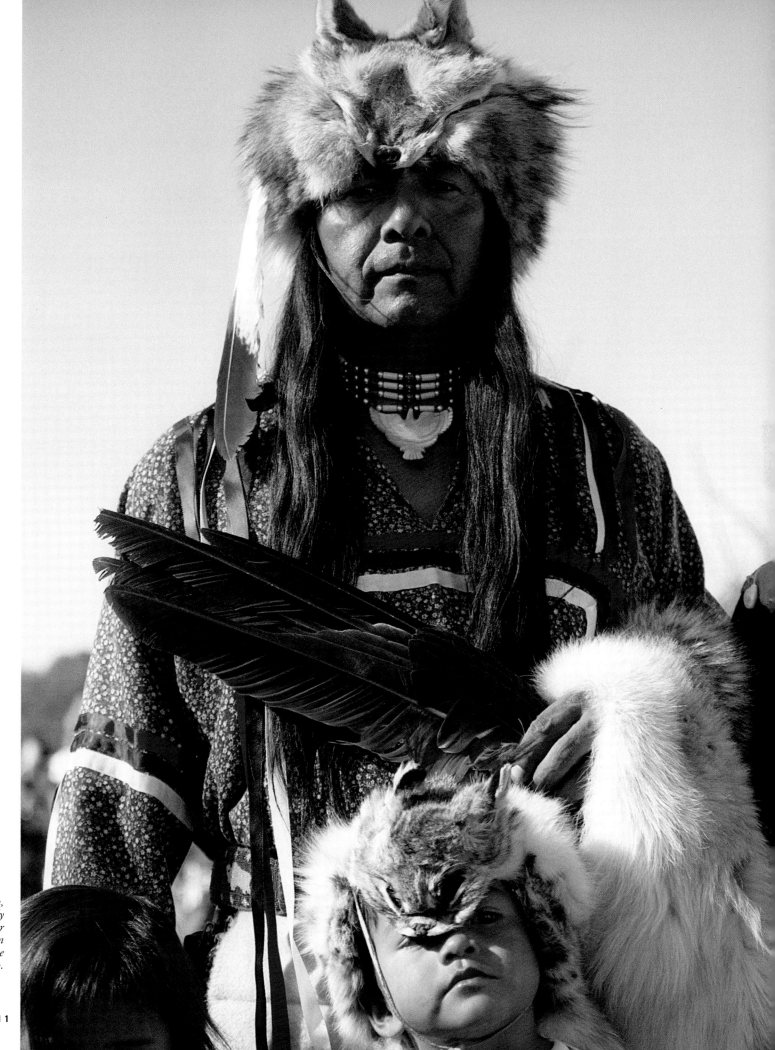

Holding an eagle-feather fan, Marvin Martinez proudly stands with his children after a display of American Indian pageantry during the Pendleton Round-Up.

111

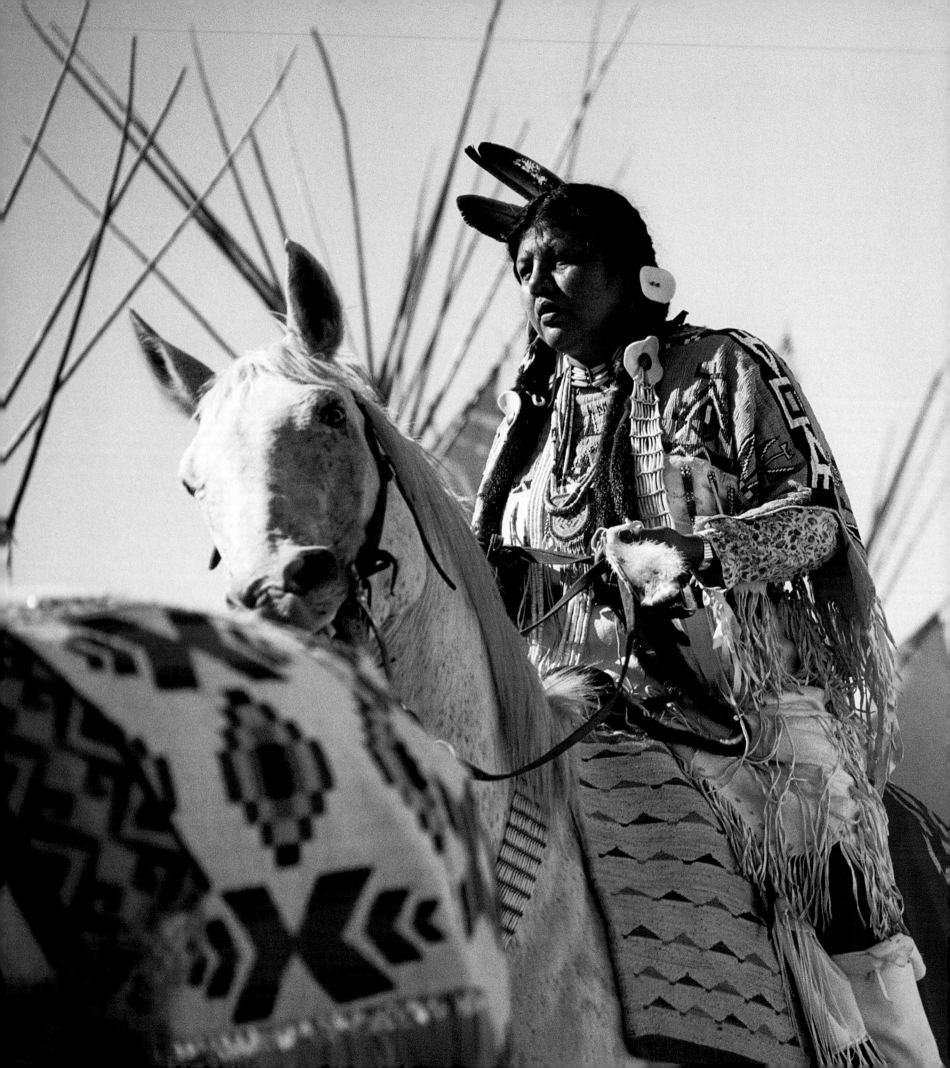

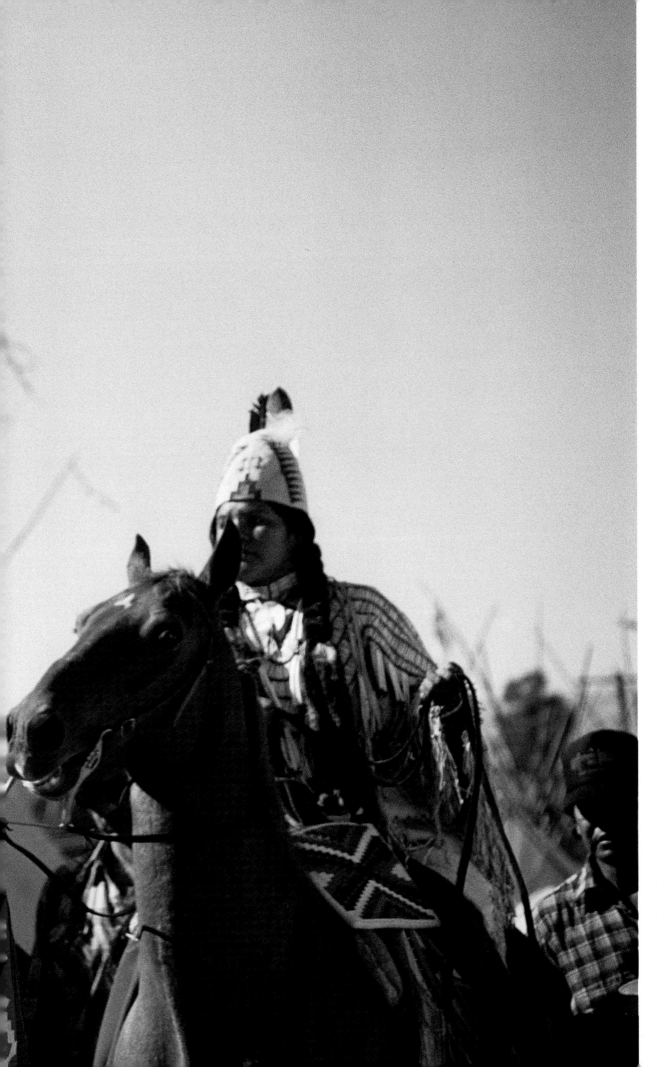

HERITAGE

Against a backdrop of tepees, women clad in brightly colored traditional dress ride into the American Indian Village during the Pendleton Round-Up.

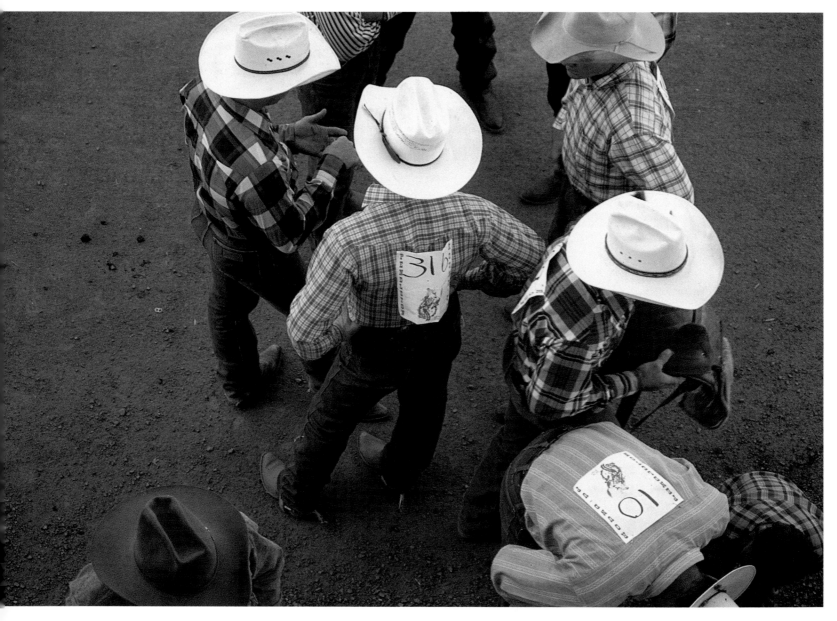

PERSPECTIVES

Above: Cowboys socialize behind the scenes at Oregon's annual Pendleton Round-Up.

Opposite right: A colorful dancer at a Boise, Idaho, centennial gathering of tribes.

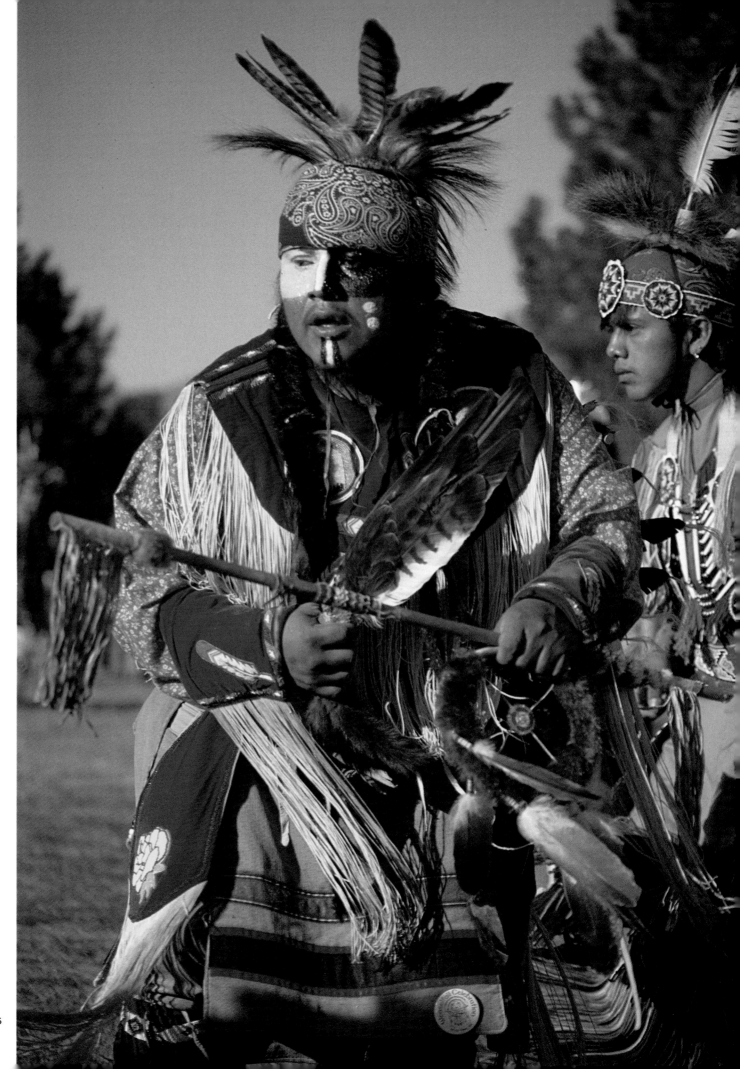

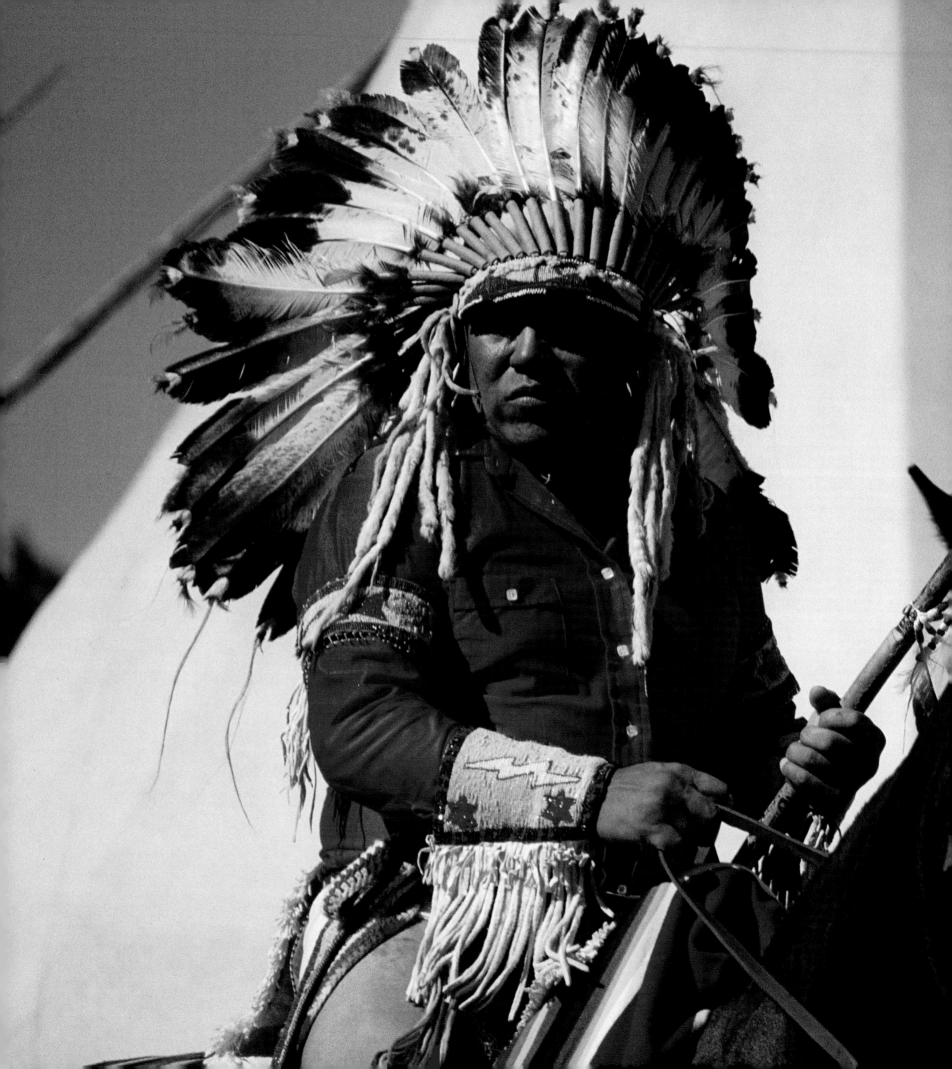

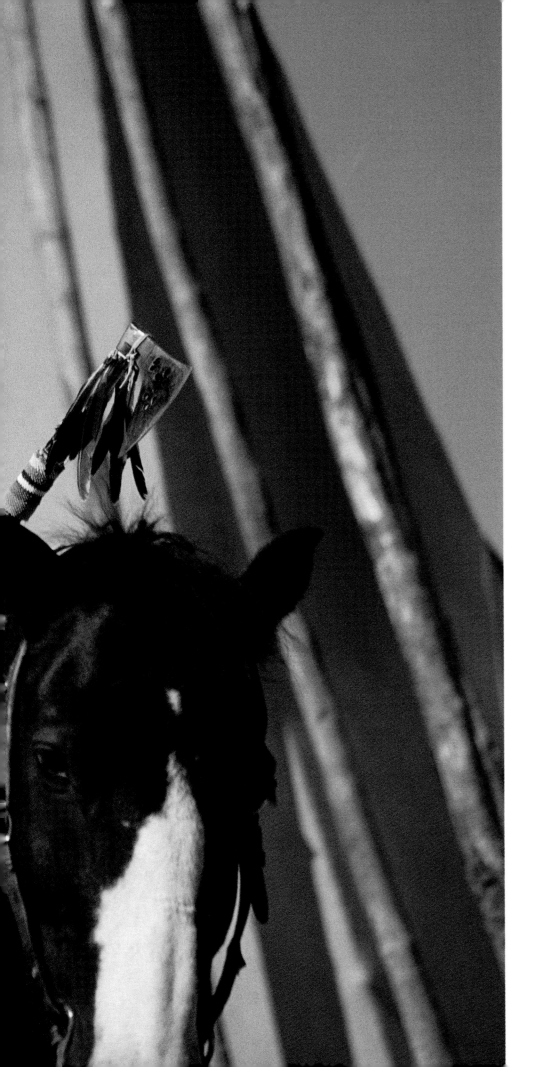

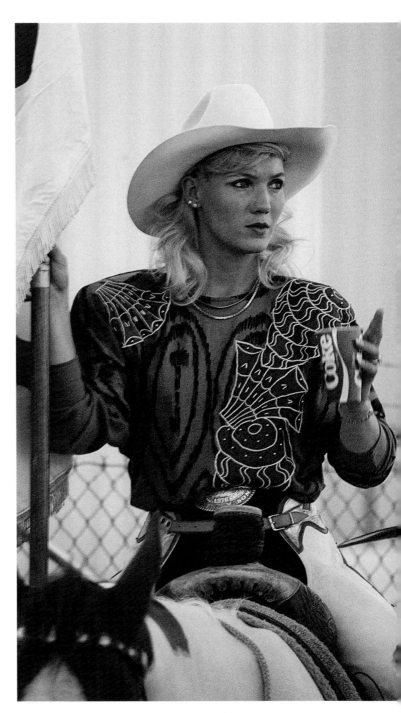

WARBONNET

Left: A red-shirted rider cuts an imposing figure during Round-Up week in Pendleton, Oregon.

Above: Shayne Mason at Idaho's Caldwell Night Rodeo.

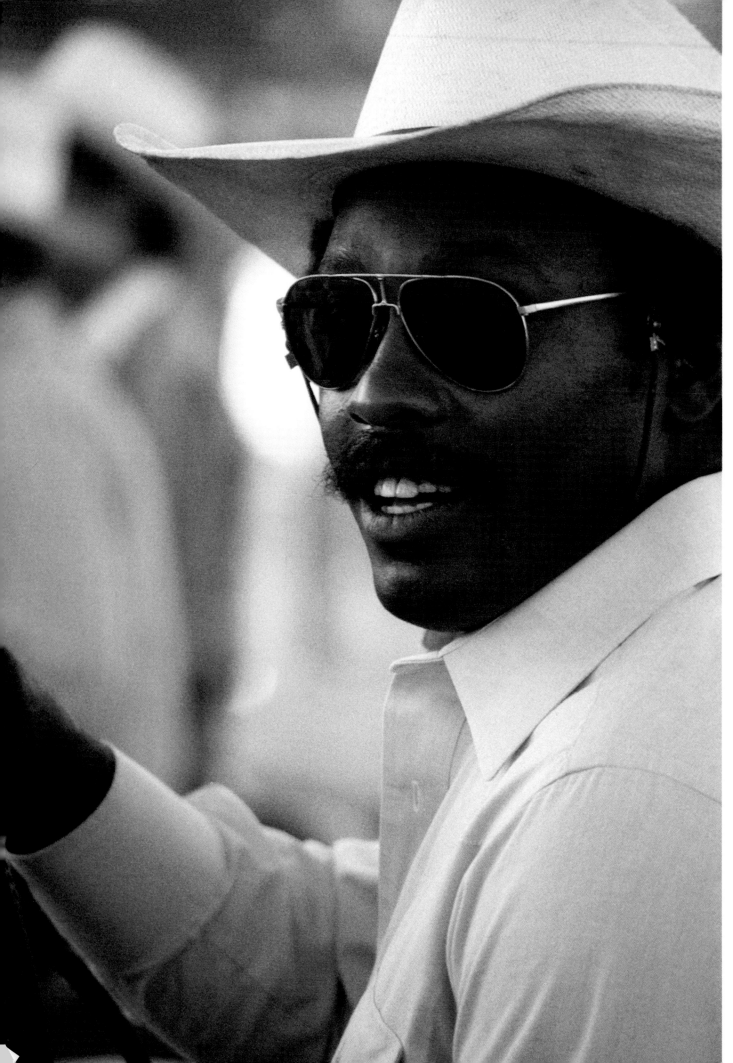

LEON COFFEE

The amiable rodeo star at Nampa, Idaho's annual Snake River Stampede.

118

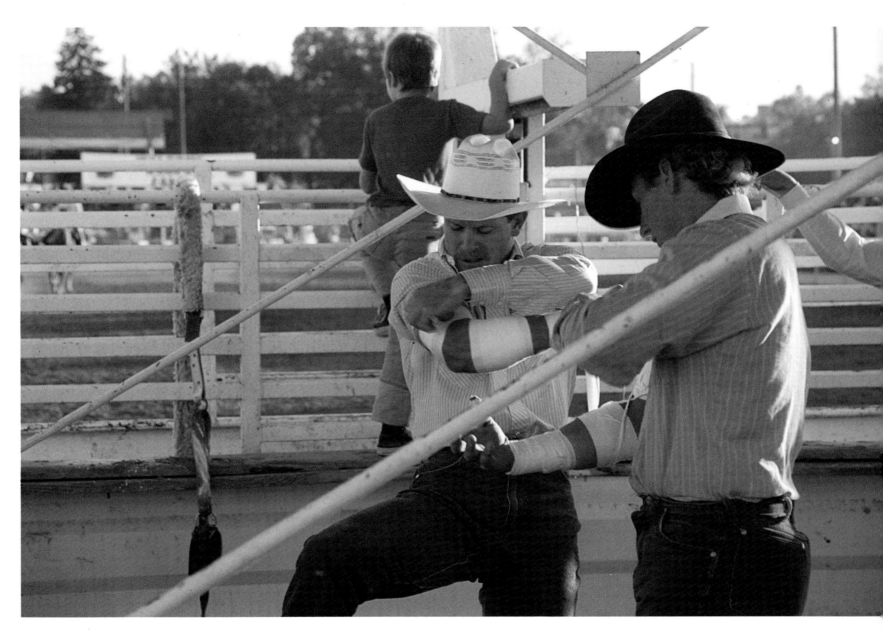

GUARDIAN ANGEL

Rodeo riders, like those above, taping up before Idaho's Caldwell Night Rodeo, are greatly in debt to the skill and protection of men like famed rodeo clown/bullfighter Leon Coffee (opposite left).

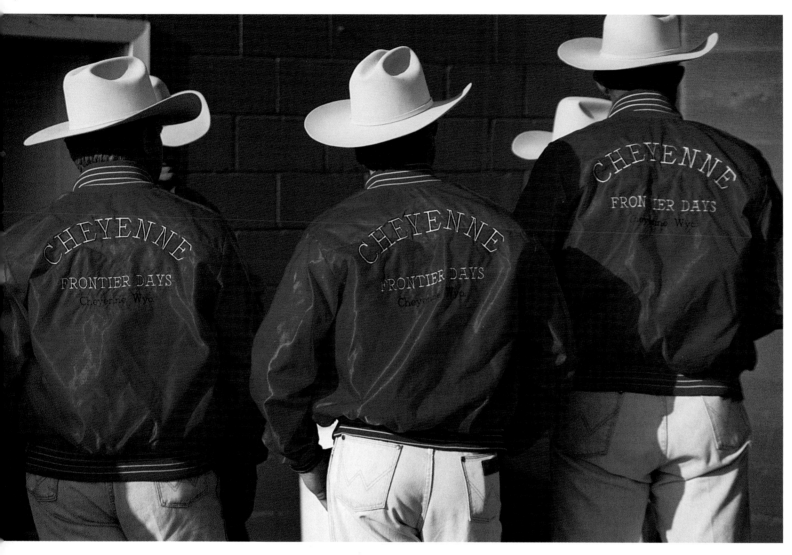

VISITING NEIGHBORS

Above: Rodeo directors from one of the West's biggest rodeos—Cheyenne, Wyoming's Frontier Days—display their colors during the Pendleton Round-Up.

Opposite right: A rodeo queen has time on her hands during the long wait as the spectacular Pendleton Round-Up parade positions hundreds of participants.

SOFT MOMENTS

Above: A tender scene in a tough place (Pendleton Round-Up, Oregon).

Opposite right: Pensive barrel racer DeAnna Dever anxiously awaits her final placing during a women's barrel-racing competition in Homedale, Idaho.

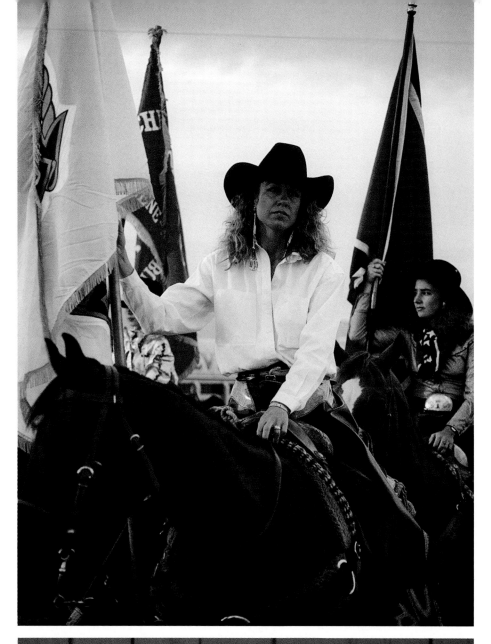

ADDITIONAL SOURCES

1. Cited in Dee Brown, *Bury My Heart at Wounded Knee* (New York: Holt, Rinehart, and Winston, 1970), 316. Also see T. C. McLuhan (comp.), *Touch the Earth, A Self Portrait of Indian Existence* (New York; Simon and Schuster, Inc. [Touchstone Books], 1971).

2. Evan S. Connell, *Son of the Morning Star* (San Francisco: North Point Press, 1984), 72.

3. Merrill D. Beal, *"I Will Fight No More Forever"—Chief Joseph and the Nez Perce War* (New York: Random House [Ballantine Books], 1989), 11, 12.

4. Thomas B. Allen (ed.), et. al., *The World of the American Indian* (Washington, D. C.: The National Geographic Society, 1989), 346.

5. For details of the Nez Perce War, see Merrill D. Beal, *"I Will Fight No More Forever"—Chief Joseph and the Nez Perce War* (New York: Random House [Ballantine Books], 1989).

6. U. S. Secretary of War Report, 1877, 630. Also see McLuhan, 120, and L. V. McWhorter, *Hear Me, My Chiefs* (Caldwell, Idaho: The Caxton Printers, 1952), 498.

7. Theresa Jordan, *Cowgirls, Women of the American West* (New York: Doubleday and Company [Anchor Books], 1982), 281.

8. Chief Luther Standing Bear, *Land of the Spotted Eagle* (Boston and New York: Houghton-Mifflin, 1933), 192-197.

9. Ibid., note 5, 6 above.

10. Standing Bear, xix.

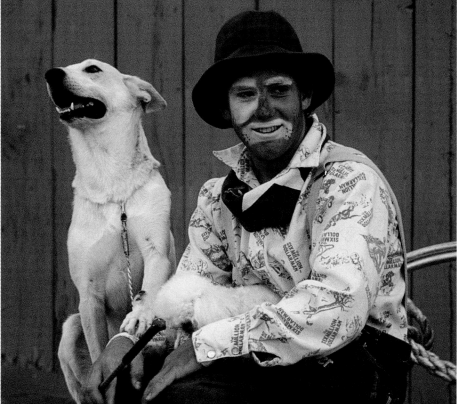

Above: Surrounded by flags, opening-ceremony riders wait in the wings at Idaho's Caldwell Night Rodeo.

NO JOKE

Left: A rodeo clown and his partners wait to perform at the Snake River Stampede in Nampa, Idaho.

Opposite right: Rodeo clowns, despite their comic appearance, are skilled athletes who protect the cowboys during rough stock events. Here, a pair take a break and view the action at the Pendleton Round-Up.

124

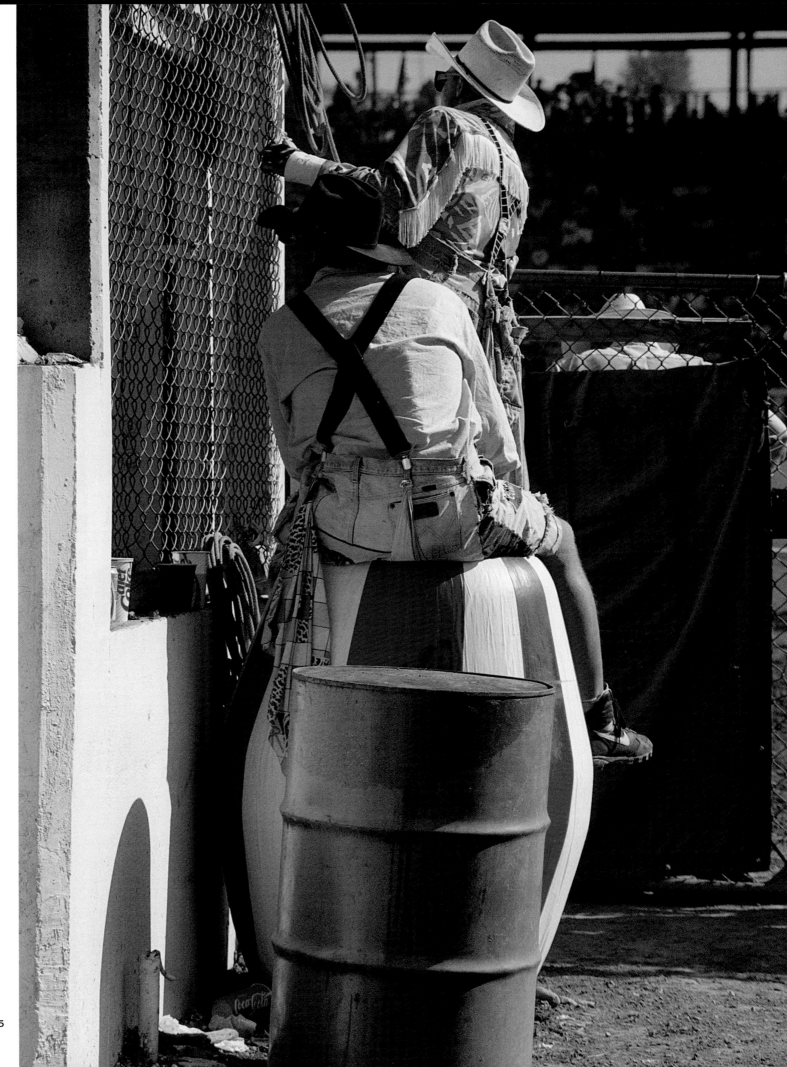

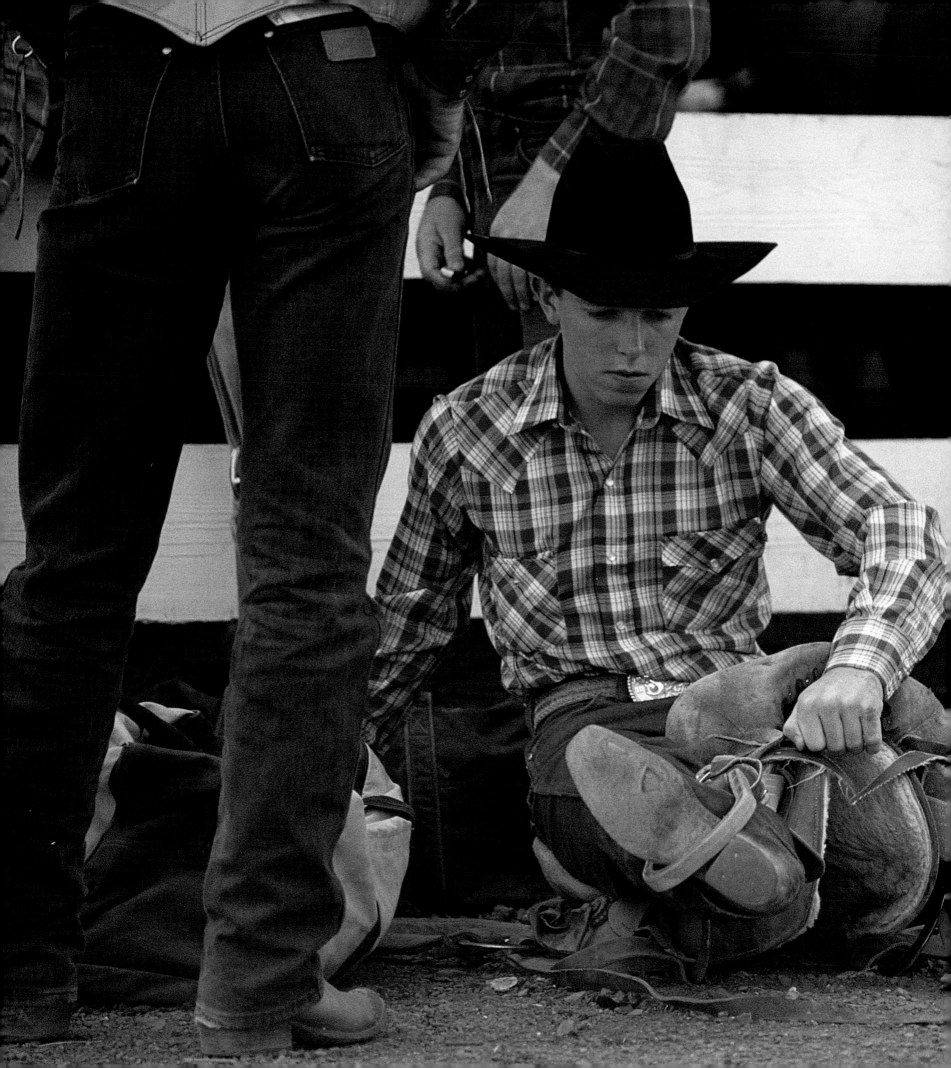

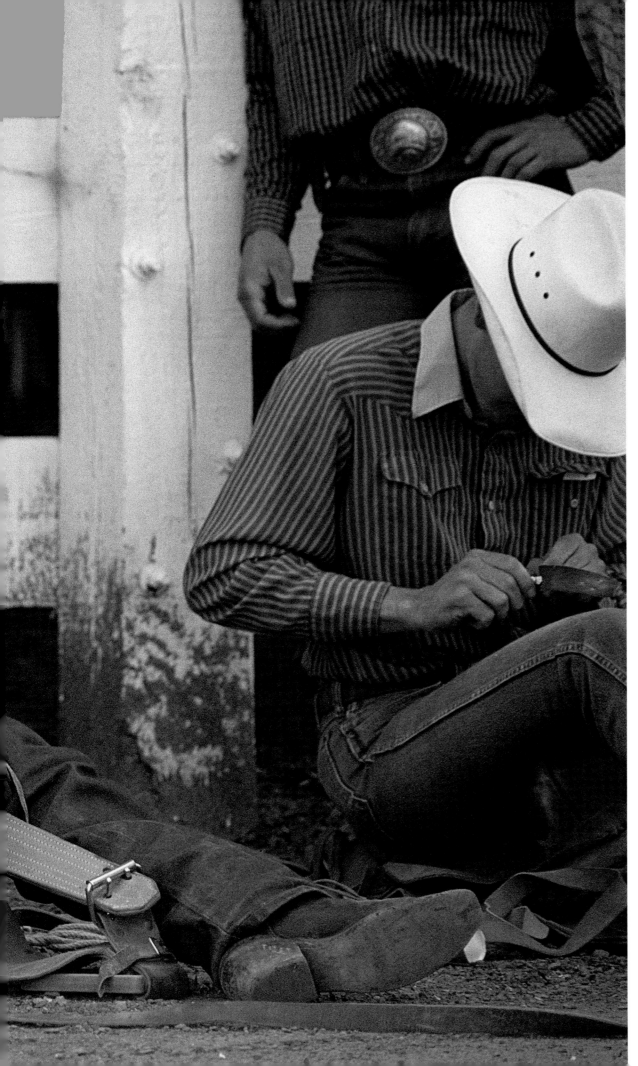

PREPARATION

Dancing with danger, a young bronc rider checks his gear in the warm-up area at Oregon's Pendleton Round-Up.

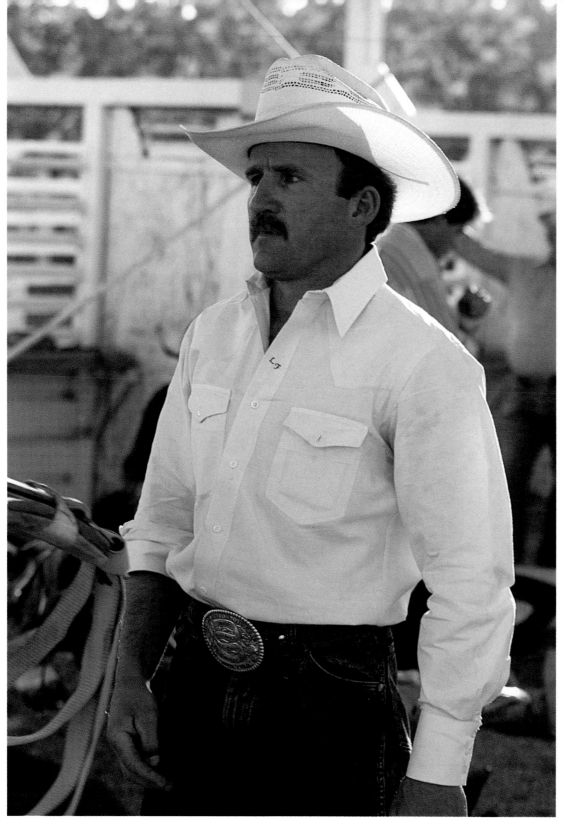

ALL-ROUND COWBOY

Above: Famed Pro Rodeo Cowboys Association champion Lewis Feild, one of rodeo's premier riders, pauses behind the chutes at the Caldwell Night Rodeo.

Opposite right: Feild's young son, his father's features evident, is on hand to support Dad.

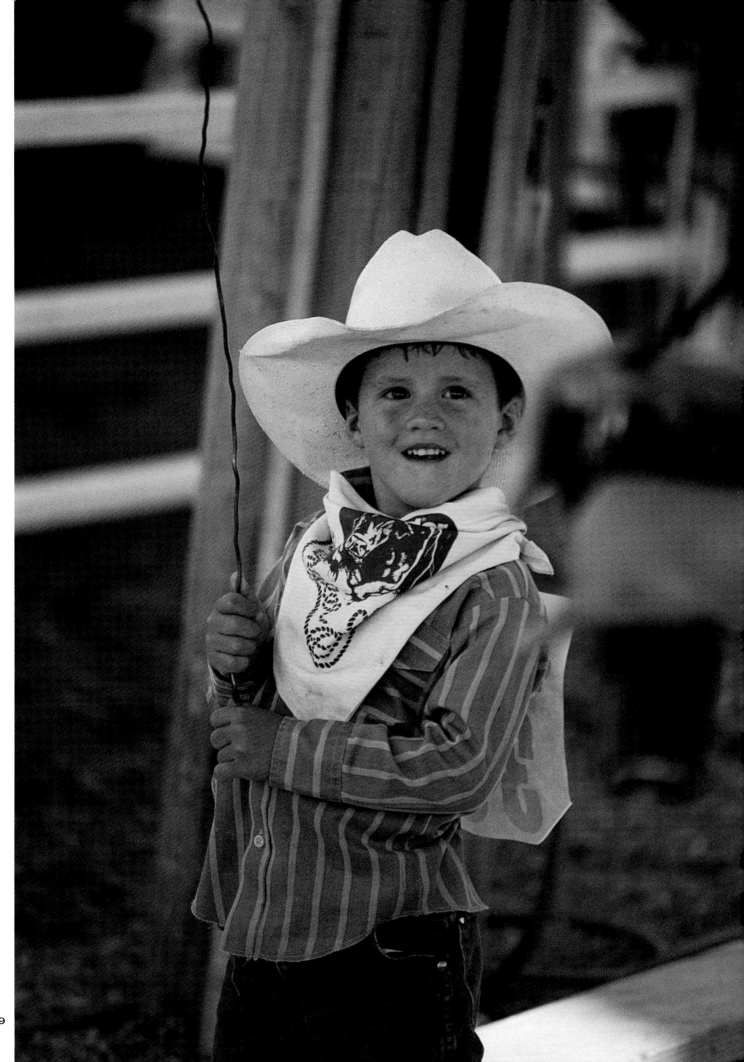

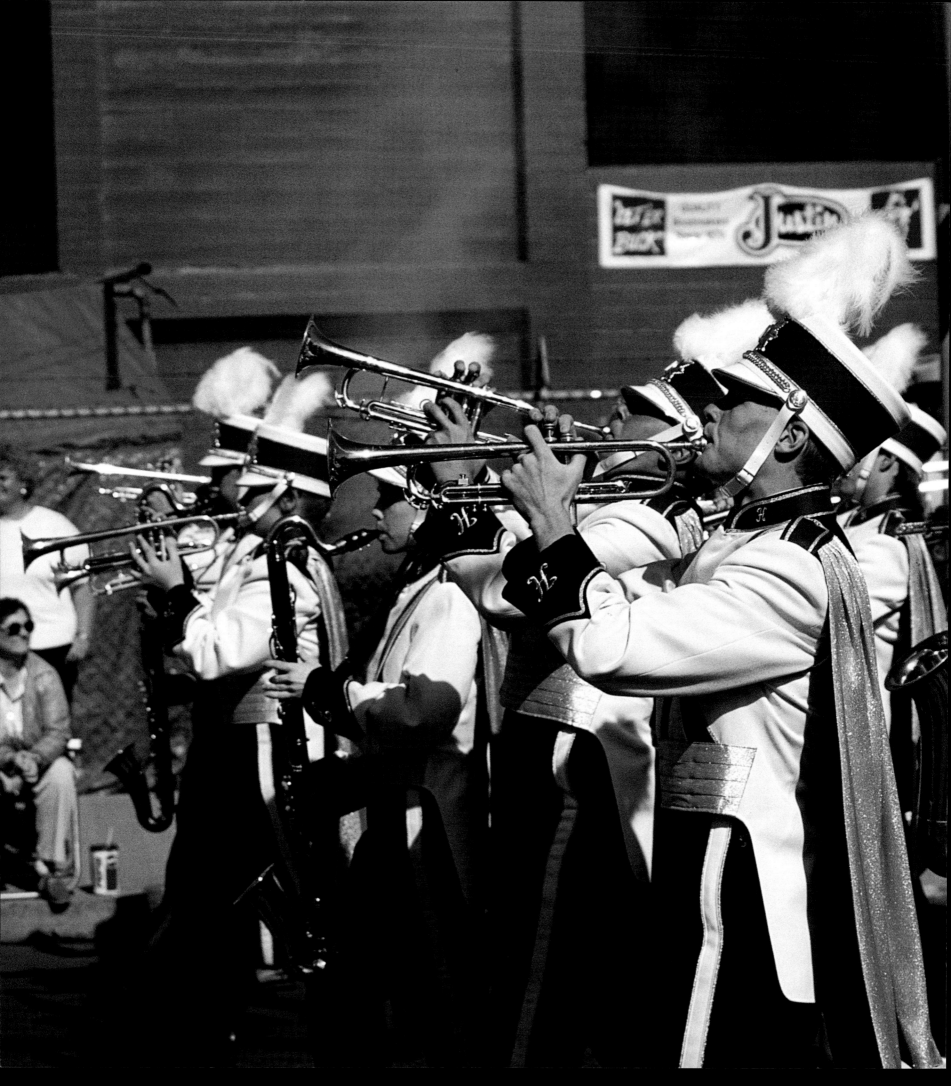

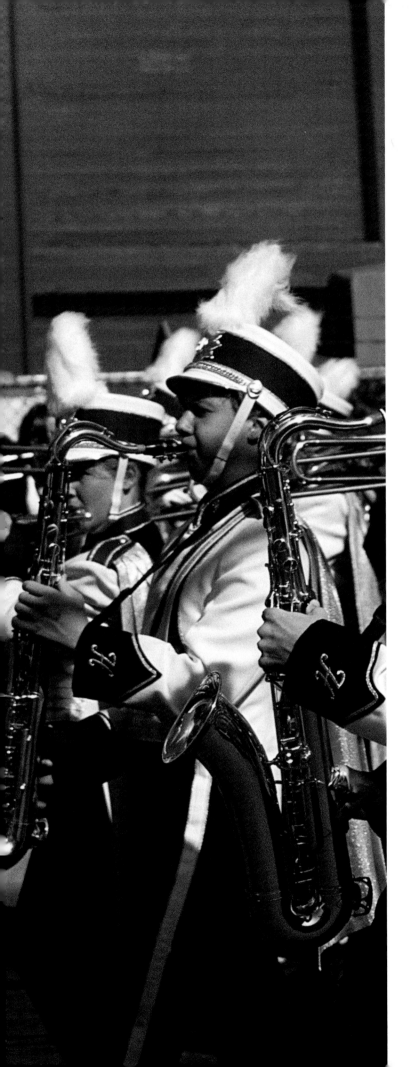

THE ROUND-UP PARADE
Left: Enthusiastic high school marching bands add to the colorful festivities of the annual Pendleton Westward-Ho Parade, an extravaganza that captures the power of small-town America spirit and Western pageantry.

Below: Vale, Oregon, rodeo royalty (Vale Fourth of July Rodeo).

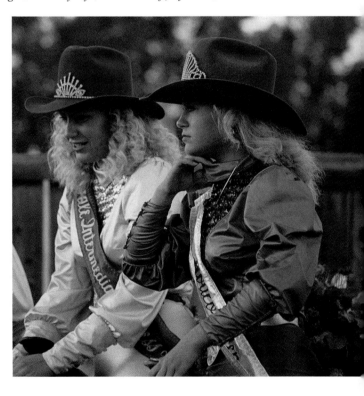

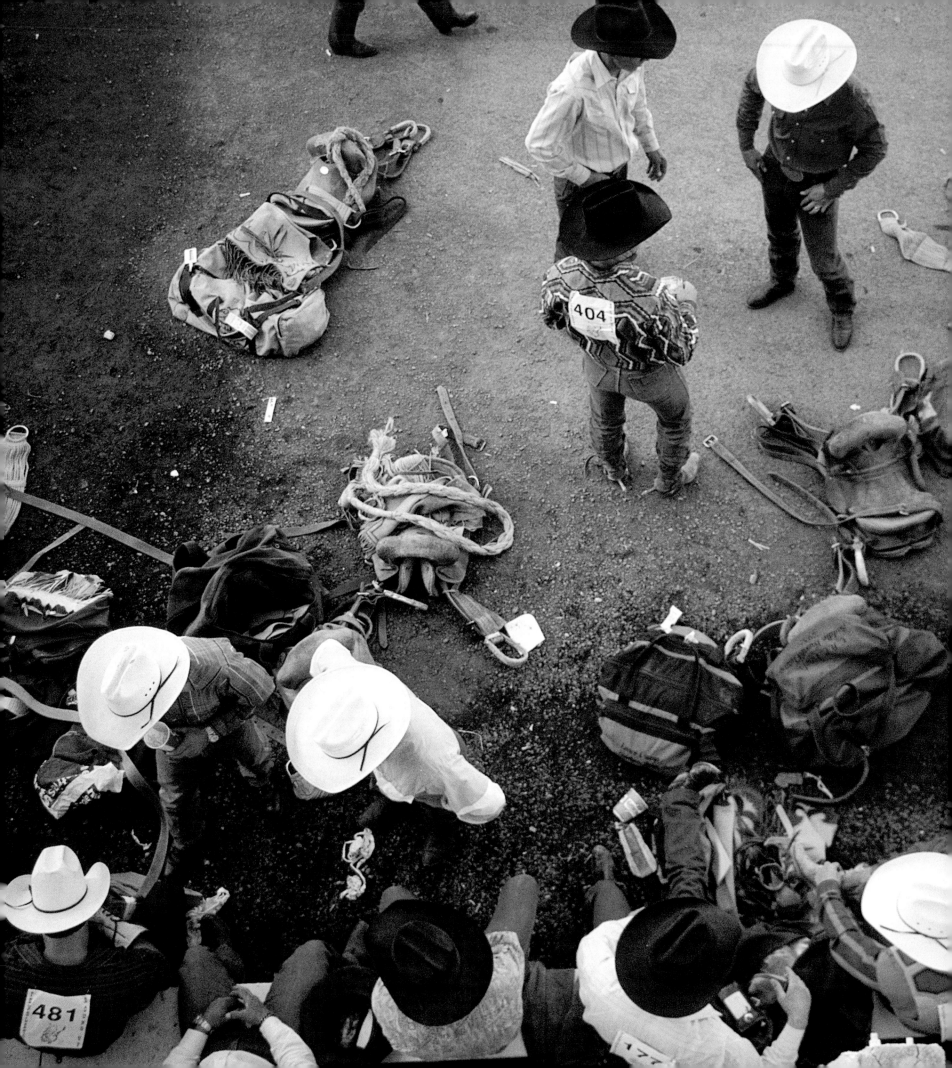

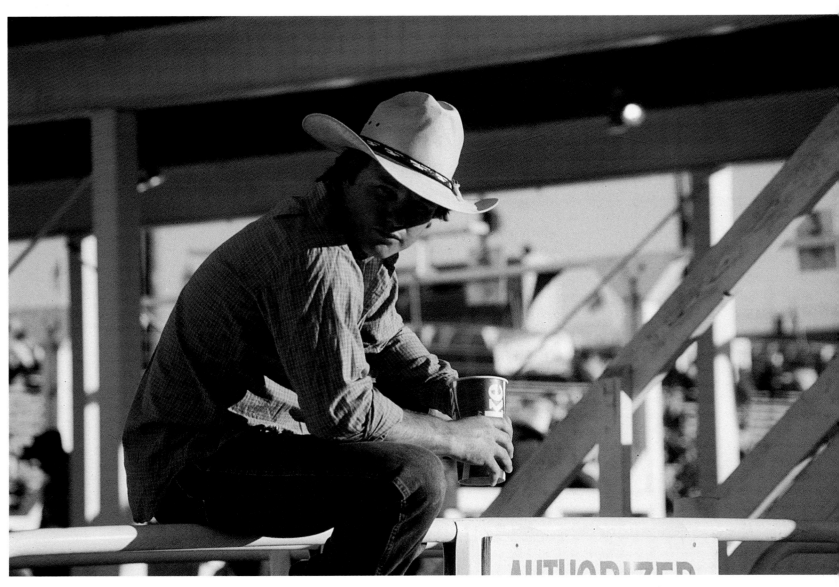

BEHIND THE SCENES

Above: A cowboy takes a break at Idaho's popular Caldwell Night Rodeo—"The rodeo where the cowboy is the star."

Opposite left: Cowboys visit and renew acquaintances amid scattered gear (Pendleton Round-Up).

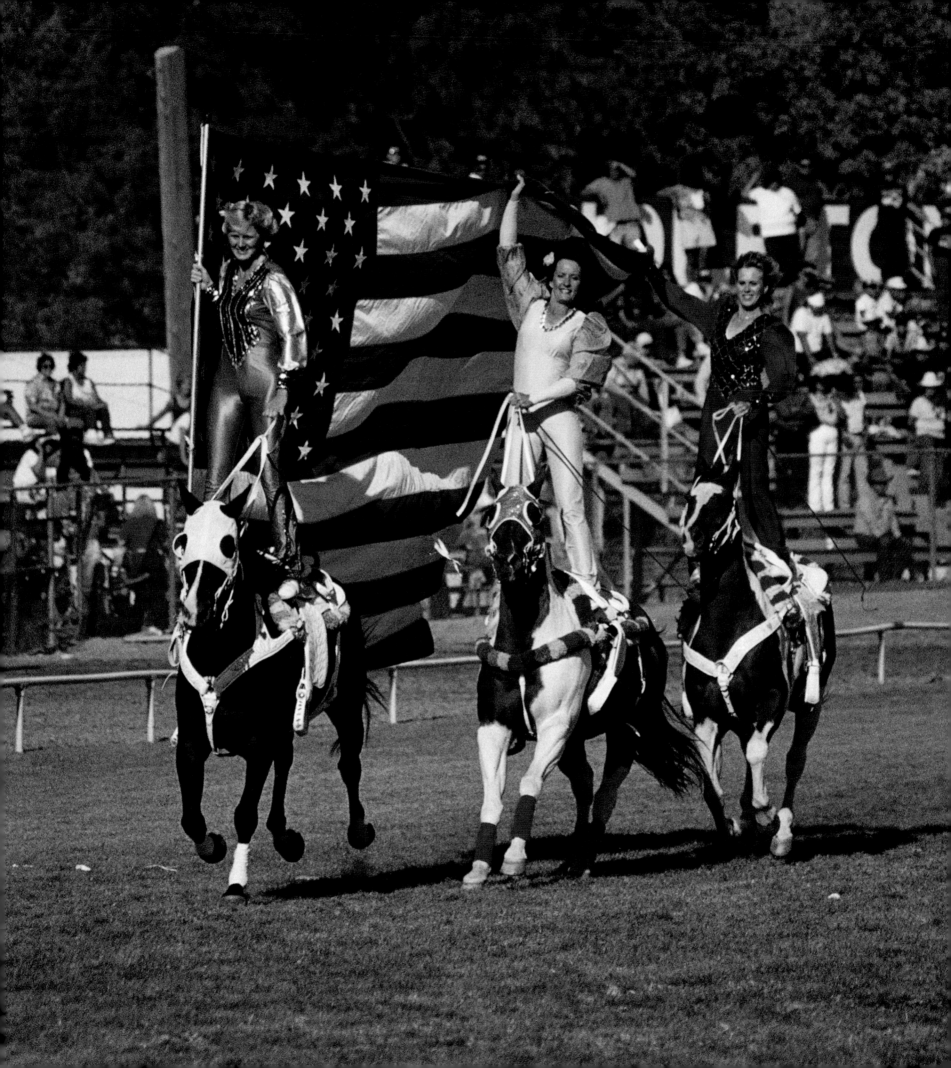

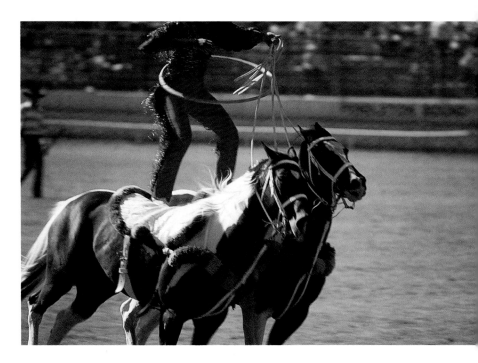

WIZARDS ON HORSEBACK

In an orchestration of timing, speed, and skill, the All-American Trick Riders team entertains at the Pendleton Round-Up. The women carry on a performing tradition that has roots reaching back to the legendary Buffalo Bill Cody's old Wild West Shows. From left: Linda Scholtz, Vickie Tyer, and Kelly Sue (Miller) Sleggert—great riders and some of the nicest people I met during the course of producing this book.

Above: Vickie performs one of the versatile moves that have assured her standing as one of today's premier acrobatic riders.

The concentration involved in trick riding is crucial. Kelly Sue, one of the best, seemingly defies gravity while executing moves such as her "Flying Fender." The trick rider affectionately calls her trusted, spotted performing horse Mr. Bojangles.

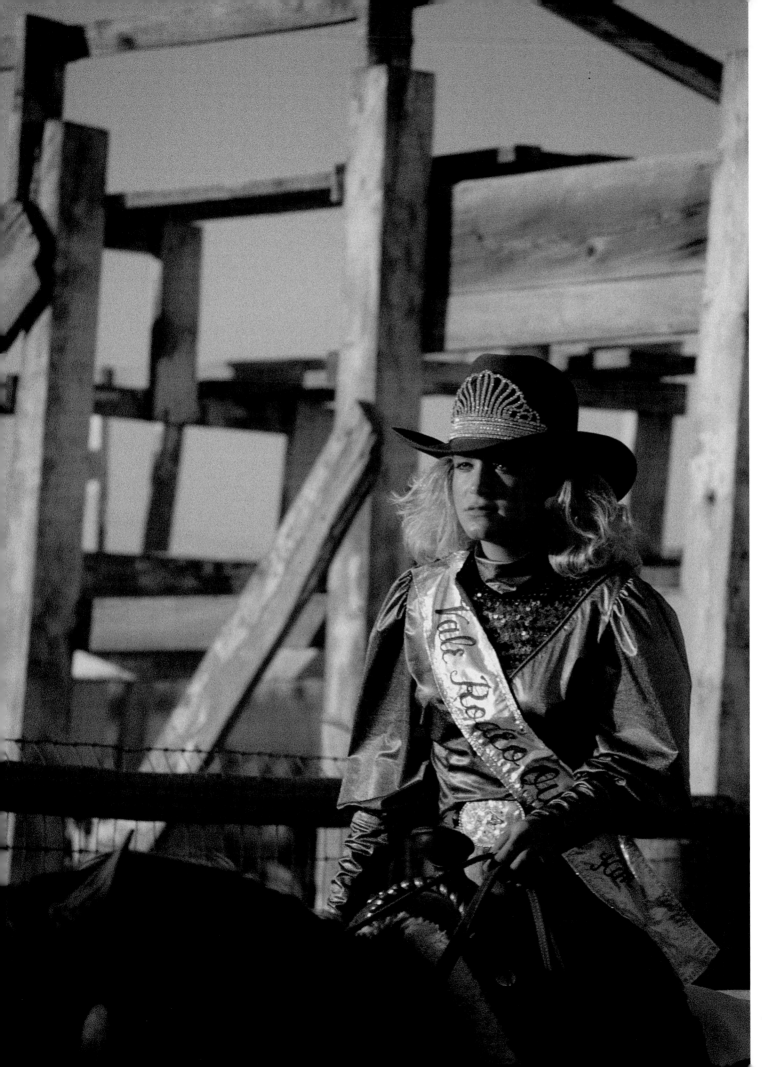

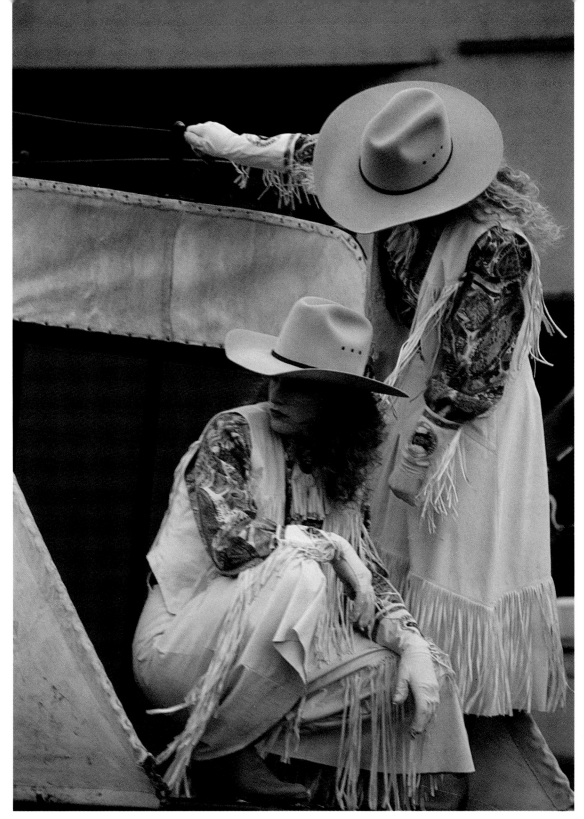

RODEO QUEENS
Above: Buckskin-clad cowgirls ride the back of a stagecoach during Round-Up week in Pendleton, Oregon.

Left: Kim Smith, a Miss Rodeo Oregon titleholder, at a New Plymouth, Idaho, rodeo.

The Ivy League Rancher

Growing up in New York State and attending Ivy League Princeton University, Dick Springs would seem an unlikely candidate to be wielding a branding iron in the rugged Owyhee Desert. Yet, as the hot Oregon sun beats down, he seems very much at home coordinating the summer roundup activities at his sprawling ranch near the Idaho/Oregon border.

Clad in a straw cowboy hat and leather chinks (shorter versions of the traditional chaps), his energy seems boundless as he alternates between branding and ear tagging calves.

Activity is whirling all around him as mounted ropers, displaying skills used a century ago, separate the calves from the herd.

Veteran rancher Bob Davis, seventy years old and still a roper of formidable skill, studies the herd with the selective gaze of an eagle. Quietly utilizing a lifetime of experience, Davis patrols along the corral fence.

Though he's done this thousands of times, one can sense roping is a matter of pride with the soft-spoken cowboy.

Each time he swirls the lariat above his head, time stands still and he is young again. He rarely misses.

A whiff of smoke hangs in the air. Dick Springs puts down the branding iron, and a just-released calf rambles back to the herd.

"How many cows do you have, Dick?" I ask during a break in the morning's activities. His brow furrows and a concerned look crosses the robust rancher's suntanned face. He shoots me a troubling sideways glance and replies, "It's a rule of the West, Eddie—you never ask a cattleman how many cattle he has. It's like asking him how much money he has."

Knowing I am unaware of the code, but nonetheless letting me know the proper Western etiquette, he then proceeds to tell me about his herd.

Dick Springs is a student of the intricacies of life. At the ranch house, his shelves are lined with books on a variety of subjects. He majored in philosophy at Princeton and blends a conservationist outlook with his approach to ranching. Quality wildlife art prints adorn the ranch house walls, along with

colorful underwater photographs of exotic marine life. Springs took the photos himself during a stint as an underwater photographer and collector for California's Scripps Institute. He played both football and hockey at Princeton, and now, in his late forties, he's lost none of his youthful enthusiasm for adventure and experience.

Years ago, desiring to keep in off-season shape for Princeton athletics, Springs telephoned long distance and begged for a summer job from a Wyoming rancher.

The cattleman, leery of Eastern "wanna-be" greenhorns, wasn't overly receptive, but Springs' upbeat attitude and work ethic earned him the opportunity.

He now operates his own ranch bordering the eerily beautiful Owyhee Mountains.

"I wanted to find a place where I would feel like the last man on the face of the earth," Dick says, smiling to himself. Truly, despite its isolation, the Owyhee country, with its rolling, sage-covered hills and prehistoric-looking mountains looming in the background, does possess an alluring feeling of peace.

AT HOME ON THE RANGE *Rancher Dick Springs (right).*

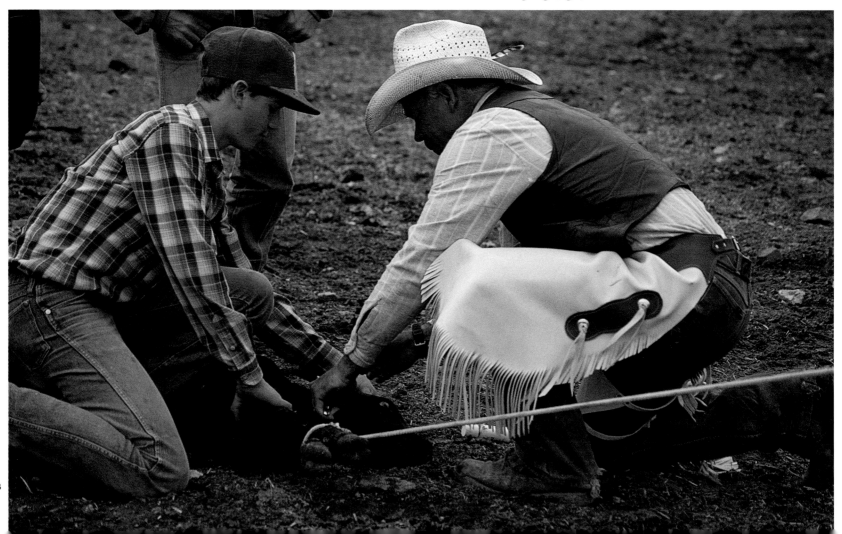

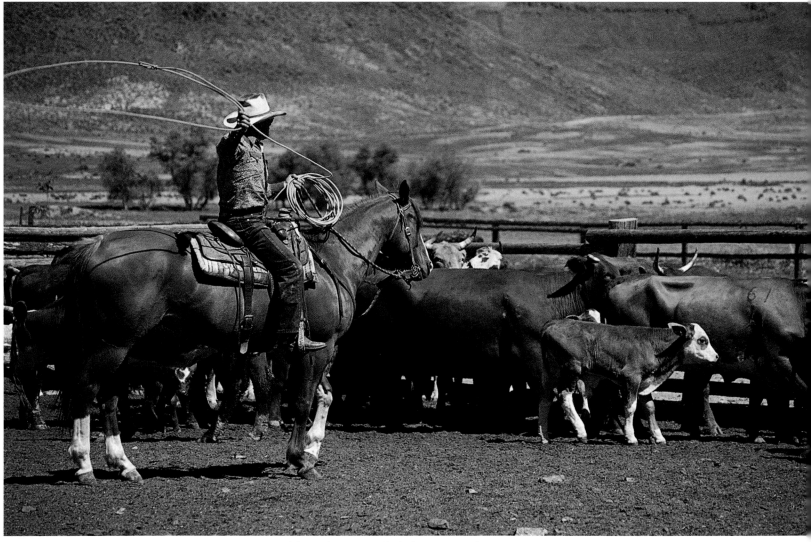

MASTER ROPER *Neighbor Bob Davis swirls the lariat in Owyhee country.*

Today, the ranch is very much a hub of activity, as neighbors like Davis and his sons have pitched in to help with the roundup, reflecting the cooperative spirit among neighbors in these remote parts.

The day's branding is a unique blend of hard work and socializing between friends and family.

Calvin, Springs' neighbor and a bit of a philosopher himself, is sitting on the back of a pickup truck parked near the branding irons.

He looks across the corral at Kenny, a diminutive roper mounted on a large, powerful black stallion.

"Do you know why the shortest cowboys always ride the biggest horses?" he asks, displaying a mischievous tone of insight and authority.

"Well, it's a rule of the West," he continues, "so that when we all ride across the horizon,

our hats will always be at the same level." That's the second rule of the West I learned that afternoon.

Another point I discovered is that in the monochromatic Owyhee Desert, the brown-and-tan-colored rattlesnakes blend all too easily with the landscape.

Approaching the corral earlier that morning, I was greeted with the news that the crew had spied a rattler just outside the corral. Had they not pointed out the patterned serpent, curled and camouflaged under a water tank, I never would have noticed it. What surprised me was that the cowboys quickly forgot about the viper and went about their business.

"I don't worry about them unless they come near the house," Dick says.

I could see the house from where we stood, and for the rest of the day was very aware of

the rattler's presence every time I knelt to take a photo.

Later, at the ranch house, Dick is enthusiastically describing a canoe trip he is planning to undertake in the Northwest Territories of the Canadian Wilderness.

It's the type of venture where they take you by plane and drop you off. You're on your own. Just you, the river, and the wilderness.

Someone mentions that such an excursion sounds pretty risky and suggests Dick carry a tracking device, should any unforeseen problems arise.

Dick looks up, then pauses, his blue eyes flashing.

". . . Seems to me that would destroy the whole reason for going," he responds with a smile.

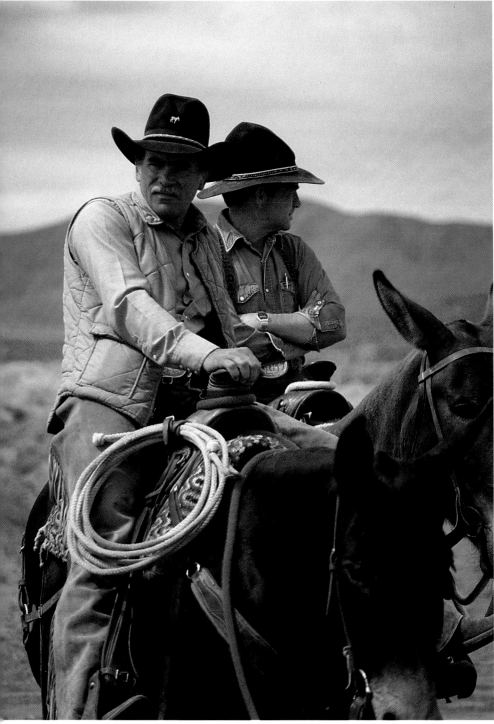

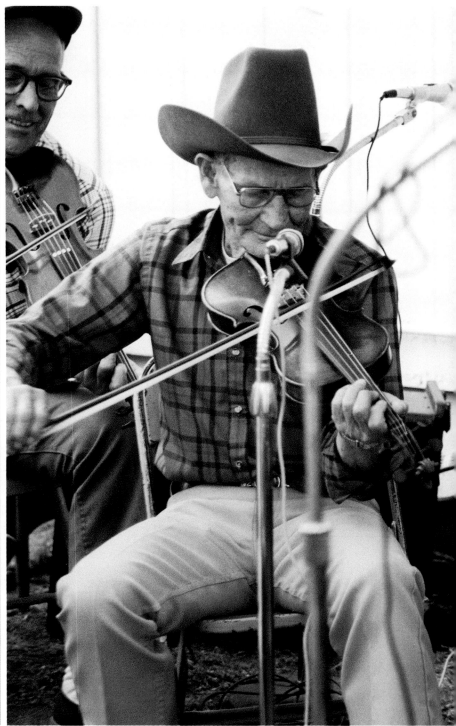

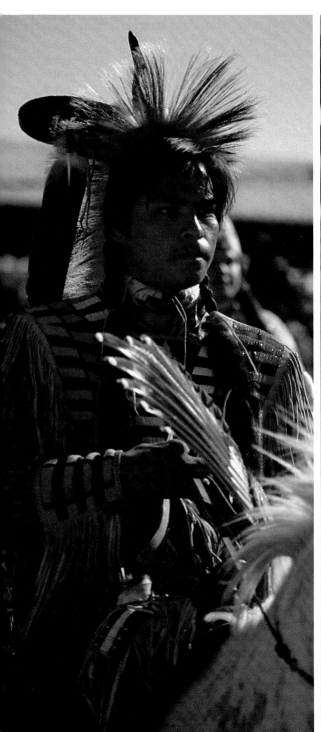

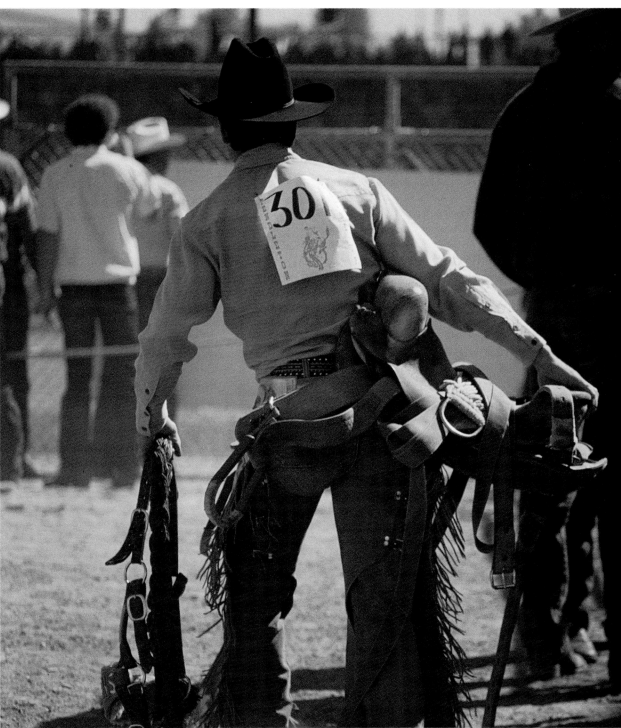

THE FACE OF THE WEST

Left to right: Mule riders at Murphy, Idaho's Old-Time Days; Old-Time Fiddlers group in full swing (Murphy, Idaho); American Indian pride at the Pendleton Round-Up; a saddle bronc rider heads toward the chutes (Pendleton, Oregon).

OWYHEE BRANDING

The rugged Owyhee Mountains accent the vastness of the Western landscape as a branding crew prepares for the afternoon's work (Springs Beefmaster Cattle Ranch, Adrian, Oregon).

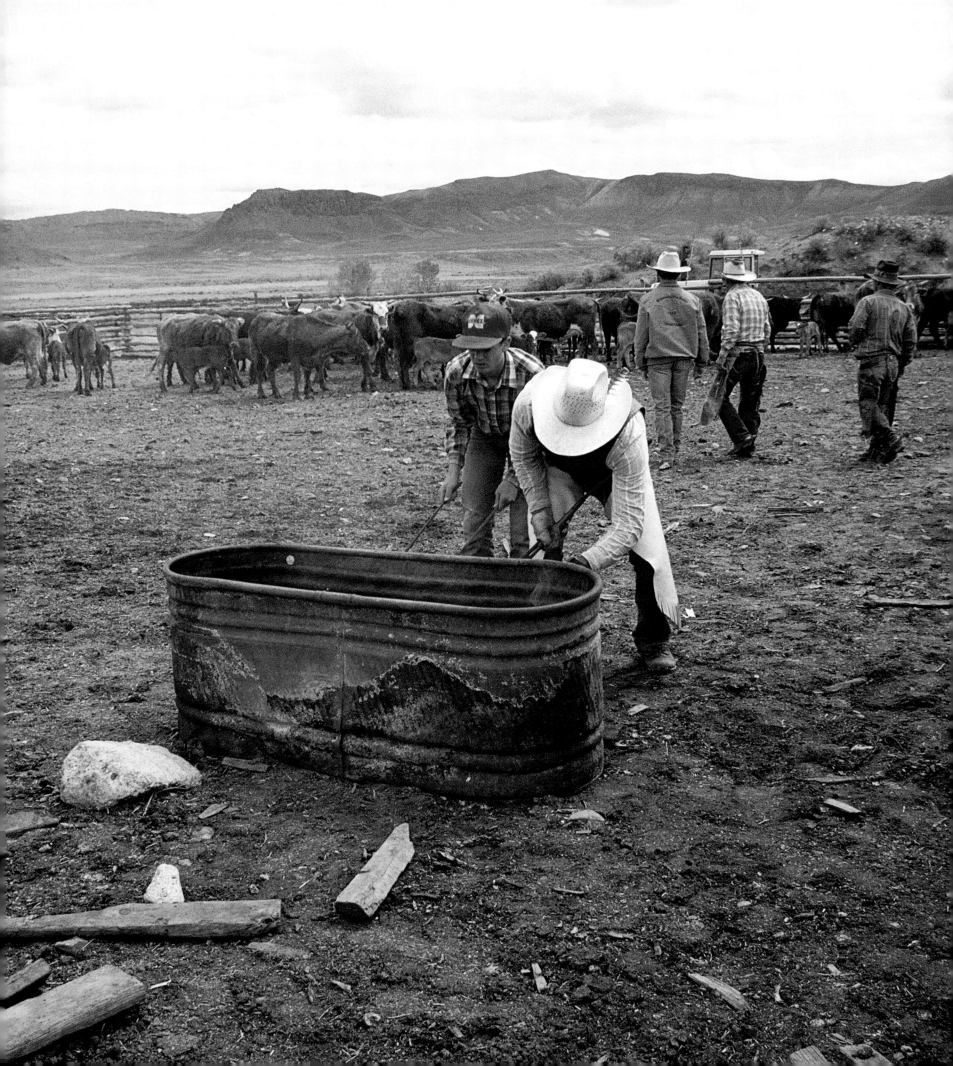

L ◆ FIRE AND RAIN ◆

ike a soft wind, the West beckons. Seductive and temperamental,
it lures us with savage splendor and the promise of new beginnings.
We are awed by the sheer expanse of its regal mountains and
sprawling desert, rich with the aroma of sage.
Yet in the grasses of paradise dwell both wildflowers and vipers.
With the subtlety of summer lightning, the West reminds us of our vulnerability,
fanning the flames of our dreams, but warning us not to fly too close to the fire.
A land of thunder and silence . . . innocence and exploitation . . .
exuberance and caution. A place of Fire and Rain, where man,
the great meddler, alternates between reverence and manipulation.
We admire the wild freedom of the West, but cannot resist the urge
to subdue it . . . build a fence around it . . . conquer it.
Perhaps by doing so, we subconsciously hope we can transfer its traits to ourselves.
In the same way, the original dwellers of the land sought the kinship
and wisdom of the wolf and his brothers.
A place of power—this land of Fire and Rain.

—Ed Guthero